Measuring Bias on Television

Measuring Bias on Television

Barrie Gunter

UNIVERSITY
UP *of*
LUTON PRESS

British Library Cataloguing in Publication Data

A catalogue record for this book is available from the British Library

ISBN: 1 86020 526 7

Published by
John Libbey Media
Faculty of Humanities
University of Luton
75 Castle Street
Luton
Bedfordshire LU1 3AJ
United Kingdom

Tel: +44 (0)1582 743297; Fax: +44 (0)1582 743298
e-mail: ulp@luton.ac.uk

Cover Design by Creative Identity, Hertford.
Typeset in Bordeaux and Galliard ITC
Printed in Great Britain by Whitstable Litho Ltd, Kent.

Contents

Part I Introduction

1 Defining the Issue 3

2 Perspectives on Determining Impartiality 21

Part II The Output of Bias

3 Cognitive Aspects of Bias: Output Perspectives 37

4 Evaluative Aspects of Bias: Output Perspectives 53

Part III The Audience and Bias

5 Cognitive Aspects of Bias: Subjective Audience Perspectives 87

6 Cognitive Aspects of Bias: Objective Audience Perspectives 107

7 Evaluative Aspects of Bias: Audience Perspectives 127

8 Television, the Future and Bias 157

References 165

Index 185

PART ONE
INTRODUCTION

Defining the Issue

Television has long been recognised by members of the public as their most important news source for national and international news, and as an increasingly significant second news source (after newspapers) for local and regional news (Gunter, Sancho-Aldridge and Winstone, 1994). The provision of news is regarded by most viewers as a key function of television and one for which it is highly valued as a medium (see Gunter, 1987). Critical to the appeal of television as a news provider is the degree of trust which audiences place in it. Television is not simply an important news source to members of the public, it is generally regarded as being a highly credible one (Gunter et al., 1994).

It is probably true to say that television, as a mass medium, prides itself on its accuracy, balance and objectivity in providing news. Indeed, by law, broadcasters in Britain are required to ensure that factual coverage of political parties and topics, matters of industrial conflict and social policy is duly impartial and accurate (ITC, 1991).

Television is not without its critics. Not everyone is satisfied with the treatment certain groups, events or issues receive when featured in television news and current affairs programming. Accusations of bias are not infrequent, and are generally characterised by aggrieved parties claiming to have been treated unfairly, misrepresented or under-represented. Some of the most severe critics of television have been politicians. Ever since television journalism adopted a more combative mode in its treatment of politicians from the beginning of the 1960s, it has been chastised by governments and opposition parties for presenting biased coverage of political affairs.

When he became Prime Minister in 1964, Harold Wilson came to believe the BBC was full of card-carrying Tories and was ineradicably biased against Labour. The Prime Minister who launched the longest sustained attack on the BBC was Mrs Thatcher. It seemed to stand for almost everything she most despised politically. In the run-up to the 1987 general election the Tory Party Chairman, Norman Tebbit, announced he was setting up a unit to monitor the BBC broadcasts for evidence of anti-Tory bias.

3

A report by the Media Monitoring Unit, a centre-right monitoring group, accused television's current affairs presenters generally, whether they worked for the BBC or ITV, of resorting to sensational, tabloid-style language depicting Britain in a negative way and indulging in crude anti-Americanism (Evans, 1987). The group stated that there had been a disturbing trend towards greater use of emotive vocabulary in current affairs reporting, accompanied by more potentially distorting dramatised reconstructions of alleged incidents involving politicians, police and immigration officers where fact and fiction were often blurred. The study monitored a selected number of prominent current affairs programmes. The monitoring was conducted by three members of the Unit who judged programmes on whether both sides in a debate received an equal opportunity to put their case and whether it was possible to discern a presenter's own views. Many details about the precise nature of the methodology used by the Media Monitoring Unit were unclear, however, and the judgements being made gave the appearance of lacking the kind of scientific rigour normally required of this form of television content analysis.

Another study of British television news output reported at around the same time, conducted by a group from Oxford Polytechnic, adopted a rather tighter methodology to show that on both the BBC and ITV the government tended to dominate the news. Over a two-month period covering May and June 1996, the 'government' was found to occupy 42 per cent of political news time, with the Conservative Party separately taking 18 per cent, the Labour Party 20 per cent and the Alliance Party just six per cent. Despite the Tories' apparent preference at that time for ITN, it turned out that on national news programmes, the BBC gave greater prominence to the Conservatives who received 15 per cent of air time compared with Labour's 13 per cent. By contrast, ITN leaned towards Labour by 19 per cent to 14 per cent. The Alliance, which had sponsored the study, had more cause for complaint. Government front benchers (including Mrs Thatcher) secured 46 mentions against 15 for Labour spokesmen and just seven for the Alliance (Jenkins, 1986).

Not all the concerns about bias on television have been restricted to questions about balancing the amount of coverage given to different parties or different sides to an argument. The qualities of coverage associated with particular topics, individuals, groups and organisations, and political value systems have also provided focal points of controversy. This point was well-illustrated in the *Panorama* libel case in which two Conservative Members of Parliament who featured in an edition of this long-established BBC current affairs programme, Neil Hamilton and Gerald Howarth, successfully sued the BBC for libel over the use of what the plaintiffs claimed were hostile interviewing techniques and highly selective cutting of programme material. The programme dealt with an allegation that the Conservative Party was being infiltrated by the far right. It contained a number of errors including a film of a supposed lunch held by the extremist 'Tory Action' Group, which in fact showed a railway buffet reunion at Oxford Station celebrating a visit there by Tsar Nicholas II of Russia at the turn of the century.

Cases such as these illustrate that concerns about television's impartiality may centre on such issues as the amount of coverage allocated to different parties in a debate or dispute, or upon the style of treatment one party receives when featured. As this book will attempt to demonstrate, however, there are many more ways of determining whether television is biased than simply quantifying the allocation of airtime to opposing parties or points of view. Further, judgements about production treatment which take on a more subjective tone may provide weak and inadequate demonstrations of partiality where they are themselves guilty of benchmarking television's coverage from a prejudicial position.

The methodology applied to assess television bias is another factor which needs to be considered with care. The quantitative analysis of programme content in terms of stopwatch-based measures of time allocation to different parties or viewpoints reveals little about the subtle effects style of coverage may have upon viewers, understanding or impression formation. Qualitative analyses of content may reveal more subtle features of television's treatment of issues and events, but cannot do more than infer what their possible impact might be upon public understanding and opinion. Eliciting opinion directly from members of the audience may yield conflicting results depending upon the pre-existing knowledge and beliefs individuals hold about the medium, a particular broadcast or broadcaster, or the party, issue or event being discussed. Thus, the concept of bias is difficult to pin down and virtually impossible to operationally define in any single fashion. Perhaps one significant set of factors, regardless of the nature of the eventual output of television or its impact upon the public, are the values and intentions of those involved in its production.

Morris (1989) argued that impartiality represented the outcome of a moral disposition towards reporting. Impartiality in the strictest sense was probably impossible to achieve, much in the same way as absolute justice or perfect truth. Nevertheless, impartiality would be attained, if at all, not simply through 'technical editorial devices, but by the exercise of plain human qualities, like good manners and self-discipline; a refusal to exploit the vulnerable or to betray a trust; by generosity of judgement and by reticence' (p. 24).

Broadcast regulation and impartiality

The concept of impartiality is particularly important in connection with broadcast journalism. As a guiding principle in British broadcast journalism, it goes back to the origins of the BBC in the 1920s. Broadcasting was originally set up as a public utility to be developed as a national service to operate in the public interest (Scannell and Cardiff, 1991). The BBC was established in its current form in the light of the recommendations of the Crawford Committee. From the outset, it was regarded as a national resource with cultural, moral and educative functions. Its role was to inform the public and to create a sense of national identity and social unity. While having a political role to play in the context of ensuring that public opinion was fully informed on

important national issues, the BBC was to fulfil this role in an independent and impartial fashion (Scannell and Cardiff, 1991).

Already though, it was clear that 'impartiality', as envisaged by the legislative and political framework within which the BBC was established, could not be defined in absolute terms. Effectively, the BBC, though ostensibly independent, was a public service established by the state, and was charged with serving the 'national interests'. The rules of impartiality and, more especially, the benchmark by which it is defined, may alter under conditions where journalism is perceived to threaten the national interest. This is especially likely to happen when the country is at war, in which case the national broadcaster is expected to support government policy and decisions, and observe extreme caution over any airing of the position of those with whom the nation is in conflict.

Despite criticism to the contrary, broadcasters take the issue of impartiality very seriously. Indeed, there are legal obligations placed upon them to do so. Fairness and impartiality in television's coverage of issues and events which have major political or social significance are written into statutory requirements placed upon broadcasters in many countries. In the United Kingdom, United States and most of western Europe, television organisations are either invited or obliged to pursue a policy of objectivity or impartiality in their news programmes and their programmes of political comment.

In the United States, for example, the Television Code of the National Association of Broadcasters (Tenth Edition, 1965) laid down the following directive to be followed by all television stations with respect to broadcasting 'controversial public issues':

> Television provides a valuable forum for the expression of responsible views on public issues of a controversial nature. The television should seek out and develop with accountable individuals, groups and organisations, programmes relating to controversial public issues of import to his fellow citizens; and to give fair representation to opposing sides of issues which materially affect the life or welfare of a substantial segment of the public.

In the United Kingdom, there is a specific requirement laid down by Act of Parliament which requires the independent television regulator to draw up a code giving guidance as to the rules to be observed for the purpose of preserving due impartiality on the part of the television companies licensed by the regulator. This code applies specifically in respect of their coverage of political, industrial and social policy matters. Appearances by politicians in news and current affairs programmes in the capacity of spokespersons for their party or for their own political point of view are also governed by the general requirements of fairness and impartiality.

During general elections in the United Kingdom, the allocation of time to the major political parties for party election broadcasts is related to electoral support at the previous general election and to the number of candidates

nominated by a party for the current election. Any party fielding at least 50 candidates is normally entitled to at least one party election broadcast of five minutes duration on mainstream television. There are also regulations laid down concerning general election appearances by candidates during times of elections to ensure that all sides are given equal amounts of coverage.

The 1990 Broadcasting Act, which covers commercial television broadcasters, requires the regulator, the Independent Television Commission, to do all that it can to secure that every service it licenses shall comply with the requirements to ensure 'that any news given (in whatever form) in its programmes is presented with due accuracy and impartiality' and 'that due impartiality is preserved on the part of the person providing the service as respects matters of political and industrial controversy or relating to current public policy' [Section 6(1) (b) and (c)].

The Act also makes it a statutory duty of the ITC to draw up, and from time to time review, a code giving guidance as to the rules to be observed for the purpose of preserving due impartiality as regards matters of political or industrial controversy or relating to current public policy. The ITC's Programme Code (ITC, 1991) stipulates that 'Broadcasters licensed by the ITC are free to make programmes about any issues they choose. This freedom is limited only by the obligations of fairness and a respect for truth, two qualities which lie at the heart of impartial broadcasting' (Section 3.2). The Code provides a further important set of qualifications which serve to define what the regulator regards 'impartiality' to mean in the context of the Broadcasting Act's requirements.

> Impartiality does not mean that broadcasters have to be absolutely neutral on every controversial issue, but it should lead them to deal even-handedly with opposing points of view in the arena of democratic debate. Opinion should be clearly distinguished from fact. In dealing with matters of political or industrial controversy, or current public policy, particular care may be needed in order to ensure compliance with the impartiality requirements of the Broadcasting Act. (Section 3.1)

In terms of the legal requirements placed upon broadcasters then, impartiality does not mean that it is necessary to ensure that two sides of an argument or dispute receive exactly equal coverage as determined by the amount or airtime allocated to them in each case. It is important, though, that information presented as 'fact' should be clearly distinguished from that which is presented as 'opinion'.

In addition to attempting to define impartiality, the ITC's Programme Code offers further guidelines on how and where the requirement applies in broadcast programming, and, in operational terms, the different ways in which it may be achieved. One important aspect of the impartiality code is that it is not expected that impartiality must invariably be achieved during a single programme. The 'series' provision allows broadcasters to transmit a series of

programmes in which particular episodes may present a distinct point of view, provided that a counter-balancing point of view is presented in another episode elsewhere in the series. This requirement recognises that with some topics, it may be necessary to deal with them over more than one programme in order to do them justice.

Another important area of the Code concerns the coverage of 'major matters'. Recognising that major news matters may receive widespread news coverage in news and current affairs programmes, nationally as well as regionally, and that agendas might vary in terms of the nature of the coverage given by different newsrooms, the regulator nevertheless advises broadcasters to take care to ensure that over the coverage taken as a whole, 'justice is done to the full range of significant views and perspectives.' (Section 3.4).

These impartiality requirements refer to news broadcasts, current affairs programmes, and drama documentaries in which the boundaries between what is fact and what is fiction may become blurred. The Code stipulates that a distinction should be clearly drawn between plays based on fact and dramatised documentaries which seek to reconstruct actual events. In both cases, clear labelling is needed to ensure that the audience is aware of the type of programme they are watching. Reconstructions of actual events, even though dramatised with some elements of characterisation, dialogue and atmosphere which may adopt a degree of creative license, must nevertheless seek to avoid distorting the facts or leaving the audience with a false or misleading impression of what actually happened.

While legal requirements place certain stipulations on broadcasters to observe 'due impartiality' and highlight aspects of programming where realising this requirement could pose problems, the assessment of how the news has performed and whether impartiality has really been effectively achieved is no easy matter. Establishing whether a subject has been treated without bias on television is not always a straightforward problem. Agreements about definitions or measures of 'bias' are seldom achieved with ease. Indeed, the degree of purported impartiality or bias in television's factual coverage of individuals, groups, events or points of view often depends upon the perspective from which one chooses to evaluate the coverage in the first place. Thus, impartiality is not a concept or phenomenon that can be defined and measured in absolute terms. Operational definitions of bias derive from different theoretical perspectives with each requiring a particular kind of methodology of assessment.

This book will examine the issue of television's impartiality or bias with special reference to its news and current affairs coverage. To begin with, it is important to establish where the notion of 'impartiality' lies in the context of news objectives and standards. From the perspective of broadcast regulation, for example, impartiality is regarded as a key aspect of quality broadcasting. The extent to which a broadcaster is judged to have failed to follow the recommendations of the impartiality code and fallen short of the requirements of good factual reporting or debate, he may also be judged to have

performed poorly in a more general sense. This flaw may be equated with a failure to meet the fundamental, though possibly unattainable, goal of objectivity.

The discussion of bias versus impartiality on television within a wider consideration of television's objectivity as a news medium is helpful in defining in the broadest conceptual sense what the notion of impartiality itself represents as an aspect of high quality news and factual broadcasting. 'Objectivity' represents a key concept in any assessment of television's performance as a quality news provider. There are a number of different ways of analyzing bias and impartiality on television. Independent criteria from the real world can be used as points of comparison against which to judge the nature of television's coverage of particular topics. Output criteria can be defined and applied in an analysis of television news content and styles of presentation. Professional criteria which derive from journalists themselves can not only yield a frame of reference for analyzing television news output, but also reveal norms and values which underpin the production of news. In addition, there are various criteria which derive from audiences which may be based either upon viewers' subjective perceptions and impressions of television news or more the more objective criteria of audience comprehension and recall of news. No single method or set of criteria will be placed above the rest. Among these different perspectives on measuring news bias on television each has its own advantages together with certain shortcomings or limitations.

Impartiality as an Aspect of Objectivity

At the heart of all good journalism lies the practice of objective reporting. This means giving a full and accurate account of events being reported which reflects as closely as possible the true facts of a matter. Thus, the facts of a matter can be independently verified and shown to be true. According to one commentator, objectivity in reporting means that 'a person's statements about the world can be trusted if they are submitted to established rules deemed legitimate by a professional community' (Schudson, 1978, p.7). As an absolute this professional goal represents an ideal which is difficult to attain. News organisations, however, devote considerable resources to getting as close as they can to achieving this ideal. Objectivity is not only valued by journalists but also expected by audiences who turn to television, in particular, as a trusted and reliable information source. A comprehensive analysis of impartiality and bias on television must give wider consideration to the concept of objectivity which, theoretically, represents an essential goal of news reporting and therefore a potential frame of reference within which impartiality in the news can also be defined.

In the pre-television era, objectivity was often considered an old-fashioned virtue which offered a standard against which the sensationalism and the political bias of popular mass newspapers could be judged (Hutchins, 1949). Journalists at the end of the 19th century were encouraged to assume the existence of an external world which could be known and reported on with

accuracy. Since television became established as a main news source, objectivity has become a routine norm of good practice rather than a rare virtue, largely because of the high and privileged status which national television channels have acquired in many countries (Kumar, 1975; Stephens, 1986).

The absence of objectivity does not simply mean that reporting is inaccurate or tendentious. Journalistic criteria of newsworthiness of stories or the best way to present them may cut across the strictest criteria of objectivity and balance. Journalists themselves may see it as part of their role to provide interpretation or to challenge certain established points of view (Janowitz, 1975; Johnstone *et al.*, 1976; Kocher, 1986).

The notion that journalists offer a direct window on world events, exposing the truth behind them, has been conceived as a type of bias in its own right. In seeking to turn objectivity into a routine in news production, the producers themselves may be influenced by subtle processes of news selection and presentation which result in a news product which reflects particular criteria of newsworthiness. Thus, even accurate news could be accused of bias from the perspective not simply of what is presented, but also from the perspective of what is not reported. According to one professional viewpoint on this: '..impartiality is uncontroversial because it is an inclusive concept; it leads to diversity. To be impartial, journalists must seek a range of views and care must be exercised, especially in longer items, that a point of view does not go by default merely because the interviewee selected is less than articulate. Evidence must be weighed. The accused must be offered the opportunity to reply. In a longer piece there should be enough hard evidence and balance so that the viewer or listener can reach an alternative judgement to the one that the programme itself may drive at' (p. 17).

Whether or not objectivity can be achieved is debatable. The manipulation of media for propaganda purposes by fascist dictatorships in the 1920s and 1930s illustrated the way facts could be distorted by subtle production features and styles of reporting which were designed to create particular 'mindsets' among audiences. The emergence also of the public relations industry underscored the assertion that facts were there to be manipulated. Today, the concept of 'spin doctors' in the political process further reflects the notion that the flow of information via the mass media can be influenced en route to achieve the particular impression about political issues or political actors which those actors wish to promulgate.

Critiques of the objectivity notion based on empirical evidence (usually in the form of content analysis) have argued that journalism is inherently biased. The mass media are regarded as information conduits which can facilitate the organization of public opinion on a mass basis (Alexander, 1981). A degree of flexibility is required in the production of news which rests on the idea that journalists are sufficiently autonomous from economic, political and other élites in society. Where there is any hint that news production is tied to vested political, economic, moral or social interests, its objectivity must be called into question.

Some observers would argue that there is no such thing as objectivity. In reality, there are a number of potential journalistic accounts of events, corresponding to the plurality of viewpoints which exist in the world. Journalism can thus never achieve a neutral, value-free representation of reality. As one example of this point of view, Fowler (1991) stated that: 'news is not a neutral phenomenon emerging straight from reality, but a product. It is produced by an industry, shaped by the bureaucratic and economic structure of that industry, by the relations between the media and other industries and, most importantly, by relations with government and other political organizations (p.222).

Given the significance of the concept of objectivity in news reporting, determining the level of bias in the news is a matter which falls within the objectivity frame of reference when assessing the standards which news presentations have attained. The presence of bias, however, does not mean the same as a lack of objectivity in reporting. According to McQuail (1992) the term bias means 'a consistent tendency to depart from the straight path of objective truth by deviating either to left or right (the word derives from the game of bowls, in which a ball can have an in-built tendency to deviate or be made to deviate by a player). In news and information it refers to a systematic tendency to favour (in outcome) one side or position over another.' (p. 191) The tendency to tread a middle path, neither to the right nor the left, has been conceived by some observers as a form of bias in which one 'truth' or perspective is chosen above others without justification or explanation (Hemanus, 1976).

It is difficult, however, to envisage how 'objectivity' can ever be anything more than relative. It represents a position for which a locus is established in relation to other positions or on the basis of available evidence. The media, in standard forms of news reporting tend to simplify issues by setting up black and white, either/or positions on issues, or reduce conflicts to a matter of dispute or disagreement between two parties. Of course, there may be other points of view which are left out because they would render a story overly complex to deal with crisply within a few short sound bites.

Objectivity then represents, in operational terms, the implementation of good journalistic practice, while bias might be seen as the absence of good journalistic practice. In setting standards of objectivity, procedures need to be put in place which facilitate the recognition of bias. Different researchers have identified a variety of indicators and definitions of bias in this sort of context.

Numerous academic discussions of bias in the media have examined the nature of the phenomenon from a variety of perspectives, but have seldom offered a definition of what it is. Efron (1971) asked: 'What is bias' and warned that bias is a 'loaded codeword' whose analysis 'requires a clear understanding of what political bias is and what causes it'. That bias, she found, is a 'specific type of selective process in a specific political context'. Efron dismissed problems of objectivity as 'old subjectivist bromides' and argued that bias exists relative to other bias. The 'objective truth or falsity of news

program statements' is not the issue; the issue rather is one of 'according preferential status to certain political positions and opinions' (p.4). Throughout, Efron equates television news bias with failure to fulfil expectations of the Federal Communications Commission's Fairness Doctrine. In other words, whether or not a particular mass media, such as television, can be judged as exhibiting bias in its news coverage may derive from an examination of the medium itself and by comparing the medium's performance against the formal, constitutional rules of the society it serves (Williams, 1975).

Epstein (1973) in *News from Nowhere* recognizes the television networks' organizational imperatives as key variables which may underpin the nature of news coverage. A mixture of commercial motives and political requirements and rules dominate the medium placing upon news media and news producers a stable set of procedures, criteria and values which determine the way news is 'gathered, selected, reconstructed and presented on television' (p.257). The television network's budget is a decisive factor and dictates an economic framework within which newsmakers must operate.

News is integral to the total television product and while its marketing is guided by the Fairness Doctrine, which also reinforces local affiliates' pressures for 'national' news from the parent networks, the news must not lose audiences for other commercially profitable parts of the television product. Imbalance or the 'tendency of network news to focus attention on certain causes to the comparative neglect of others, proceeds more from organizational problems than from the political biases of individuals' (Epstein, 1973, p. 270).

Frank (1973) preferred a more neutral definition of bias as 'selective encoding'. Hofstetter (1976) identified four different kinds of bias: as lies, 'deliberate, purposeful deception by assertion or untruths'; as distortion, when a 'news account is affected by unjustifiable omissions of significant facts, under-emphasis or overemphasis of certain aspects of an event'; as value assertion, in the form of ideology. Finally, there is structural bias in television, as when the major television networks all report the same topics in the same way.

Elsewhere, it has been suggested that propositions about bias can come from sender or receiver variables (selective encoding or selective perception) and that they also divide into cognitive or non-cognitive variables (the latter mainly presentation factors) (Williams, 1975). Classical models of communication would explain the causes of biased messages in relation to sender-receiver relationships. In the television news context, the sender is both the original source of the news and the television producer or, more broadly, the television industry. The receiver is the audience for television news. This model is regarded as too simplistic in its division of the world into those who send and those who receive messages. The fact is that those individuals who originate and send news are also news consumers, while those individuals traditionally classified as receivers, may also be makers or senders of news today.

Whilst most performance assessment research has concentrated on selection and presentation, Stevenson and Greene (1980) also emphasized the

contribution of the receiver. Their definition of bias was conventional enough: 'the systematic differential treatment of one candidate, one party, one side of an issue over an extended period of time. The failure to treat all voices equally'. However, they went on to propose that bias is really information in news which is discrepant with mental pictures held by the receiver, a discrepancy which evokes an evaluative response, essentially a function of perception. Bias needs to be considered from the perspective of cognitive variables which govern news selection, as well as from the perspective of non-cognitive factors which govern techniques of presenting news quickly, economically and electronically.

Conceptualizing Bias

Journalistic work to a large extent consists in the evaluation of news, choosing between what to publish and what to throw away. The choices must be made very quickly, of necessity against a background of more basic values and evaluations. It is obvious that this background must make itself felt in the journalistic work. News therefore reflects the basic values of journalists and their audiences.

The study of news flow and news structure has taken place within rather self-contained research traditions. These include the 'objectivity tradition' (Westerhahl, 1970, 1972); the 'international flow tradition' (Galtung and Ruge, 1965; Gerbner and Marvanyi, 1977); and the 'credibility tradition' (Carter and Greenberg, 1965; Edelstein and Tefft, 1974; Arvidson, 1977). While the first two of these traditions deal with news reports and the process leading up to the news, the last one deals with the relationship between the news and the public.

In examining issues related to the credibility of the news media, Rosengren (1977) argued that the news reporting in a country must be partial in a way reflecting the basic values and actual sympathies of the population. The reason for this is simply that otherwise the credibility of the media will disappear. Rosengren cites the case of a debate about relations with Portugal conducted in the Swedish media. A Social Democrat freelance journalist objected to an allegedly communist perspective of a radio correspondent who seemed to have deviated from the rest of the Sveriges Radio (SR) reporting. In actuality, however, the general SR reporting was as imbalanced or partial as that of a communist daily, only the other way round. But the SR was not criticized on this basis, it was criticised because one of its staff members may have been partial in the opposite direction. Thus, imbalance or partiality *per se* was not criticized. Only partiality which did not fit in with the basic values and sympathies embraced by a majority of the people was criticized, because such partiality did not produce reports perceived as trustworthy, credible, or reliable.

Table 1.1 Conceptual Scheme for Assessing News Credibility

		Holistic Long-term Evaluative Trustworthiness	Detailed Short-term Cognitive Credibility	Reliability
Medium				
Characteristic of	Public in relation	Trust	Credit	Reliance
	Public at large	Credulity		

Source: Rosengren, 1977, p. 41.

A useful model for the definition and placement on impartiality within the wider framework of news delivery standards and performance was proposed by Westerhahl (1983). This conceptual framework was developed to guide an investigation into whether Swedish public broadcasting was meeting its legal obligations of impartiality. In this model 'impartiality' was identified as a component of 'objectivity', along with another factor, 'factuality'. Both factuality and impartiality were conceived to have two major sub-components each. In the case of factuality, these two aspects were labelled 'truth' and 'relevance'. In the case of impartiality, which was regarded as a complex mixture of ingredients, two sub-components were 'balance' and 'neutrality'.

These two major divisions of objectivity can also be differentiated in terms of whether they represent 'cognitive' or 'evaluative' criteria of performance. The cognitive dimension of factuality relates to the information quality of the news. In other words, does a news presentation serve to enhance the audience's factual knowledge, or its comprehension and learning about the stories being presented and associated issues. To the extent that the news is truthful and relevant, it is argued within the current conceptual framework, that significant audience learning and understanding can take place.

Figure 1.1. Westerhahl's Classificatory Scheme

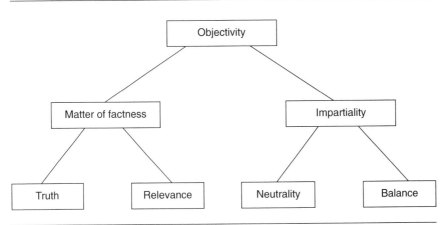

Source: Derived from Westerhall, 1983

Rosengren (1977) argued for a merger between the credibility model and Westerhahl's objectivity model. Imbalance and partiality – both key concepts in the objectivity tradition – are closely connected with trustworthiness and credibility which are key concepts in the credibility tradition. In trying to relate the 'objectivity tradition' and the 'credibility tradition' to each other, it might be fruitful to try to create to take the credibility conceptual scheme and adapt the objectivity framework to it. In this way, the following schematic representation of a framework for assessing news bias was derived (see Rosengren, 1977).

Figure 1.2.Dimensions of News Assessment

| | | Criteria for Assessment | |
		Cognitive	Evaluative
To be	Content		
assessed	Presentation	Truth	Neutrality
	Selective	Relevance	Balance

Source: Rosengren, 1977, p.42.

Although criticised by some writers (Hemanus, 1976; Hermeron, 1973), Westerhahl's distinction between truth and relevance as cognitive values and neutrality and balance as evaluative values is useful. But, as Rosengren (1977) pointed out, it is equally the case that truth and neutrality go together in that both are related to the contents of news stories – the presentation part of journalistic work, while relevance and balance have as much to do with what it not reported – in other words are concerned with the selection part of journalistic work.

Cognitive Aspects of News

Looking at the criteria of 'factuality', the truthfulness of the news is concerned primarily with whether the information in the news itself is reliable or credible. Are news reports factually correct in terms of what audiences themselves know to be the case, or in the sense that people exposed to this information would have sufficient confidence in it to act upon it. According to McQuail (1992), there are a number of distinctive and measurable criteria which underpin the truthfulness of news accounts:

> *Factualness*, in the sense of clearly distinguishing fact from opinion, interpretation or comment, backing reports by reference to named sources, avoiding vagueness and redundancy;
>
> *Accuracy*, a matter of correspondence of report to reality, or to other reliable versions of reality, especially on matters of fact or quantity (numbers, names, places, attributions, times, etc);
>
> *Completeness*, or fullness of account, on the assumption that a minimum amount of relevant information is required for understanding.(p.197)

Turning to 'relevance', the key attribute here seems to be that the news must be of value to audiences and reflect matters which are of current concern.

Stories may be grounded in fact, contain clearly presented details which testify to their accuracy, and provide a sufficiently informed account to enhance audience understanding but fail to represent all that is of current importance. Thus, relevance, as an aspect of news quality assessment, is concerned essentially with the news selection process. Individually, the stories that are presented may fulfil the truth criteria, but collectively fail to satisfy the relevance standard.

The relevance standard is not easy to meet because it begs the question not simply of the significance of news topics or events, but more especially, significance for whom. Whose judgement is to be relied upon to determine whether a story is sufficiently 'relevant' to warrant inclusion in a news broadcast? The news selection process, in practice, is conducted by news professionals who observe certain intuitive rules and guidelines about what represents 'newsworthy' material about which audiences would or should want to know. Given the way in which the major news media operate, with daily deadlines, tight time or space constraints, and the need to compete 'effectively against competitor news suppliers, it is essential that the news selection and production process is routinized (Schlesinger, 1978; Hetherington, 1985). Such rigid practices, together with the stereotyped assumptions about audiences they often embrace, can lead to certain inherent 'biases' in the way news topics are chosen and presented (Glasgow Media Group, 1976, 1980).

News values and impartiality observance

Polemics about bias in ordinary language usually concern 'slanted' reporting which does not portray political events, actors or issues as they really are. Bias may consist of outright lying, distortion by presenting certain facts and not others, or disagreement over basic values, beliefs or mores. Slanting may be used, from time to time, but is not always easy to investigate scientifically to establish what its impact might be. Lying or distortion are not commonplace because the longer-term costs to journalists, if found out, far outweigh any perceived short-term benefits.

One approach to bias is to treat it as a form of selectivity in news reporting which may or may not lead to the unbalanced, inequitable or unfair treatment of individuals or issues. In this light, when journalists are accused of being biased, they are accused of being selective with the facts in a story so that the details are not fully presented and individuals or events are misrepresented or distorted. Selectivity is a central facet of news production, however. news broadcasts cannot possibly present all the news stories which surface each day because or all the details surrounding particular stories they simply have not got the time and space available to do so. Thus, certain stories are selected for presentation and those which are chosen are written so as to reflect the key facts, while omitting other details. Facts are chosen or omitted according to professional judgements about their degree of centrality, relevance and likely interest to audiences. The audience thus receives only a partial reconstruction and interpretation of events.

Relevance is closely related to the criterion of 'newsworthiness' which determines which stories will be reported and which will be ignored. This criterion usually ranks stories according to uniqueness, conflict, drama or human interest. Only highly ranked stories are broadcast. But even newsworthiness may contain implicit social and political biases (Epstein, 1975).

News may appear to be biased because stories have implications for deeply ingrained values or beliefs. Betrayal of public trust, for example, might be presented in a balanced impartial way, but stories relating to public corruption would probably evoke the audience's hostility. Areas of controversy on which little social consensus exists probably shade into areas of outright controversy on which considerable public agreement exists. For example, it would appear that to be biased against one's own country during a time of war would be inappropriate (Russo, 1971-72). Indeed, there is evidence that for news broadcasts to be completely impartial during a time of war, might be construed as exhibiting a lack of support for one's own country and hence of being 'biased'. The conception of bias can therefore shift with the particular frame of reference. Where a values-oriented frame of reference for the determination of news bias is adopted controversy arises when there is a lack of agreement over whose values are to be promoted. According to Hofstetter (1978):

> In instances of consensus, little difficulty arises. But consider social protests and demonstrations that represent specific interests. Partiality on questions involving less than consensual or near consensual responses may be at the heart of the dispute between the so-called 'advocacy' and 'objective' journalists. In cases of conflict, does one report the viewpoints of the hardhats, the protestors, intellectuals, or of whom?' (p.519).

Another view would argue for a more exalted position for the media than what they ought to occupy in a democratic society. The media should strive to present relevant, balanced and impartial accounts of events no matter what value-laden normative frames of reference attempt to impose themselves upon journalists' practices.

We have seen that 'bias' in television news may emanate from the activity of selecting news for presentation, a process which is shaped by professional criteria of 'newsworthiness' of the stories or factual details of stories themselves. Selectivity, however, may also result from specific characteristics of the news medium as well as of values of journalists and their editors. Media researchers have identified a number of distinct kinds of bias in television news. One type is political bias. This kind of bias in television news exists when it would appear that news editors and reporters attempt to advance a particular political cause with the aim of cultivating or increasing viewers, support for that particular ideology (Hofstetter, 1976). Another kind of bias which has been referred to as 'structural' bias, refers to a selective way of presenting the news which is influenced by the 'essential nature of television and the organization of television news, the desire of the people in the business to do their jobs

17

according to the medium's established professional standards..' (Ranney, 1983, p.36).

Structural bias represents the tendency of television newsmakers to determine which stories are the most important according to their often intuitively-based professional criteria of newsworthiness and to make them entertaining as well as interesting for viewers by playing up certain ingredients of stories and visualising events on film as far as possible. Television has the highest credibility of all news media. Credibility may be due to simultaneous observation of action and verbal description of events. Audiences do not have much knowledge about the production processes which lie behind the news or of the subtle effects variations in editing, especially film editing, can have upon the way a scene appears. Audiences react differently to pictures photographed from different angles, to variations in camera shots, and to text when accompanied with certain pictures as compared to when it is presented on its own. Thus, significantly different audience reactions to news can derive from subtle 'biases' in news presentation which result from structural characteristics of newsmaking.

Further biasing effects can derive from organisational incentives which favour certain kinds of news content and style, and are hence termed 'organisational bias'. Epstein (1973) argued that 'organisational imperatives' shape the pictures of society that exist for the television networks. Timing, length, content and style are all based on budget, audience flow and legal considerations. Commercial television companies must make a profit on news programming. Audiences must be maintained after viewing prior programmes through the news period.Revenue for the news, as well as for programmes that immediately follow the news, is based on ratings in the same way that advertising revenue is for other programming. According to some commentators, the focus on the need to maintain audience levels leads to restricted sets of topics and styles of news reporting. Stories which feature violence and conflict, human interest topics and celebrities tend to be over-represented, while many other types of news are under-represented. This orientation is reinforced by rewarding reporters, directors and producers who can deliver stories that consistently fit within the above demands (Epstein, 1973).

In addition to biasing effects which have been linked to news selection and organization, concern has been voiced about the way news stories are told. News was not held to be incomplete or partial because of editorial selectivity, but because it created a 'bias against understanding'. Television news bulletins were accused of presenting narrowly focused accounts of events and issues which inhibited rather than enhanced the public's knowledge and comprehension of them (Jay and Birt, 1975a). News about economic problems was held up as a primary example of the shortcomings of television reports in explaining complex issues. Simply reporting on the latest unemployment statistics provided no insights into the real reasons for poor economic performance.

Jay and Birt argued that television journalism could be differentiated in terms of news, feature and issue journalism. These different types of reporting varied

in terms of the generality of context in which information was communicated. Television news bulletins provided only a superficial grounding for events. Such broadcasts suffered from an inability to convey more detailed and comprehensive accounts of important issues. The bias against understanding was not the only kind of bias of which televised news was accused. Jay and Birt also identified a bias in favour of the powerful.

> Most current broadcast journalism is partial – it favours the views of one group at the expense of those of another. This is because, lacking a clear sense of its obligation to society as a whole, most journalism lives under the shadow of the state and the other main repositories of power in our society: the political parties; business; the trade unions; and so on. It might almost be called 'corporate journalism'. (Jay and Birt, 1975b)

Evaluative Aspects of News

Impartiality represents the evaluative component of Westerhahl's (1983) model of objectivity. Quite apart from whether or not news can be judged as factual, accurate, complete and as dealing with the pertinent issues of the day, there are subtle features which characterize the telling of a story, in the language that is used, the way information is structured, the use of images and other visual production treatments, the degree of attention certain issues or parties receive as compared to others, and the style of presentation which can lead an audience in one direction rather than another not just in relation to what they learn but also to the impressions they form about personalities, events and issues in the news. The key point where impartiality is concerned is that the news should not tend systematically to favour one side of an argument or dispute over another. Where this does happen, then the news can be legitimately described as 'biased'.

Bias can occur in different forms. Different kinds of bias require different methods of investigation and assessment. Unwitting bias and partisanship are more easily dealt with by way of face-value classification and statistical methods, while 'hidden bias' (ideology and propaganda) may call for more depth or qualitative analysis and more interpretation and argument. Methods of assessing impartiality and bias are discussed in more detail in Chapter 2.

Westerhahl (1983) chose to distinguish between the concepts of 'balance' and 'neutrality' in defining and analyzing the occurrence of impartiality. Balance is concerned mainly with an evaluation of news selection, while neutrality focuses on the form and manner of news presentation. Ultimately, while the cognitive indicators are concerned with bias in relation to the kind of understanding engendered by news coverage, the evaluative indicators are concerned more with the impressions audiences form about news stories, whatever 'facts' have been presented (Rosengren, 1980).

With balance, an assessment of how well a news account has been formulated will tend to focus upon the extent to which different points of view or the different parties involved have been represented. Balance does not require

exactly equal treatment to all sides, however. The allocation of attention to different parties may be qualified by their status or the degree or centrality of their involvement in an event or issue. In that respect, it reflects the regulatory notion of 'due impartiality'.

The idea of neutrality can be distinguished from balance principally through reference to various qualitative features of presentation, in particular where the use of certain words, images and styles of interview are concerned, which may carry emotive meanings rather than purely rational ones. A news account could be perfectly factual and yet still adopt a tendentious position by using particular terms or phrases in connection with one party in a dispute, or certain images and production treatments (e.g., camera angles, music) that are known to have the capability of influencing audience opinion. Interviewers may adopt different styles of interviewing with potentially powerful effects upon the impressions viewers may form about interviewees.

Ultimately, the news is about imparting knowledge to audiences. Knowledge itself can comprise a number of ingredients which include not just statements of fact which are judged to be either true or false, but also opinions, feelings and impressions which represent a more evaluative dimension qualifying the nature of the factual information that has been learned. In assessing the quality of news, all these attributes of knowledge need to be considered, together with the different ways in which broadcasters can influence the way that knowledge is presented.

Perspectives on Determining Impartiality

The absence of bias in television's factual coverage was introduced in the first chapter as an aspect of the objectivity goal of good journalism. The requirement for impartiality on television is not just a professional objective of news editors, however, it is embodied in broadcasting legislation. Codes of practice written to guide programme makers about impartiality requirements and how to achieve them provide general rules of thumb which highlight the types of programming where these requirements are especially likely to apply and provide some indicators about how they can be met. The guidelines must themselves maintain a balance between the need to protect the interests of audiences and at the same time providing a workable frame of reference which does not place excessive constraints on programme makers to produce watchable and informative accounts of events and issues.

For some observers, impartiality in news broadcasting is an impossible goal. Partiality and selectivity characterize news gathering and dissemination generally, regardless of the medium of communication (Potter, 1975). Proponents of this view have argued that rather than 'impartiality', it may be possible to attain a degree of 'balance', which effectively has to do more with the internal organization of a news programme, whereby a variety of 'partial' reports might balance each other out. Diversity of news provision and diversity of control of that provision represent key antecedents of this objective. Some media researchers have taken issue with this notion of news quality being grounded in the presentation of a range of counter-balancing viewpoints, which they further argue is seldom readily apparent in television news broadcasts anyway (Glasgow University Media Group, 1980). News 'objectivity' would be lost amidst a plurality of 'subjective' perspectives on various newsworthy events and issues. The outcome of this for television news broadcasting could be a loss of public credibility.

Smith (1976) also rejected the idea of news as a 'plurality of viewpoints'. In his analysis, news was aimed at a mass audience assumed capable of adopting a common frame of reference on news events and a common set of

expectations about the news. No single news broadcast could be expected to give the whole story, nor would multiple broadcasts necessarily provide a more accurate account of an event. By their very nature television news bulletins present little more than headline accounts, which the public nevertheless expected to be accurate and neutral. To serve the public better, television should strive to provide more extended accounts of those same stories in programmes dedicated to that purpose.

Assuming that television news programmes should strive to be unbiased in and consistent systematic fashion, the degree to which they achieve this goal begs the question of how such an objective should be operationally defined. As we have seen already, impartiality may be represented as an aspect of 'objectivity' which, itself has been conceived to embrace the need for factuality in factual programme making. This means that the news, for instance, should be truthful and relevant in addition to being balanced and neutral in its content and form of presentation (Westerhahl, 1983). Equally, bias in the media has been discussed within the context of credibility, where it may be defined in terms of prevailing value systems and the pervading climate of public opinion or political expectations of media in the way they cover particular issues (Rosengren, 1977).

Defining these terms requires some general consensus about what they mean conceptually, but in a more practical context, there must be a methodology that can usefully be applied to measure the extent to which, as objectives of factual programme-making, they are being achieved. Four main sources of measurement criteria will be examined in this chapter. These derive from: (1) output criteria relating to programme content and presentation formats; (2) external, real world criteria; (3) professional, journalistic criteria; and (4) audience criteria which refer to viewers' subjective reactions and the objectively assessed impact of television on viewers' awareness, comprehension and knowledge. It is important to recognise that these different perspectives can yield different kinds of results and that there may be limitations to how much each method, individually, can achieve in determining whether television news and current affairs coverage has been biased.

The basic content analysis approach, for instance, enables precise measurement of the amount of time allocated to different sides of an argument, different perspectives on an issue or to representatives of different political or industrial groups or parties. It can also permit the classification of arguments and other aspects of coverage of qualifying topics in terms of *a priori* features or attributes.

Assessment of television content on its own, however, cannot reveal whether the audience's understanding or perceptions of issues have been biased or distorted. Only implicit assumptions can be made about such effects, based on an objective analysis of television coverage in which comparisons are made between the television treatment of a particular subject and a general view about what the major factors or sides of an argument happen to be. For example, if a spokesman for one political party only is interviewed in relation to an

important political issue, questions may legitimately be raised about why representatives from other political parties were not also invited to give their opinion.

In assessing impartiality from the audience's standpoint, there are two broad aspects to the problem. First, questions can be asked about how members of the audience perceive the nature of television coverage. Is a programme's treatment of an issue perceived to be accurate and fair or not? Second, there is the important issue of whether audience members develop a distorted impression of events, or a biased understanding of issues as a result of the information supplied to them by television.

Members of a television audience may evaluate a programme as biased, but this does not necessarily mean that it is biased. Every attempt may have been made by the programme maker to ensure that the treatment offered to the subject being covered was balanced and neutral. Audience members enter the viewing situation with certain cognitive and emotive 'baggage', however, which represents their existing beliefs, impressions and feelings about topics, which colour their opinions about a programme. One way in which this can happen is that existing beliefs prime viewers to focus on the elements in the programme which take up a position contrary to their own, and they may mistakenly form the impression that such elements received more than their due share of coverage. Audiences members with a different point of view about the topic, may develop a different impression about the programme because they will interpret its coverage from an alternative perspective.

Table 2.1 below provides an overview of the different modes of analysis which can be applied to media news content in the assessment of news quality. Each of these modes of analysis, in some sense, touches on the issue of bias in news. The model adopted here follows the conceptual framework outlined in Chapter One which distinguishes between cognitive aspects of news provision (embodying such concepts as truthfulness and relevance) and non-cognitive or evaluative aspects of news (comprising such elements as neutrality and balance). This classification of news content features is cross-referenced with the four principal sources of performance criteria, namely output criteria, external criteria, journalistic criteria, and audience criteria.

Thus, the issue of impartiality on television can be approached and analyzed from a number of different perspectives. This book will not argue that any one of these approaches is necessarily more legitimate or valid than any other. Each of these perspectives and the research methodologies which accompany it have their strong points and their weaknesses as analytical instruments. Ideally, the best recommendation might be that since they each tackle different, but nevertheless important, aspects of impartiality, they should all be referred to and utilised to some extent, if possible. Each perspective will now be examined in more detail.

Table 2.1 Modes of Analysis of News Bias

	Presentation		Selection	
	Truth	**Neutrality**	**Relevance**	**Balance**
Output Criteria	Information depth	Presentation format (Camera angles; use of film/visuals; Interview styles		Content analysis
	Readability Checkability Range/diversity of topics covered			Source bias Semantic/ discourse bias Frames of meaning (Discourse & format analysis)
External Criteria	Eyewitness comparisons Event records Source perceptions		Institutional agendas Divergent audience realities (Influentials' opinions) Normative approaches Use of experts Needs of democracy	
Professional Criteria			Selection criteria News values	
Audience Criteria	Audience perceptions of news media, news programmes and news content			
	Memory/ comprehension			Understanding of issues

Output criteria

Signs of bias can be identified through various forms of analysis of television output. This general category of analysis can centre on a programme's

narrative content or styles of presentation. When analyzing content, though, there are different depths to which the assessment might proceed.

One form of content analysis, often used to investigate the nature of media coverage given to matters of political controversy is to assign evaluative codes to news reports. Media news accounts can be classified as offering a positive, negative or neutral perspective on an issue. Thus, they can be viewed as being for or against a particular position. A method of analysis is applied which judges whether reported actions, events or facts of a matter are likely to reflect favourably or unfavourably on one side, position or party to a particular dispute or controversy. It is a method which requires speculation of a common sense kind on the likely impression made on an average audience. Westerhahl (1983) applied this approach in assessing the neutrality of Swedish broadcasting in covering the Vietnam War (and other issues). His examples of news favourable to Vietnam included: support given by the civilian population; release of prisoners; willingness to negotiate; successful military action. Items unfavourable to the Vietnamese cause included: low morale; murder of civilians; and no desire for peace. The numerical sum of negative and positive items, assessed in this way, constituted a scale along which different media channels and different objects of reporting could be compared in terms of the implicit direction of reporting. Clearly, the mathematical 'mid-point' along such a scale will be an arbitrary outcome (depending on the specific value implications) and not an absolute standard. The method can, however, serve to provide comparative and relative assessment of bias in news reports.

This approach to news content assessment has been widely used. Examples include comparison of the CBS and NBC television news coverage of the United States' Vietnam War policy (Russo, 1971); assessment of the treatment of ethnic minorities (Hartman and Husband, 1974; van Dijk, 1991); assessment of the balance of news treatment of workers and management in disputes (McQuail, 1977); comparison of news images of Israel and the Arab countries (e.g., Rikardsson, 1978); assessment of the German media treatment of the 1973 oil crisis (Kepplinger and Roth, 1979); and assessment of media coverage of nuclear energy (Westerhahl and Andersson, 1991). In an adapted form, it has been used for comparing United States' media treatment of elections in El Salvador and Nicaragua (Herman, 1985), where 'supportive' and 'non-supportive' aspects of news were cited. Shoemaker (1984) also used the approach to compare differential media treatment of 'established' and 'marginal' minority groups.

Reasonable degrees of reliability seem to be attainable in assigning positive or negative values to news, although these judgements must presuppose some broad consensus about what is 'good' or 'bad'. It is clear from the research, however, that many elements of news reports cannot be classified as either positive or negative, so that an assessment of overall balance or tendency may often depend on a rather small proportion of the total volume of relevant news information. The results ought also to reflect a considerable element of 'reality' input (thus not just media 'bias') if the news really is independent and

objective. Thus, unsuccessful participants in events (e.g., Carter in Iran, the United States in Vietnam), or those with negative roles (e.g., unions in strikes), or various kinds of victim, are likely, in the nature of the case, to come out badly (in a negative light) according to such measures, without there being any intended, or even avoidable, *bias* on the part of the news media.

We are dealing with a predictor of *effect on audiences*, rather than with a measure of intention by the sender. Where different media channels do deviate sharply from each other in reporting the same event, however, we have some control of the 'reality' component and there is *prima facie* evidence of conscious editorial choice on the part of news media to favour a particular side as well as of prediction of effect. What is presumably happening is *differential selection* of (and possibly different prominence for) positive and negative aspects, sometimes out of policy, sometimes by chance or as a result of organizational factors.

A variety of measures have been devised to provide indicators of more subtle kinds of 'bias' in the news. These measures have been applied to various aspects of the content and format of news and require techniques of analysis which are sensitive to subtle features of news narratives and visual production which can have significant effects on the impressions or meanings audiences take away with them. In relation to the content of news, media researchers have assessed degrees of bias in terms of the sources (structural and geographical) referred to in reports; the use of language to describe particular actors, events or issues; and broader organizational features of news broadcasts. On format, attention has been paid to visual production treatments such as the way film is used, the order in which items are presented, and the use of different camera perspectives.

Source bias

A frequent element in impartiality analysis is a count and classification of sources referred to or cited, according to side or perspective on an issue. In general, the balance norm calls for an equal or proportionate reference to sources of similar standing, on similar terms. These conditions are rarely achieved, because of varying power and status of groups (sides) in disputes. Most studies show more attention to official, more authoritative, sources or more attention to the 'voices' with the best organization and resources. Powerful groups tend to be more satisfied with the media coverage they receive than less well-resourced groups (Donohue *et al*, 1985).

In British industrial relations reporting, research has shown there to be a tendency for union spokespersons to have higher 'visibility' than management in disputes (McQuail, 1977), but also to be often associated with strikes portrayed as harming the public. The possible contribution of management to the causing of strikes was implicitly underplayed, as a result of their low profile in news reports (Fiske, 1987). In television's coverage of Parliament in Britain, balance was assessed in terms of the number of times members of different political parties were featured as news sources (Tutt, 1992).

In some cases, the very absence of certain sources may indicate a one-sided definition of an issue or will predictably lead to one-sided reporting (Wulfmeyer, 1983). A study of the media reporting of the United States withdrawal from UNESCO in 1984 focused on the differential use of sources by American media (Giffard, 1989). Most news came from the main American news agencies, whose reports were overwhelmingly hostile to UNESCO in thematic content, the news agencies themselves obtained the bulk of their attributed statements from the US government (also hostile to UNESCO). In consequence, there was a prevalent UNESCO imbalance permeating media news reporting which failed to represent the full range of positions on the US withdrawal issue (Preston *et al*, 1989).

The effects of over-reliance by the American media on State Department information about Central America (Herman and Chomsky, 1988) and about other incidents closely related to national foreign policy concerns have also been detailed (e.g., the manipulation of the media after the shooting down of the Korean airliner in 1983; Herman, 1986). The nature of what are conventionally acceptable as sources for news limits the range of diversity (Brown *et al*, 1987), and sometimes it is virtually impossible to balance sources acceptably.

Semantic and discourse bias

This level of analysis focuses on the way language is used to convey subtle meanings or interpretations of events or issues. The choice of words and phrases can often convey evaluations of issues which could potentially influence the impressions audiences form about the subject matter being reported (Graber, 1976; Edelman, 1977; Porter, 1983; Geis, 1987; van Dijk, 1991). Specific terms or turns of phrase could make a difference to the type of message conveyed, particularly where certain descriptions have special cultural meanings or suggest subtle positive or negative evaluations of objects or events.

A number of methods of analysis can be applied to investigate this form of news bias. Some researchers have identified the extent of occurrence of pre-specified types of words, known to convey different connotative meanings (Glasgow University Media Group, 1985). Another related approach is to catalogue terms in a news text which have been pre-classified in terms of their evaluative direction or pre-weighted in terms of their emotive intensity (Holsti, 1969; van Cuilenburg *et al.*, 1986). Texts can thus be scored for frequencies of occurrence of descriptors which lean towards one evaluative direction or another yielding an overall measure of the evaluative valence of a news report vis-a-vis a particular topic (Westley and Higsbie, 1963).

Organizational frameworks

This approach considers the broader organizational aspects of news production. This may entail an in-depth study of the general nature of news discourses and the organizational conventions and practices of newsrooms which lie behind them. There is a general concept that the news is manufactured and structured by newsrooms according to certain principles of professional

broadcast journalism. This may give rise to a news 'product' which embraces and is shaped according to a 'professional' view of how the world should be presented to audiences (Altheide, 1979; Schlesinger, 1978). In some instances, it has been argued that broadcast newsrooms apply 'frames of meaning' to events to present a (politically) 'preferred' interpretation which reinforces a dominant 'establishment' perspective on events (Halloran, Elliot and Murdock, 1970; Iyengar, 1991).

Presentation features

Aside from the view that visual devices designed primarily to catch attention are incompatible with strictly neutral reporting, it has also been agreed that visual elements in television news are often irrelevant to, or diversionary from, the essence of a news story as told in words (e.g., Katz *et al*, 1977). If so, visual elements can distract attention from, or interfere with 'learning' from the verbal text of news, which may itself remain neutral in form. The increasing use of a 'happy news' format in television in which presenters chat with each other, has also been suspected of reducing the information value of news (Dominick *et al*, 1975).

Even so, news has to attract and interest an audience in order to communicate at all, and most of the presentation features which have been mentioned seem likely to contribute to this and, especially under conditions of competition for audience attention. The ideal of total presentation neutrality is only likely to be reached under monopoly channel conditions or in cases where highly motivated (and relatively small) audiences are being addressed.

Studies of the presentational 'bias' of television news has emphasized stereotyping in the way the news is sequenced and embellished with captions, headlines and summaries (Glasgow Media Group, 1976). These factors can significantly affect the way news is remembered by the audience (Gunter, 1987; Robinson and Levy, 1985). Television news style is only beginning to be analyzed in detail. Nimmo and Combs (1985) distinguished four journalistic styles in television news; the 'popular/sensational'; the 'elitist/factual'; the 'ignorant/didactic' (treating the audience as very diverse) and the 'pluralist' (treating the audience as very diverse). Only the second of these really conforms to the objective mode.

Attention has also focused on camera angles, timing, distance, and shot framing as devices for conveying meaning (Tiemens, 1970; Frank, 1973; Mandell and Shaw, 1973; Zettl, 1973; Tuchman, 1978; Kepplinger, 1983). Tiemens *et al* (1988) concluded from a detailed analysis of visuals in reporting by five television sources of Jackson's 1984 Democratic convention speech that each version was a different experience for the viewer and also different from the actual speech as it occurred. By implication, there was no objective mediated version, but also no way of reliably assessing any bias in intention.

External source criteria

The search for the truth of a matter requires a comparison to be made between the contents of a news report and a set of independent, external

criteria relating to that same matter. There are numerous potential avenues open to journalists through which facts can be checked and their truthfulness and accuracy verified. It is theoretically possible to apply external and independent standards of 'truth' or reality to what is found in news reports, for instance, by way of official or judicial reports of events such as riots and civil disturbances, but this is unusual.

Another possibility is to measure supposed media bias on a controversial matter against an external standard of truth furnished by 'experts' or official statistics. Lichter and Rothman (1986), for example, looked at the issue of nuclear power and claimed to have revealed a pronounced 'anti-nuclear' bias by the *New York Times* and US network television news, compared to opinion held by the relevant scientific community. Even in this case, however, 83 per cent of 486 newspaper stories were classified as 'neutral or balanced'.

The truthfulness of reporters' accounts can be checked directly with people appearing in the news (Berry, 1967; Charnley, 1936; Scanlon, 1969). This methodology has generally shown that most errors are trivial. Often any dispute sources may have with the way they were covered arises out of differences of interpretation or opinion rather than genuine errors of fact or intentional distortion of representation. Journalists tend to dispute any errors claimed by sources (Tillinghast, 1983).

Alternatively, planted observers can be used who provide on-site accounts of what happened at particular events which can then be compared against news coverage of those events (Halloran, Elliott and Murdock, 1970; Lang and Lang, 1953). The study by Kurt and Gladys Engel Lang focused on television reporting of the return of General McArthur from Korea. News accounts of the event were compared with observations made on location in New York along the procession route. The results showed that the news was more like a script written in advance than an actual account of what was going on. The situation was defined in advance by the media, giving reportage which conformed to what some writers later referred to as 'media logic' (Altheide and Snow, 1979).

All the same, there are cases where no ready-made external-to-media data are at hand. Then another solution must be utilised. The researcher must establish a list of relevant events and conditions, and make this list the starting point of any investigation. Reference sources and chronicles of events can be referred to in this context. Of course, it is important to bear in mind that such records themselves may have been fed by media sources. When no such reliable external source materials can be located, another distinction can be made between 'event-oriented' approaches and 'report-oriented' approaches.

References made to event records can yield an independent point of comparison against which to judge the accuracy and completeness of journalists' accounts of specific events. These external reference sources might comprise transcriptions of court proceedings, a record of the proceedings of Parliament, a press conference with press release(s), or some other kind of written record

(minutes of meetings). Analysis can be made of how selective reporting has been as well as how factually accurate are journalists' accounts.

In an event-oriented approach, events are studied with respect to the amount and type of stories that get in the news media, from the ones known to be available. In a report oriented approach, reports are studied with respect to what types of events they cover, once again, in the context of the known universe of events within a certain category. With these approaches, however, it may be difficult to differentiate between bias inherent in reality and bias inherent in the reporting of reality.

Comparisons can be made between different media or media channels or publications and broadcasts in the way they handle or select from the same range of news items or the way they report and present particular stories. In this case, of course, one is making comparisons between different media versions of 'reality', none of which, on its own, may represent actual reality. McQuail (1977) compared different newspaper accounts of the same stories on the same days in terms of the equivalent sets of facts and figures offered. Differences did emerge, but these seemed to have more to do with stylistic differences in ways of presenting facts rather than providing any indication about newspapers' performance in terms of accuracy of reporting. There may be a host of legitimate reasons why some or all media should, for example, under- or over-represent the statements of some parties in connection with particular issues or events. The important aim of research should be to establish why such under- or over-representation actually occurs, and then to discuss the facts against the background of common custom and consensual values. In this context, Rosengren (1977) noted that:

'Knowing that partiality in news reporting often may be inevitable, it is all the more important from time to time... to show in concrete terms precisely how great the partiality may have been, against whom. It is also important to discuss how partial one should be allowed to be, against whom. And above all, it is important not to let the knowledge that partiality may be inevitable serve as a pretence for all sorts of conscious bias. On the contrary: the effort should be to curb as far as possible the seemingly inevitable partiality' (p.39).

Professional or journalistic criteria

What do journalists and editors think about 'relevance' in news selection. Research conducted under the label of 'gatekeeping' has sought to describe and explain the systematic features of decision-making (Carter, 1958; Shoemaker, 1991). This work has revealed little about the meaning of relevance for journalists. The choice of news items to present tends to be driven by a variety of factors including subjective ideas about audience interests and needs, ideas about what makes a story topical, and the pressure of time. The financial cost of gathering and presenting news has also become increasingly significant as a factor influencing journalists' decision making.

The selection of news has been charted through observational studies of journalists in their work place. This approach has, on occasions, indicated sets of

news values which appear to determine whether a story is deemed worthy of coverage. Factors such as involvement of famous people, sex and scandal, number of people involved, geographical proximity, and the degree of drama or surprise have emerged as significant (Hetherington, 1985).

According to Gans (1979) 'story importance', as distinct from its potential interest, was judged by journalists according to four main dimensions: rank in government (or other hierarchies); impact on the nation and national interest; impact on large numbers of people; significance for past and future (e.g., scoops and record-breaking events). There is also a belief that stories already in the news have a higher chance of remaining in the news (Galtung and Ruge, 1965). Journalists have also been accused of paying too much attention to 'bad news' (Gieber, 1955; Haskins, 1981; Haskins and Miller, 1984; Stone and Grusin, 1984).

Support for drawing on professional journalists' judgements of significance in assessing performance can be derived from surveys of journalists and editor opinion which compare what editors think important with three other indications: what they think audiences actually want; what is actually offered as news priorities; what audiences say they want (Bogart, 1979; Ogan and Lafky, 1983). The evidence suggests that journalists do have a view of significance which differs from the priorities 'inscribed' in output or from the immediate interests of audiences. Journalists in television newsrooms may also hold misconceptions about audiences' news-related general knowledge and over-estimate what the average viewer will remember from television news broadcasts. Part of the reason for this stems from the fact that news editors' and journalists' own recall of recent news stories tends to be very good, and they mistakenly expect the same level of performance from ordinary viewers (Robinson and Sahin, 1984).

Audience criteria

Most journalists think that whatever affects and interests the public should have most influence on news selection. For performance assessment, the main requirement is to have a scale of news interests based on the views of the audience which can be applied to what the news media actually offer. With broadcast news, viewers and listeners can be questioned about their subjective news interests or tested for their levels of attention, recall or comprehension of different stories at some variable point in time after transmission (Robinson and Levy, 1986). This approach indicates something about news interests by inference according to whether the news stories presented got through to viewers and listeners and in some way enhanced their knowledge of those topics. The caveat here is that audience memory and comprehension of broadcast news may be poor even when interest in the content is high, especially where presentational features interfere with rather than assist information processing (Gunter, 1987).

There are several other ways of assessing the performance of the news in terms of audience-based criteria. With respect to the concept of 'relevance', for example, members of the public can be asked directly which events they consider

31

important during a previous year, with a view to comparing the audience's perception of news values with that of media decision-makers (Ogan and Lafky, 1983). The latter study appeared to show a higher audience rating for major international and national events than conventional news decisions make allowance for. This conflicts with a more commonly heard view that responsible journalism has to struggle against the more 'trivial' interests of their audiences.

Another approach is to ask members of the public what kinds of news they would most miss, if they were no longer available (Weaver, 1979). The argument made here is that conventional measures of audience needs or interests are too strongly shaped by what is currently on offer and readily available. Consequently, reference to the audience will not necessarily produce an independent assessment of relevance. Most evidence does confirm a mismatch between supply and demand for serious and background news and analysis, reflecting the conflict between professional judgements of relevance (as a sign of significance) and the apparent immediate gratification-seeking of news audiences (Levy, 1978).

If objectivity (or its absence) is ultimately significant because of its probable or actual effect on audiences, there would seem to be scope for audience research on several of the questions discussed. Much attention has been paid to the general question of credibility, a quality which is related to accuracy as well as to perceived independence and neutrality of the news offered. Certainly, there is no shortage of methods for enquiring into how the audience evaluated media presentation or for assessing perceptions and possible effects of bias in media content.

In the early days of research into persuasion and propaganda, the question of whether it was better to present 'both sides' of an argument rather than one in order to achieve some persuasive purpose was investigated. At issue was the possibility that 'bias' (even when used with good intentions) might always be counter-productive, because it would undermine credibility. The news situation, however, differs from that of planned persuasion and the findings are not likely to be interchangeable. In general, research into the effect of bias has been of a quasi-experimental or intensive nature, yielding results concerning particular content and events (Halloran *et al*, 1970). The findings have usually lent more support to the school of audience resistance, 'differential decoding' and unpredictability of effect than to those who fear the direct effects of biased news.

In respect of 'believability' (credibility) of news, audience research does not typically show much potential for discriminating among particular channels or sources. For instance, Robinson and Kohut (1988) report ratings of 'believability' for a number of United States news 'sources' (persons as well as specific programmes and channels), showing that such ratings vary within a rather narrow range. On a scale of zero (low) to 4 (high), the MacNeil/Lehrer News Hour came second, with a score of 3.22 and USA Today was in eleventh place with 2.94 (only Ronald Reagan and the sensationalist weekly The National Enquirer received lower scores).

The perceived credibility of broadcast news, however, can depend upon the frame of reference within which it is assessed by members of the audience. Global perceptions of television as a whole or of television channels or stations generally indicate a high level of public trust in the medium (Gunter and McLaughlin, 1982; Gunter and Winstone, 1993; Gunter, Sancho-Aldridge and Winstone, 1994). Perceptions of the credibility of television's treatment of specific issues, in contrast, can reveal some degree of public disquiet with the medium, especially in connection with events or disputes about which certain sections of the audience feel very strongly. This phenomenon has been observed in relation to perceptions of television's treatment of opposing political parties in elections (Gunter, Svennevig and Wober, 1986; Wober, 1992) and of opposing sides in an industrial dispute (Cumberbatch, McGregor, Brown and Morrison, 1985).

In addition to whether or not the news media present credible accounts, there is the question of their neutrality. For instance, are they 'fair' to opposing parties in a dispute or points of view on an issue? This is a more evaluative type of judgement, which questions not the accuracy or believability of news accounts, but whether they have been selective with the facts or opinions which have been presented. Research into public attitudes to newspapers has indicated little variation in attribution of 'fairness' to the main national newspapers despite large differences in measured 'sensationalism' and in type of readership (British Royal Commission on the Press, 1977). But the attribution of 'fairness' was not overwhelming. The same seems true of the United States media, to judge from the Times/Mirror survey (Gallup Organization, 1986). According to this, only 34 per cent agreed that news organizations are 'fair to all sides in presenting political and social issues'. On the other hand, Comstock (1988) discounts the view that there is deep or growing public lack of confidence in the media. The public is simply inclined to see bias where it disagrees.

This book will examine the notion of 'bias' in the specific context of television broadcasting from a number of different perspectives. Already it is apparent that as a concept, it can be considered within the broader context of 'objectivity' in media news provision and professional journalistic practices. As a phenomenon or attribute of news, however, it can be operationally defined in many different ways, utilising objective and subjective indicators. Bias is not simply a subjective phenomenon which resides in the extent to which audiences disagree with media news accounts of events or issues, although it can quite legitimately be defined in this manner. Certainly, the media, as providers of news services, need to be mindful of audiences' interests and concerns because these audience attributes will influence the way the news product is judged by its target market. To analyse bias in the news, however, it is also necessary to consider criteria other than the subjective judgements of audiences. Producer intentions, professional journalistic practices and the activities of external sources of information can all play a part in shaping the news which reaches the television screen and, in each case, may affect the accuracy,

balance and neutrality of the accounts of events and issues that are presented. 'Biasing effects' can therefore occur at the stages of news selection and news presentation, as well as in respect of how the news is received. Ultimately, of course, the most significant concern must rest with what is received, and the extent to which public understanding and opinion is distorted not because of selective attention fuelled by prejudice on the part of individual audience members, but because the full array of relevant facts and opinions were not equitably presented.

PART TWO
THE OUTPUT OF BIAS

Cognitive Aspects of Bias: Output Perspectives

Within the objectivity framework outlined in Chapter One, the quality of information provision in news and other factual programming on television was partly defined in terms of its truthfulness, which meant its factualness, accuracy and completeness, and in terms of its relevance. The latter concept was concerned with the significance of news for those at whom it was directed. In many instances, a degree of ambiguity about who the real target audience might be could result in news information of questionable relevance to the general public. While distinguished from 'impartiality' within that conceptual model, it is argued in this book that news which falls down in terms of its factual accuracy and completeness and which is selected on the basis of its perceived relevance to élite groups rather than the general public, can be considered biased in certain of its crucial aspects.

In order to achieve duly impartial coverage, for example, broadcasting legislation clearly stipulates the need to distinguish 'fact' from 'opinion'. Although opinion and comment are permitted, they must be clearly labelled for what they are, and broadcasters must take steps to ensure that one opinion is effectively counter-balanced by any alternative and relevant points of view. Even when facts are clearly established as such, however, bias can creep in where facts are selectively presented. In this case, the 'bias' is one factor that may affect audience understanding. A lack of completeness or fullness of coverage of issues by television news broadcasting, for example, has been challenged in the past as representing a 'bias against understanding' (Jay and Birt, 1977a). This chapter will therefore examine these 'cognitive' aspects of news broadcasting and distinguish between a number of key concepts and methods for assessing them. Research will be reviewed in each case to illustrate how effectively television has been found to perform. Some of the evidence reviewed derives from studies of other news media and where necessary the implications for television will be discussed.

The Information Quality of News

The information quality of the news can be assessed in terms of a number of criteria of performance. According to Westerhahl (1983) news must be factual, accurate and complete. As we saw in Chapter Two, there are several methods available for checking these attributes of news. They generally require some form of news output assessment which focuses upon the narrative content of news reports. In addition, however, it may be necessary to refer to external sources for validation of content details. Audience measures of perceived credibility and of comprehension can provide further indications of news quality.

Factualness

News production is devoted to the pursuit of objectivity in the sense of being factual. According to some researchers, the language of the news takes a form which lends itself to a fairly straightforward test of its truth or falsehood (Glasgow University Media Group, 1980). One balance which has to be struck is between the dry reportage of straight factual information and the provision of an interesting and interpretive narrative which will attract and maintain the audience's attention. News tells 'stories' about events, thus embracing a notion of 'performance' (Morin, 1976). The interpretive performance aspect of news may cause news accounts to stray from the essential facts of an event or issue, while facts on their own may convey little meaning when divorced from context or interpretation. The 'factuality' of news which distinguishes it from mere entertainment or propaganda may depend to a significant extent on the credibility which audiences attach to it as a genre (Smith, 1973). Its neutrality derives from the regard in which it is held by the public as much as from any balancing act it may achieve between a plurality of viewpoints or perspectives (McQuail, 1993).

The importance of *factualness* assessment stems from the need to ensure that the principle of separation of fact from commentary or opinion has been observed, to check on the reliability of reporting as a key professional, journalistic objective, and to determine just how informative a news account has been in terms of reducing any uncertainties the public may have had about the event or issue being reported.

The earlier discussion of perspectives on bias assessment indicated that media researchers have developed techniques for measuring the breadth and depth of information contained in a news report (e.g., Asp, 1981) and the readability or likely ease of comprehension of a news report in terms of the way it was written (Taylor, 1953), Stemple, 1981). Although these forms of news text analysis can indicate intrinsic features of news reports which may influence the extent to which factual information can be readily understood by members of the audience, they are limited to the text itself and cannot indicate whether those details reflect accurately and comprehensively the reality of what actually happened. To make this kind of assessment, it is necessary to combine an analysis of news output with a reference to external criteria of assessment

which can be utilised to establish the validity of the information contained in news accounts.

Accuracy

The *accuracy* of a news report can be verified against some independent record of 'reality'. This mode of assessment also applies in the case of judging the completeness of news coverage. To do this, the original source needs to be located and compared with the details that finished up in the news report. A variety of types of error can affect the accuracy of a news account (Blankenberg, 1970). Often these original source materials are not available, in which case comparisons can be made between different media for the accounts they have offered. A prestigious newspaper, renowned for the accuracy of its reporting, might provide an alternative benchmark. To work effectively, however, it is important to have complete confidence in the publication which occupies the benchmark position.

Another method of assessing the accuracy (and completeness) of news accounts is to refer to 'experts' for their views. The facts as reported can be checked with an expert known to have considerable knowledge of a subject. Where news has derived from particular individuals or organizations, it is possible to check back with the sources themselves for their perceptions of news reports. This approach has been adopted to study the accuracy of reporting in a newspaper context (e.g., Berry, 1967; Scanlon, 1969; Meyer, 1988; Bell, 1991). In principle, it is also relevant to any consideration of the accuracy of reporting in a broadcast sense. The problem with this approach is that reporters and their sources may not always agree on the accuracy of news reports and their judgement, in each case, may be affected by prejudicial and partisan interests (Tillinghast, 1983).

Independent eyewitnesses may provide a further source of verification of the veracity of the news. Once again, this technique requires the occasion of fortuitous circumstances from out of which such evidence can be acquired. A classic study by Lang and Lang (1953) investigated the television reporting of the supposedly triumphal return of General McArthur to New York, after his dismissal from supreme command in Korea. News commentaries on the event were compared with observations made by informants located at the points of television coverage along the procession route. The results showed that the news followed more the lines of a script written in advance than the reality of what was going on. The news report conformed to what was subsequently termed 'media logic' (Altheide and Snow, 1979).

The same strategy of comparing eyewitness accounts with media accounts of an event was applied in a British study of the way the media reported an anti-Vietnam War demonstration in Grosvenor Square, London. This analysis showed that media coverage, prior to the rally, built up an anticipation of violence, which was attributed to Marxist extremists. This interpretive frame derived from earlier media treatments of student-led civil disturbances in Paris and Kent State University in the United States. While the leaders of the

London demonstration had repeatedly professed their peaceful intentions, the news media chose to place a different gloss on events. While the actual rally passed off with few incidents of confrontation between students and police, the news reporting gave an impression of greater civil disturbance than had in fact occurred on the evidence of eyewitnesses present at the demonstration itself (Halloran, Elliott and Murdock, 1970).

A further feature of accuracy measurement, which has been referred to as a news report's 'internal accuracy', focuses upon the degree of internal consistency between different elements of a news item. In particular, this approach assesses the consistency between the information presented in the headline and the substance of the story which follows. This form of analysis has generally been carried out with press reporting, but could equally well apply to broadcast news. News headlines are known to possess the capacity of influence the way viewers process information from news stories, by priming them to pay extra attention to those aspects of the news story singled out in the headline itself (Gunter, 1987).

In many major news broadcasts, news headlines are read out at the very beginning of the bulletin and serve as a device for hooking the audience right from the start of the programme. One practice is to read out headlines over brief clips of film, stills or captions before the newscaster appears on screen. News broadcasts that are divided by commercial breaks provide further opportunities for headline summaries prior to each break. This device is used to encourage viewers to stay with the channel through the break. Headlines and leads are significant not just for their role in attracting and maintaining audiences, but also because they can affect the way the audience interprets news stories and remembers details from them.

Psychologists have found that memory for passages of text can be influenced by the presence of a thematic title before the passage is seen. Passages preceded by a title tend to be remembered better in consequence (Dooling and Lachman, 1971; Dooling and Mullet, 1973). This effect only worked, however, when the title was presented before the passage, and not when it was presented afterwards. Further work in this vein found that picture 'summaries' as well as verbal headlines could also enhance the comprehension of passages of text presented in written form or read aloud in the form of a sound recording (Bransford and Johnson, 1972).

One explanation for the effect of headlines is that they can alter the comprehension of a text by affecting the selection of information from it and the way this information is then organised in memory (Kozminsky, 1977). Headlines can function as advance organisers, indicating to the audience what the central theme or most important aspects of the text are about. In processing any piece of new information, we do not treat it as something totally alien but generally make attempts at first to link it with knowledge we may already possess about a subject. Headlines can provide cues as to where this new information might belong in terms of its placement in our existing store of background knowledge. In this way, headlines therefore have the capacity to bias the way the text is understood by directing our

attention towards those text elements emphasised in the headlines. This type of effect can cause a distorted or incomplete recollection and understanding of broadcast news stories (Findahl and Hoijer, 1972, 1975, 1976).

Completeness

As we have seen already, completeness can be assessed using many of the procedures applied when investigating accuracy. Completeness is important as a distinct performance criterion in that while a news report may be factually accurate, its information content may not be complete. If there are important details missing from them, for example, news accounts will provide audiences with an incomplete understanding of events and issues. Completeness operates on more than one level. News broadcasts can be judged in terms of the completeness or thoroughness of specific news accounts and in terms of how comprehensive is the range of news stories covered.

Determining whether a news report is complete can be difficult. Standard forms of content analysis are not very helpful in this context because some external criterion is needed to establish whether key details are missing. This external source of validation is not always available. Moreover, with some issues it would be physically impossible to cover all their various aspects. As we saw in the discussion of accuracy assessment, it may be possible to refer to external sources for some stories, particularly where these take the form of published documents or official statistics, to check whether news accounts were overly selective in the details they chose to report. Comparisons of the news accounts provided by different news media or different newsrooms may also provide some indication that certain reporters have been selective, although without necessarily clarifying to what extent.

The *completeness* of news coverage can be further assessed in terms of the range of different types of news topics or events, or of detail within some topic area. Routine content analysis of media output using a comprehensive taxonomy of news topics can yield a profile of news coverage which indicates whether certain topics, sources or references occur relatively frequently or infrequently (McQuail, 1977; Curran, Douglas and Whannel, 1980).

Gaps in news coverage have been well illustrated by research into television's coverage of international affairs (Gerbner and Marvanyi, 1977; Golding and Elliott, 1979; Womack, 1981; Adams, 1982) and politics (Danielson and Adams, 1961; Graber, 1976a). The external standards for assessing completeness have mainly been found in public documentary records or in official statistics relating to the topic area. Harvey and Stone (1969) used a historical standard – the main known facts of a crisis – in comparing the fullness of news coverage by US national newspaper front pages and network television. They found rather high percentage coverage and little difference between media or channels.

With respect to television, however, questions have been raised about the comprehensiveness of its political coverage, particularly during election times. This assessment has focused on the observation that television tends to give

much more attention to political candidates' personal qualities and professional qualifications for elected office, than to the issues upon which they may be fighting their campaign. In relation to American presidential campaigns, for example, Graber (1976a) reported that the ratio of issues to personal qualities coverage on television news during the 1972 presidential campaign was 37 per cent to 63 per cent. Most of the information given to the public about candidates focused on candidates' personal qualities, while issue coverage was narrow and superficial. The same researcher also noted that the media, bound by codes regarding objective reporting and neutrality in electoral contests, gave little guidance to their audiences in respect of judging the conflicting claims of different candidates. Much issue coverage was devoted to campaign events and projections of election outcomes. Furthermore, choice of issues by newsrooms was heavily influenced by what campaign participants said. Issue-related information was patchy, lacking in depth and diversity. This applied to the press as well as to other news media, but was especially true of the pre-dominantly image-oriented television newsrooms.

Relevance

Information quality in the news depends not only on whether news accounts are factual, accurate and complete, but also on whether they have contemporary significance and interest to audiences. News that is out of date, trivial or irrelevant to people's current concerns may have little value. A key factor in the assessment of the relevance of news is that of selection. Which stories are selected for coverage? Does the choice of topics represent the major issues of current interest?

There are several indicators that can be called upon to assess whether news is relevant. One view is that it might be possible to devise a normative standard of news relevance by which to judge whether news broadcasts are fulfilling their responsibilities to a democratic citizenry. External criteria can be applied to identify what are the key items of the agenda of key institutions and actors in society. Further guidance may be obtained from journalists' own professional criteria of relevance which involves some consideration of news values. Finally, audiences may be consulted directly for their opinions about what matters to them among the events in the world today.

Content analysis can be applied in respect of many of these indicators to assess the degree to which news coverage meets its performance targets. This form of analysis, for example, can indicate the prominence given to particular topics by the news media. Measures of the amount of space or time allocated to topics, events or participants in an event, are indicators of prominence and, by implication, of the perceived significance or relevance of different news items. As well as the amount of time or space allocation, the position of an item is important. News stories which are presented at the head of a sequence are afforded a degree of primacy which underpins their relevance. These factors are also known to influence audience attention to the news and recall of its details (Gunter, 1987).

Normative approaches

Normative expectations about the needs which news information is supposed to meet in society provide one potential source of criteria. These may claim to specify 'objective' needs, but they are essentially subjective, often based on criticism of media shortcomings and on a commitment to some theory of media functions in a democratic society. Nordenstreng (1974) explored the possibility of basing television news selection on a consistent 'informational policy', in which criteria of external objective significance might be deployed, but ended with more modest suggestions for separating decisions about the real significance of news events from decisions about form or presentation. He also recommended providing more background commentary to explain the significance and make sense of the news.

The normative approach tends ultimately to emphasize heavy or serious news concerning politics, economics and world events. These subjects are believed to have significance for people's own lives in that they concern matters which can have an important bearing on the way people live. The world is viewed as a political place and within this context, the normative view is that the news should deal with issues which can affect people.

Accompanying this view is another belief that in a democracy, citizens need to be informed about issues which could influence they way society operates because they may, from time to time, be invited or required to offer their own opinion by voting on issues. The news media therefore play an important role in ensuring that members of such electorates are supplied with the information they need to understand these issues and to make informed choices. Of course, it is generally the case that some sections of the public are better informed than others. Furthermore, the better informed tend to pay closer attention to the news media while the less well-informed pay less attention. The outcome of this is a knowledge gap between these different sectors of the population (Gaziano, 1983).

There is some concern in the case of television that it has greater appeal to the less well-informed and is also less informative anyway as a news medium than are newspapers. Those individuals who are dependent largely on television for their news become disadvantaged (Clarke and Fredin, 1978). This concern has become particularly acute in recent times because television has emerged as a primary medium for political campaigning. Critics view this development as a symptom of the increasing trivialisation of politics, whereby campaigns are fought on the basis of personalities rather than issues or policies. Evidence has emerged to show that covering political campaigns, television does tend to pay more attention to politically superficial matters than to substantive issues (Graber, 1971; Adams, 1983).

The alleged superficiality of television news, as evidenced by its greater focus on the actors in events than on the underlying issues which those events may represent, is regarded as having an impact upon both public understanding of serious matters which are central to the political fabric of a democracy, and the

impressions people may form about political institutions. In this respect, the major news media are more concerned with their own business objectives than about the implications of superficial news coverage for the public's understanding of important social, economic and political affairs (Mazzoleni, 1987).

The concentration of many of the major news media on personalities also reflects an emphasis upon more sensational news topics such as crime, scandal, show business and royalty. Collectively, such news categories are often labelled as 'human interest' (Curran, Douglas and Whannel, 1980). This type of news coverage may over-emphasize or exaggerate the significance of individuals in relation to particular events, whilst failing to give due attention to the more serious or fundamental issues which underpin them (Ostgaard, 1965). For some media scholars, changing economic circumstances for news organizations, faced with growing competition as a result of technological and regulatory developments, have caused a bias towards trivialisation in news reporting (Hallin, 1992; Mancini, 1992).

The alleged superficiality of television news, given its greater focus on the actors in events than on the underlying issues which events may represent, is regarded as having an impact upon both public understanding of serious matters which are a core part of the political fabric of a democracy, and the impressions people may form about political institutions. In this respect, the major news media are more concerned about their own business objectives than about the implications their style of news coverage have for public understanding of important social, economic and political matters (Mazzoleni, 1987).

Real world indicators

The establishment of news 'relevance' through 'real world' indicators requires an analysis of agendas that are set by institutions, the divergent realities conceived by different audiences, and the specific views about the news agenda which may reside among special interest groups.

Some media researchers have examined the relevance of news coverage by comparing media priorities with actual events. Behr and Iyengar (1985), for example, collected information about the current state of play in respect of a number of issues, using official economic statistics and government releases and then measured media coverage of these issues. An analysis carried out over a six-year period found that network television news was partially determined by real world conditions and events and then subsequently influenced the public agenda. According to these researchers, real-world indicators may provide important benchmarks for judging the sensitivity of television newsrooms to issues of current significance. They can also assist in distinguishing between the effects of news and real world conditions on public concern for various issues.

The evidence compiled by this research indicated that television news coverage is at least partially determined by real-world conditions and events. There was a notable overlap in respect of unemployment between variance in news

coverage and real-world indicators of changing economic conditions. Comparing the relative impact of real-world conditions and television news coverage on agenda setting, it was found that television news established the public's thinking in respect to many issues. An exception was unemployment where public concern was directed entirely by economic conditions. The low level of coverage accorded unemployment by television news suggested that information about it was being acquired by the public from other sources.

Thus, real-world conditions can exert direct influences upon public perceptions of certain social and economic issues, just as much as, if not more so, than television news. Real-world conditions may complement the news media as determinants of issue salience. Furthermore, real-world factors may affect individuals' sensitivity to the news media agenda (Erbring, Goldenberg and Miller, 1980). Under conditions of rising unemployment, for example, citizens may become alert to this particular issue and then monitor the news media more vigilantly for news about unemployment. To the extent that an issue has personal significance, news about the problem can boost an individual's concern to even higher levels, if the news coverage can offer no comfort for those who feel economically vulnerable. Thus, personal experience and news media agendas may interact to shape citizens' political, economic or social concerns.

Research evidence has not always corroborated the finding that real-world agendas determine news media agendas, however, and the news media do not apparently invariably follow real-world agendas (Funkhouser, 1973). The Behr and Iyengar study is nevertheless interesting for the methodology it applied in examining the extent to which the real world and news media displayed dissonant agendas.

Real-world agendas are themselves neither constant nor universal. Different real-world agendas derive from different sources. The audience for television news, for example, may comprise a variety of groups with divergent tastes, interests and priorities. Certain élite groups in politics, business, the judiciary and certain other professions may have different expectations of the media and use them for different purposes than the general public. These groups may also be active in setting particular news agendas.

Professional criteria

Professional, journalistic criteria can influence the profile of news coverage through the application of selection procedures and the operation of value systems which determine what should be covered and how it should be treated. The selection of news is determined by journalists who operate under a variety of time and space constraints which require the establishment of sets of routines and procedures designed to maximize the efficiency with which they put the news together. News editors decide on which stories shall be aired and therefore act as 'gatekeepers' who effectively decide what the media news agenda is to be (Carter, 1958; Shoemaker, 1991). News selection processes are governed by criteria of what represents a newsworthy story. The application of participant observation and content analysis techniques by

media researchers has revealed sets of values which play a key role in controlling news selection and presentation decisions.

One of the most significant contributions to this subject was research conducted into factors believed to influence the selection of foreign news stories (Galtung and Ruge, 1965). While focused on newspaper coverage, the principles identified here probably apply equally to television news and to news genres other than foreign news. Three key types of factors were defined: organizational, genre-related, and socio-cultural. Organizational factors were the most universal. News media were thought to prefer big events; events which were clear and unambiguous; events which occurred in a time-scale which fits the normal production schedule; events which were easiest to pick up and report, and events which were of obvious relevance to the national, social and cultural concerns of the audience.

Genre-related factors included: a preference for events which matched advance audience expectations; a bias towards what is unexpected and novel within the limits of what is familiar; a wish to continue with events already established as newsworthy; and an aim to attain balance among different types of news events. Socio-cultural factors tended to reflect north European values and included news editors' apparent preferences for events about élite people, élite nations, and bad news.

In a content analysis study which covered television and newspapers, Hetherington (1985) described a 'seismic scale' of news values comprising: significance; drama; surprise; personalities; sex; scandal; numbers; proximity. The components of 'significance' for most British media he describes as: 'events or decisions which may affect the world's peace, the prosperity or welfare or people in Britain and abroad and the environment in which we live' (p.12). Hetherington argued that significance as interpreted by journalists generally tended towards 'sociocentrism' – the reinforcement of established society, upholding of law and order, gradualist reform. He concluded that journalists, consciously or not, 'base their choice and treatment of news on two criteria (i) what is the political, social, economic and human importance of the event? And (ii) will it interest, excite and entertain our audience?' (p. 12). He claims that the first takes precedence over the second, but this is unlikely to be a universal rule. Cross-national evidence suggests that much the same factors play a similar role in different media systems (Golding and Elliott, 1979; Gaunt, 1990).

Journalists' impressions of what represents significant news does not necessarily reflect that which is of greatest importance to the audience. Journalists often have their own priorities and their perceptions of their audiences' interests, needs, and ability to understand the news may not reflect reality (Robinson and Levy, 1986). Journalists may display excellent memories for news stories themselves because they are totally immersed in the news making process. This can lead them to believe, mistakenly, that ordinary viewers are equally adept at news consumption (Robinson and Sahin, 1984).

An important and fundamental aspect of fairness in television news is the degree of selectivity which prevails over the choosing of news stories to be broadcast. Some news stories will be judged by news editors to have more inherent appeal than others. In this context, the 'appeal', so called, represents a judgement editors make on behalf of audiences. It may sometimes be difficult to discern, however, whether the level of likely interest to audiences is the key here, or whether the editorial judgement is driven by intuitive journalistic criteria of 'newsworthiness'.

Media researchers who have tackled the subject of news selection processes and resultant news profiles in broadcasts have identified a number of fairly basic news values or story attributes which news editors appear to use in deciding which events are worth showing. According to Galtung and Ruge (1965) events are more likely to be reported if they concern short, dramatic happenings, have a clear interpretation, have meaning and familiarity for the audience, are relevant to the audience, are about things one expects to happen, or are highly unexpected.

Another important factor is the way in which selected news stories provide a coherent overall composition. News editors aim to achieve a certain degree of variety across different types of stories. If a number of stories surface at a given time which concern similar kinds of events, those stories will have to be characterized by a number of key newsworthiness attributes if they are to stand a chance of being selected. The more unique is a particular story, the greater its chances of selection. This brings us back to the question of what makes a story 'unique' or composing sufficient 'news quality' that it will be used in a bulletin. A story is placed at an advantage if it concerns élite nations or people who have an important part to play in world affairs, or important things to say or do. If a story is characterized by key actors – especially if they are well-known people – though even if they are not, if people can readily identify with them, then it has a greater probability of being broadcast. Finally, bad news, particularly that stemming from events involving violence and conflict, is a popular editorial choice because it embodies such important qualities as drama, surprise and concreteness.

Analyses of news profiles have tended to confirm these assumptions. To what extent though do these news values make a difference to what viewers remember from televised news or how they react to it? In a study of television news coverage and voter behaviour, McClure and Patterson (1973) listed five criteria necessary to produce television news that they claimed would leave the viewer with a 'unique and powerful impact'. There were clear-cut parallels between the qualities listed by these researchers and the qualities identified by Galtung and Ruge (1965) as important for news selection. According to McClure and Patterson, the news coverage should be of live events; it should be repeated and/or saturation coverage; and it should be outside the context of a political campaign.

Hudson (1992) studied the decisions taken by a sample of television news editors who viewed six versions of a story, ranging from one with no violent

footage to one with very violent footage. The event featured the on-air suicide of Pennsylvania State Treasurer R. Budd Dwyer who shot himself through the head. The versions varied in the extent to which they showed the shooting, the impact of the shooting, the injuries caused and the victim lying dead and bleeding afterwards.

Each news editor chose a version representing his/her perception of an 'acceptable' level of violence for broadcast. Most considered the shooting and the victim falling to the floor acceptable, but excluded images of the dead body. This finding was consistent regardless of market size or preference for 'neutral' versus 'participant' journalism. However, journalists who labelled themselves 'objective' cleared a more violent version for air than self-labelled 'interpretive' journalists. Objective journalists are more inclined to want to show the world the way it is, while interpretive journalists believe they have an obligation to offer some filtering and evaluation or interpretation of events on behalf of viewers. Large market television producers and news directors were not more inclined to broadcast more graphically violent pictures than their small market counterparts.

Journalists who exhibited a preference for neutral, objective news values showed about the same amount of restraint (or lack of it) as those who preferred interpretive, participant ones. When given an opportunity to label themselves as 'objective' versus 'interpretive', however, a significant difference was found. These seemingly contradictory findings lead to an obvious concern regarding the validity of the 'objectivity' test as adapted for this study versus respondents' perceptions of their own news orientations. For one thing, 52 respondents labelled themselves as objective, while only 37 were labelled neutral using the seven-question news values test. Extended use of other measures, and a refinement of procedures for making these designations may lead to more informative explorations, says the author.

Still, those 52 television news gatekeepers who considered themselves 'objective' were markedly more likely to clear a more graphically violent version for air than the 20 who described themselves as 'interpretive'. There is evidence of a connection between the way a journalist views his or her professional orientation and the way he or she might handle a difficult or controversial news presentation decision. The fact that some journalists claim to be holding a mirror to the world while others consider themselves qualified (even duty bound) to organize, synthesize, and interpret the world for the audience did manifest itself in their decisions for airing or excluding the graphically violent material presented on the television screen.

Observers of the newsmaking process have noted a great deal of similarity between news professionals in the types of news they select for presentation. This tendency for journalists to exhibit uniformity in reporting news on TV stems from their observing common news values, rules of news selection, their tendency to confirm their own opinions, their dependence on certain news sources, and the fact that many journalists are demographically similar types of people with similar views on the world (Noelle-Neumann, 1973, 1984;

Noelle-Neumann and Mathes, 1987).

If there is a common value system operating which leads journalists to make similar judgments and decisions about news, this is likely to result in a rather narrow style of presentation and limit the diversity of content. Atwater (1987) discovered the most frequent television news duplication among 'crime/courts, government/politics, and accident/disaster topic categories,' and concluded that, 'By reporting similar news stories and topics, stations may be influential in the formation of a community's public affairs agenda' (pp. 470-471). It has long been recognised that the major news media can set the public's news agenda, that is, the news media tell people what to think about. This role is particularly potent in relation to politics (Blood, 1989; Hill, 1985; Hugel, Degenhardt & Weiss, 1989). This effect may be defined in particular by the values and beliefs of journalists have about what constitutes news and what the people most need to know about (Wanta, Stephenson, Turk and McCombs, 1989).

Whether one believes that journalists can tell people what is appropriate to say or do in public, or merely what factors to think about in their personal search for truth, broad agreement among those journalists would certainly play an important role. The power of the media over public opinion might be significantly mitigated if members of the media were shown to hold an array of points of view and express this pluralism in their work. Rather than a pluralism, however, there appears to be a consonance in the views held by the profession. News gatekeepers hold similar news values about what makes 'news' and exhibit similar tendencies in reporting the news (Altheide, 1982; Atwater, 1986, 1987, 1989; Noelle-Neumann and Mathes, 1987).

Further corroboration of this impression has arisen from studies of broadcast news output. Television news programmes have been shown to resemble each other a great deal, both at network level (Altheide, 1982; Fowler and Showalter, 1974; Lemert, 1974; Meeske and Javaheri, 1982) and local level (Atwater, 1986).

On the other side of the coin, Stempel (1985) argued that such concern about news standardization had been overstated and that the major media are not all simply reporting the same news stories. A number of researchers have found that news gatekeepers from small markets (small towns and rural areas) often make measurably different news selection decisions from their counterparts in larger markets (Buckalew, 1969, 1970, 1974; Carroll, 1985, 1989).

In considering how and why news decisions are consonant, specific attributes of the gatekeepers themselves have come under scrutiny. Johnstone, Slawski and Bowman (1976) studied interpersonal attributes of nearly 1,400 journalistic gatekeepers and found that 'the newspeople' could be placed on a scale from 'traditional/objective' to 'participant/interpretive', with significant and identifiable distinctions between the two categories.

According to Shoemaker and Mayfield (1987): 'Some people, notably

journalists, believe that the mass media are mere channels for the transmission of information about reality to the audience ... The role of the gatekeeper is seen as that of a neutral gatherer and transmitter of information, not unlike that of a sponge that daily soaks up information about the world and then releases it on a predetermined schedule. In the extreme version of this approach, the journalist is a disinterested, totally independent, all-seeing, and ever-present observer and recorder who never makes a mistake.' (pp. 5-6) They go on to conclude that news does not hold up a mirror to reality. 'Explanations for the media's not mirroring reality at times can be found in journalistic routines, journalists' socialization, and influences from advertisers and audiences' (Shoemaker & Mayfield, 1987, p.7).

Journalistic routines have been studied not only in relation to the gatekeeping functions of news selection, but also in connection with the way that that news which is selected is produced and presented (Altheide, 1974, 1985; Altheide and Snow, 1979; Frank, 1973; Gans, 1979; Glasgow University Media Group, 1976, 1980, 1985; Hetherington, 1985). Production format attributes are linked to the structure and organization of news in broadcasts. News production is characterized by regularity of structure, determined by repetitive professional routines and practices. News bulletins are regular in appearance, in terms of duration, and in the balance they afford to different types of news story. The same kinds of topic categories occur day after day (McQuail, 1977). Often these topics are organized in a stereotyped fashion within news broadcasts, with certain types of news (e.g., politics and economics) occurring predominantly at or near the beginning and other types (e.g., sport, human interest) more often occurring at or near the end (Glasgow University Media Group, 1976, 1980). Some of these features of regularity have been observed to occur across different countries (Rositi, 1976). In effect, news professionals reduce a large and unpredictable universe of events to a more manageable and structured number of news reports.

The order of news within a broadcast also signifies something about the relative importance of the event being reported. The events deemed by news editors to be the most important of the day tend to occur at the beginning of the bulletin. Such stories will also tend generally to receive more time (Glasgow University Media Group, 1980; Schlesinger, 1978). While the ordering of news stories is explained by journalists in terms of a need to build and maintain a certain pace and rhythm within a bulletin, which has important implications for the maintenance of audience interest and attention, some media researchers have argued that there may be deeper ideological reasons, embedded in the culture of the news organization, for giving greater prominence to certain stories, which reflect the needs of the political establishment (Glasgow University Media Group, 1976, 1980).

The cognitive aspects of bias in broadcast news are centred on its factual quality and comprehensibility and its significance for the public. The production of news which systematically falls down in terms of its factual accuracy and completeness may provide one set of indicators about the presence or absence

of bias. The validity of such indicators of bias depends primarily on whether there has been some demonstrable failure of commitment in newsrooms to produce accurate and complete factual accounts of events.

In addition to the factual quality of those reports which are aired, there is the further issue of their potential interest to audiences. News must generally be up-to-date and relevant to people's concerns. Determining how news relevance can be defined is far from simple. The news agenda may be decided through a normative approach which attempts to provide a general set of rules about what it is important for individuals living in a particular society to know about. Contrasting with this consensual orientation towards determining news provision is an alternative perspective which stresses the divergent interests and concerns of different groups within a society and calls for better recognition and representation of the plurality of tastes and priorities which typifies a modern cosmopolitan society. Generally overriding these two perspectives in practice, though often purporting to represent them, are professional criteria which are routinely implemented by journalists in news selection and production. News editors act as gatekeepers and play a key role in determining the news agenda. They take decisions about which events to report and the degree of attention chosen reports will receive. These decisions are shaped by professional, and often intuitive, beliefs about the psychology and tastes of audiences. Stereotyped professional news selection criteria and production practices determine the substance and form of the news agenda. Such practices may exhibit certain biases in relation to the selection of certain news categories and the way they are presented, thus determining what audiences will think about and learn of current news events and issues.

Evaluative Aspects of Bias: Output Perspectives

The Concept of Impartiality

Impartiality represents a central performance criterion for broadcast news as laid down statutorily in broadcasting legislation. For some writers impartiality also represents a key component of the need for objectivity in news reporting and as such is a quality expected of the news by its audiences. The presence and extent of impartiality in the news is not always a straightforward characteristic to identify and measure. Broadcasters themselves tend to refer mainly to a stopwatch criterion whereby opposing sides to an argument or dispute receive more or less equal amounts of airtime. Broadcast regulators may talk about 'due impartiality' which attempts to take the measurement issue beyond a rigid quantitative allocation of time to different points of view and does, at least to some degree, allow for the operation of news imperatives and news values. This latter approach tries to be mindful of the public's need to be informed comprehensively about news events and issues, in respect of which one party may have played a more prominent role than another. Clearly, if this is factually the case, it should be reflected in the coverage. To create an artificial equanimity in this way could itself be conceived as imposing some sort of bias on the coverage.

Concealed bias can potentially creep into news reporting in the form of propaganda or ideology. The latter may refer, of course, to political ideology in the prevailing culture, reflect the current political climate with regard to an issue, or be a function of professional news value requirements which determine the worthwhileness of particular stories or story angles. The key point where impartiality is concerned is whether news accounts exhibit some form of consistent and systematic favourability of one side over another in matters of controversy which could mislead the audience's impressions about and understanding of the issues being covered.

The impartiality concept has been divided into two parts to facilitate its analysis. These parts represent the criteria of *balance* and *neutrality*, with the former referring principally to the way the news is selected and the latter with the

manner in which it is presented. Balance in this context is closely associated with diversity or range of coverage. A news programme may lack balance if it fails to cover the full range of important contemporary issues worthy of report, or if particular stories omit significant facts or ingredients, thus rendering them incomplete. Neutrality depends upon the treatment of a story that has been selected and centres on which manner of presentation could cause audiences to adopt positive or negative impressions about the event or issue being covered whatever 'facts' have been included. Thus, a news report could be perfectly correct in a factual sense, but through subtle production treatments, invoke a particular kind of interpretation of the facts. This effect can be achieved through the use of certain descriptive terms or phrases which carry positive or negative connotations, or through images, camera shots, and music which can create a particular 'mood', all of which operate upon audiences' emotional reactions rather than any rational or cognitive reactions (see Tuchman, 1978). With neutrality, assessment of the extent to which it has been achieved is closely linked with probable or actual audience responses. With balance, in contrast, the systematic omission of stories or story angles or details can be assessed through reference to a combination of output measures and independent, external sources of validation. Throughout, it is also possible that pressures which derive from various 'professional' criteria might also be playing a part.

With *balance* therefore, the key sub-criteria are (1) whether news broadcasts give due access to the important stories of the day and therefore provide a diversity of news coverage; and (2) whether they provide a full and comprehensive account of stories themselves, including all the important facts of the matter. With *neutrality*, it is essential that news reports strive to avoid presenting misleading impressions or emphases through the use of subtle production treatments and using undue sensationalisation of events, leading audiences to believe that such events were more dramatic or significant than was really the case. We can now turn to examine the balance and neutrality concepts in greater detail. In each case, reference will be made as appropriate to the four main modes of assessment: (1) output criteria; (2) independent, external source criteria; (3) professional/journalistic criteria; and (4) audience criteria.

Balance

Research into balance in the news has tended to depend significantly on broadcast news output measures. These measures operate at a number of different levels of detail. At a macro-level, broad distinctions may be drawn between categories of content and the form in which they are presented. Thus, the news on different television channels may be compared or divisions drawn between straight news reports and editorials or commentaries. At a more micro-level within specified stories, smaller units of analysis may be deployed which focus on particular production features such as the kinds of visual materials used, camera shots, use of headlines or summaries to present

the main points of a story, the grammatical structure of the narrative, use of certain phrases or words, and the amount of factual content. At this level of analysis, it becomes possible to measure how much time or space is given to different parties or different sides in a dispute, and to different arguments or points of view. It is also possible to examine closely the extent to which particular sides or viewpoints are described in certain terms which themselves carry specific connotative meanings. This type of analysis can be used to indicate whether a news programme has allocated disproportionate amounts of attention to certain positions, perspectives or participants over others in relation to a news story.

Determining whether or not a news programme or news story is balanced is dependent upon setting an effective and appropriate frame of reference within which to assess the nature of the coverage that has been given. Balance, or the lack of it, can be judged at different levels. A news story may be internally balanced in terms of the range of central or pertinent factual details it provides. Balance can also be assessed over an entire programme or, indeed, over a number of programmes in a series. As we saw in Chapter One, the code of practice on impartiality devised for programme makers by Britain's commercial television regulator makes reference to a 'series requirement' which allows for due impartiality over different editions in a television series (ITC, 1991).

The selectivity notion of balance, which refers to stories or story-related details which have been included or excluded, represents one perspective on this issue. Another approach has been to examine the structural features of a news programme which affect the degree of prominence a news account receives. Broadcast news is governed by production conventions which determine the way the news is put together. These conventions represent professional codes of practice, which may often embrace intuitive assumptions about audiences (Schlesinger, 1978). Thus, news programmes may afford differential degrees of prominence to news stories through where they are positioned in a bulletin (i.e., in the first three positions as opposed to lower down in the programme), the amount of time allocated to a story, the use of various kinds of visual illustrations in addition to a talking head, and whether the story is highlighted in the opening headlines or closing news summary. The language used with a story may further influence the potential impact it has. Linguistic features can affect whether the story adopts a positive or negative tone towards certain actors or issue perspectives (Frank, 1973).

Impartiality depends crucially on the overall balance achieved by a story or programme. Negative remarks or connotations must be counter-balanced by positive ones, with each side of a dispute and all aspects of a controversy being given the degree of attention to which they are due. News stories should avoid slant in which they accord criticism or praise disproportionately to particular actors or arguments and seek to achieve perspectives whereby through citing from a variety of different sources, they reduce the likelihood of a one-sided interpretation of events (Entman, 1989).

Output analysis

The analysis of balance in news broadcasting can be conducted through an assessment of the output itself. This may be carried out in quantitative terms as well as in a more evaluative fashion. Much of the research on balance has been conducted around the reporting of political election campaigns. On these occasions, the opposing sides are readily identifiable and the criteria for assessment are clearly defined in terms of equal or proportional representation of political parties or candidates. It is generally expected that broadcasters will be scrupulously fair in their treatment of the competing parties and much emphasis is placed on the access each party is afforded to put forward their points of view and their policies on air. Other more subtle features have been identified in connection with a potential lack of balance in news presentation, both in the context of reporting political news and other categories of news.

Evidence from Political Coverage

(a) Research on election coverage. Research on balance of media election coverage spans more than 50 years. Early investigations were carried out in the United States which focused on the two main information media of the day – newspapers and radio. One study of the media coverage of candidates Roosevelt and Wilkie in the 1940 US presidential election found that, in quantitative terms, Roosevelt received the greater amount of coverage by a margin of three to two, but that Wilkie was judged to have received more favourable coverage in more evaluative terms (Lazarsfeld, Berelson and Gaudet, 1944).

Subsequent research during the 1950s focused primarily on newspaper coverage of elections. Bias in newspaper coverage of the 1952 US presidential election was identified in which bias was defined as the 'existence of a differential, larger than could be expected by chance alone, between the front page coverage allotted the two candidates by the two sets of papers (supporting Eisenhower or Stevenson)'. The differential coverage was measured by 18 variables, including aspects of prominence, language, quotes, photos and biased remarks.

With the growing prominence of television as a news medium in the 1960s, more media researchers began to focus on the nature of network television news coverage of elections (Cirino, 1971; Efron, 1971; Weaver, 1972; Meadow, 1973; Stevenson and Shaw, 1973; Paletz and Elson, 1976).

In 1971, a number of issues of scientific and political interest were raised by the publication of Edith Efron's *The News Twisters*. The author presented a content analysis of American network news between 16 September and 4 November, 1968, that led her to conclude there was considerable bias. She found decidedly more favourable treatment of liberal positions and the Democratic candidate, Hubert Humphrey, than of conservative positions and the Republican candidate, Richard Nixon.

Efron focused exclusively on the favourability or unfavourability of reports and opinions in regard to the candidates and the issues she defined as

important in this campaign. Two major units of analysis were frequency of statements judged as expressing an opinion and the number of words of coverage in the reports said to be favourable or unfavourable to a candidate. Efron was quite explicit in stating her view that network coverage inevitably will be biased in favour of liberal positions because, in her opinion, almost all network newsmen are of liberal persuasion. The result, she believed, was to limit and distort coverage not only of conservative but also radical viewpoints.

Efron's view was that bias could be observed only in evaluative content. This meant that there was no formal statistical check on reliability among coders. Efron argued, however, that the definitions of favourable and unfavourable opinion in coverage were unambiguous and could (and by implication would) be applied by anyone in a consistent fashion.

Her technique involved multiple tallying, with every issue and candidate mentioned in a statement receiving credit as the targets of unfavourable opinion or words of coverage. Thus, a single paragraph containing an attack unfavourable to positions A and B and a comment judged as favourable to candidate X would be tallied in three separate places. The consequence was that the procedure tended to produce a quantitatively impressive set of tallies even from a few instances of alleged bias.

Stevenson and Shaw (1973) conducted another study using different techniques. They confined themselves to CBS newscasts for the same period as Efron. They counted lines of coverage which four coders classified as favourable, unfavourable, or neutral. Reliability of coding was statistically supported by an adequate level of intercoder agreement.

The results showed that all candidates received more favourable than unfavourable coverage on the CBS television network in 1968. There were no marked differences between the treatment of Hubert Humphrey and Richard Nixon, but coverage of the third contender, George Wallace, was less favourable than for the other two. Efron, on the other hand, found Humphrey treated far better than Nixon in terms of words of coverage, with Humphrey coverage divided 53 per cent favourable versus 47 per cent unfavourable, Nixon divided six per cent favourable versus 94 per cent unfavourable, and Wallace divided 46 per cent favourable versus 54 per cent unfavourable.

One problem dramatically raised by the Stevenson analysis is the effect of ignoring neutral content. This study found that nearly two-thirds of all CBS candidate coverage was neither favourable nor unfavourable. Direct film of candidates (about 40 per cent of all lines of transcript), neutral commentary (17 per cent) and mixed reports (9 per cent) were found to take up twice as much coverage as anything classified as pro- or anti-candidate reports. Surprisingly, the proportions were almost identical for all three major presidential candidates – Humphrey, Nixon and Wallace. On the other hand, Stevenson identified one type of imbalance that Efron did not find. Humphrey averaged about three minutes more coverage per week than Nixon

and about four minutes more per week than Wallace. The major issue raised by the comparison of these two studies is that of the appropriateness and jus- tifiability of procedures employed to detect bias.

Hofstetter (1976) conducted a further careful analysis of the network news coverage of the 1972 US election campaign, for possible bias in attention to the presidential candidates, McGovern and Nixon. Balance was assessed in terms of amount and kind of attention, choice of topics, coverage of policies, linkages of candidates to other groups and interests, and any possible evalua- tive associations. Little evidence of any tendency to favour one or other can- didate was found, nor any differential political bias by the three networks.

Patterson and McClure's (1976) study of network news in the same election, however, reached a different conclusion, reporting that network news disad- vantaged McGovern, especially by neglecting his policy positions and person- al qualities for leadership. While he received about the same attention as Nixon in these respects, the result was said to be relatively unfair to the con- tender for office (as opposed to the incumbent).

Clancy and Robinson (1988) looked in great detail at the balance of attention to Reagan and Mondale in the 1984 US election campaign, computing the precise number of seconds on several dimensions of coverage, according to whether the candidates received a 'bad' or a 'good' press. On matters of can- didate quality, Reagan received 7,230 seconds of 'bad press' and Mondale only 1,050, while on 'horse-race' stories, the balance was reversed at 1,200:5,880.

It is clearly difficult to reconcile the claim for precise numerical balance in these terms with the expectation that news will faithfully reflect a reality in which the candidates, as well as their policies and their chances of success are very likely to merit varying evaluations. The 'real world' has no obligation to be statistically fair. Relevance criteria are also unlikely to coincide precisely with the norm balance. The real significance (by whatever criterion) of what candidates do or say and their potential interest to audiences are not likely to coincide. The studies cited above illustrate well the limitations of precise quantitative measures for reaching conclusions about 'bias' and also the ten- uousness of arguments and interpretations based on omission.

McQuail (1992) eloquently describes the limitations of this approach: 'The stop-watch measure of balance in output only takes one to a certain point. It reflects the concerns of interested 'senders', rather than any rational weighing of likely consequences of balance or imbalance. Unless audience research (and, if possible, response) is also taken into account – thus factors of timing and for- mat, which determine how much of what kind of message is likely to reach how many and what kind of viewer – amount of media attention is limited as an indicator of media performance. Nor can time/space measures reveal much without reference to the context and the specifics of actual content' (p.226).

More subtle measures of the balance achieved by political reporting have focused upon the level of attention devoted to particular orientations adopted

by journalists. Instead of measuring the amount of time given to opposing political parties in a campaign, the perspective is one of examining whether particular styles of reporting are adopted which may direct the public's attention towards specific aspects of a campaign, at the expense of others.

Mazzoleni (1987) looked at media coverage of the 1983 Italian general election campaign. He identified four potential functions of the media in the campaign: propaganda, information, 'spectaculization' and 'topicalization'. 'Spectacularization' referred to coverage elements which pointed to the spectacle, or entertainment dimension of the campaign, such as a focus on the horse-race and image of politicians. 'Topicalization' referred to the independent contribution of the media to 'setting the agenda of the political debate' by, for example, introducing fresh issues.

The degree to which campaign communications appeared to serve these functions was taken to signify whether the campaign was structured around 'party logic', 'media logic' or a negotiation between the two. The degree of media logic was determined by features of media campaign coverage which reflected attempts to sensationalise and personalise the election, such as the emphasis given to election news through the way it was scheduled, references to parties' campaign strategies, the horse-race, and the personal characteristics of candidates (not a traditional feature of Italy's party-oriented polity).

The study examined whether traditional news values were apparent in coverage via the extent of investigative reporting such as interviews, public surveys, special programmes, and also the extent of media partisanship to determine whether coverage was 'information oriented' or 'propaganda-oriented'. Finally, the study examined the extent of media influence on the campaign agenda via the use of formats implying evaluative positions, and also by overt evaluative commentary.

The findings suggested that the institutional context of Italy's news media had a profound effect on campaign messages. The public service broadcast material did not present a high level of media logic, with only a few attempts to turn the campaign into an entertainment spectacle or to focus heavily on party images. The commercial television networks, however, exhibited a much stronger indication of media logic, in the sense that they focused much more on personalising the campaign and trying to create some kind of spectacle out of it. Perhaps the important finding though, was that traditional news values appeared to be applied across all channels, with a concentration on voter interests rather than party propaganda. Even so, partisanship was present whether news broadcasts were driven by informational or entertainment orientations. Mazzoleni concluded that the content and nature of the election campaign indicated that party-media relations were subject to 'dynamic processes' where the changing broadcasting environment was also altering the style of campaign coverage in general, and also the campaign communication strategies of the political parties.

(b) Coverage of controversial matters. There are many matters of political controversy, besides elections or party politics where news has to deal with

alternative positions and opposing sides, or even multiple parties to an event. These issues include nuclear power, industrial relations, pollution, abortion, crime and punishment, international conflicts, armaments and defence. The norm generally applied in such issues is based on the widespread public expectation of 'fairness' in presenting alternative points of view which, in turn, is often interpreted as requiring strict neutrality.

There are events, however, (e.g., a terrorist outrage on innocent bystanders) where such strong emotions are aroused that neutrality is not even an acceptable option (Hemans, 1976). In practice, the expectation of neutrality is relative and can even be reversed, where fundamental values are at stake.

The aims of analysis are much the same in most such controversies: to identify the direction and strength of tendencies in news reports, which can in the end be reduced to a positive or negative sum, for or against one position or the other. The question is whether a news account could be anticipated as generating a favourable or unfavourable audience reaction on the basis of the kinds of evaluative statements it includes about different sides in an argument or dispute. A numerical count of positive and negative statements within a news account can be made to provide a quantitative assessment of the overall balance of a story or programme.

This approach to analyzing balance can yield reliable estimates of the positive or negative position adopted by news reports, although they are dependent upon an agreed view of what constitutes each type of statement. Another feature of this analytical perspective is that many statements may be difficult to place either as positives or negatives, thus the final analysis may be based upon somewhat less than that total information content of an item.

(c) Reflecting political divisions. In political communication research, this particular issue is usually tackled by comparing the balance of media attention to different parties and political figures, especially during election campaigns, with the political balance in the society (e.g., Hofstetter, 1976; Patterson and McClure, 1976; Blumler, 1983).

A new issue for assessment has been introduced as a result of the televising of the proceedings in Parliament in Britain (Blumler, 1990). There can also be bias of camera attention, not only among political party lines, but also along lines of regional representation and, possibly, unjustifiable attention to prominent national figures.

In order to assess the relative amount of attention to different politicians or political positions, samples of politically relevant media content (generally news, comment, background and political access material, including advertising and parliamentary reporting) are analyzed according to amount of space or time which either originates from, or simply pays attention to, a party or candidate, and the distribution of the 'population' of political actors, as this appears in media content. The results of such measures can be compared numerically with a chosen standard of representation (e.g., equal or proportional reflection).

When reporting Parliamentary stories, broadcasters may try to maintain a balance not only between parties but also between front-bench and back-bench Members. To promote an enhanced public understanding of Parliament, television coverage ought to show the various facets of the House and the full range of Parliamentary events. Tutt (1992) reported content analysis of the televising of the House of Commons which utilized a number of measures of party balance in the coverage. One measure recorded the number of actuality contributions made by specified Parliamentary groups; a second measure noted the number of contributions by party to individual broadcast news items; and a third recorded the percentage of total appearances by members of each political party.

These measures generated two broad conclusions. First, television coverage of the Commons presented the Chamber as a two-party forum. Other Parliamentary parties gained negligible news exposure, and achieved only marginally better coverage in television review programmes. Second, within this broad two-party emphasis, the governing Conservative Party routinely enjoyed a prominence in programming unrivalled by the opposition Labour Party. Only in a single aspect – back-bench coverage on national news – did Labour members appear more frequently than Conservatives. The Conservative Party was represented in news and current affairs broadcasts more often than members of all other Parliamentary parties combined.

In placing this apparent imbalance in a wider context, there are two important observations which ought to be noted. First, the greater prevalence of Conservative members in news coverage of Parliament reflected the inevitable prominence which broadcast media bestow on all governments. When broadcasters seek statements or comment about key political issues, the key figures are senior ministers in government. Another point is that this analysis of the numbers of contributions made by members of various political parties took no account of the substance or direction of their contributions. During the period monitored by Tutt, there were a number of attacks on government policy that derived not from opposition benches but from the Conservatives own back-bench MPs. The balance measure here therefore recorded the level of attention given to different parties and not the support for those parties' policies.

Parliament's own procedural rules may also have contributed to the imbalance in party coverage. The governing party and the Prime Minister in particular are afforded more opportunities by Parliament to make statements than are opposition parties and their leaders during Ministerial and Prime Ministerial Question Times, thus creating an imbalance of opportunities among parties for broadcast coverage.

Another type of question concerns the balance of attention to the *substance* of politics, rather than to the range of political actors. Political content can be more or less diverse in its range of factual coverage or reference to reality. Most evidence on this point comes from so-called 'agenda-setting' research, which seeks to determine the issue priorities in potentially relevant media

content and to compare the result with either the issue 'agenda' of politicians or that of public opinion (McCombs and Shaw, 1972; Funkhouser, 1973; Chaffee and Wilson, 1977; Becker, 1982; Iyengar and Kinder, 1987; Rogers and Dearing, 1987; Reese, 1991).

The more the media agenda corresponds with that of politicians or the public, the more we suppose reflective diversity to be realized. The alternative would be a concentration by the media on a small number, or a narrow range, of subjects, unrepresentative of debate in society. In that case, one supposes that the interests of some politicians and some sectors of the public are being neglected.

The methods for investigating these matters are straightforward enough (Graber, 1976a; Weaver, McCombs, Graber and Eyal, 1981), Comparisons can readily be made between the content of different channels and the balance of emphasis in public opinion or in statements or speeches made by politicians, as long as one accepts the validity of comparing statistical distributions derived from quite different original material.

Gerbner, Signorielli and Morgan (1982) tested the proposition that the medium of television (in the USA) exerts a powerful pressure towards homogenization and 'mainstreaming' in social and political attitudes and thus contributes to a reduction of political diversity in society. According to this view, the diversity of television content is noticeably less than that of American society. The economics of television, in particular, and the search for maximum audiences, lead to the avoidance of fundamental controversy and to attempts to balance discordant views. Gerbner *et al* wrote: 'these institutional pressures suggest the cultivation of relatively moderate or 'middle of the road' presentations and orientations' (p. 101). The evidence confirmed that those most exposed to television did in fact opt for political outlooks of this kind. Even so, it may simply be that mainstream television tries to reflect the consensual views of mainstream 'heavy television viewers'.

Assessing Balance in the News.

(a) Source bias. One aspect of assessing the external validity of news reporting is to count and classify the sources referred to in relation to different perspectives on an issue or sides to a dispute. Balanced coverage would normally mean that all relevant parties or perspectives are covered and are allocated equal or due proportionate reference. This objective can be difficult to achieve because different parties may also differ in terms of the status they hold and because all the relevant parties may not be available for comment. This state of affairs has already been illustrated in respect of Britain's governing and opposition political parties. Journalists must weigh up the need for comprehensive source referencing against the time and effort needed to gain access to them, particularly when working to tight deadlines.

In the context of election campaigns, source bias has been examined with special reference to the agendas being set by news editors as distinct from those being promulgated by political parties. News sources have been assessed in

televised reports to determine the effectiveness of the political parties in setting the campaign agenda (Semetko, 1989; Semetko, Blumler, Gurevitch and Weaver, 1991; Semetko, Scammel and Nossiter, 1994). Distinctions were made between party-initiated statements (planned public statements and activities) and media-initiated (investigative reports, issues stories, analysis and poll stories) statements (Semetko *et al*, 1991). Stories were also analysed for statements initiated by official bodies (eg, councils, quangos, ministeries), non-government organisations (eg, pressure groups, trades unions), European institutions (eg, European Commission), European figures (EU member state politicians, EU officials, MEPs from other countries), the general public, and others (eg, celebrities, the clergy, the armed forces, etc).

A number of American writers have observed that news in their country does exhibit signs of deviation from reality or, at least, from some standard of accuracy whereby it depicts a genuine balance, diversity and authenticity of event presentation (Berkowitz, 1987; Dominick, 1972; Epstein, 1974; Fishman, 1980; Gans, 1979; Tuchman, 1978). Two principal types of source bias have emerged from these analyses of news presentation: (1) geographical bias – referring to where news stories derive from; and (2) structural bias – referring to who makes the news.

There are numerous indications of how the news departs from 'reality'. It may do so because it reflects power hierarchies and systems more than serving some functional need to provide representative coverage of issues, groups and events (Fishman, 1980; Gans, 1979; Gitlin, 1980). Moreover, as Tuchman's (1978) metaphor of the 'news net' suggests, journalists' routines and news organizations' practices are themselves biased: journalists are stationed where news, as defined by their organization, is presumed most likely to occur, at the expense of locations and sources not in the net (Goldenberg, 1975). This, 'biasing' of this sort can be read in at least two ways. The first of these is that in their selection and coverage of news sources, in particular, news media do no more than reflect, not a 'reality of humanity', but a reality of power, influence and publicity. Second, this kind of reflection, by its very nature, reinforces and legitimates such a reality (Tuchman, 1978).

Likewise, economic and technological constraints render some sorts of news more likely than others to receive coverage. News is organized bureaucratically, and economic and technological constraints are most apparent in the most technologically intensive medium, television (Berkowitz, 1987; Hofstetter, 1976).

Who makes news, that is, who gets quoted as a source in news stories, has certainly been shown to exhibit inequitable distribution among different types of individual and group. Gans (1979), in a content analysis of national television and news and news magazines in the USA, divided news sources into 'knowns' and 'unknowns' and animals, objects and abstractions. The former accounted for 71 per cent of 1967 television news sources and about three - quarters of a sample of 1967, 1971 and 1975 news magazine sources, and largely comprised federal government officials (especially the President, who

accounted for 20 per cent of 1975 news magazine domestic news space), state and municipal officials, well-publicised 'violators of the laws and mores', professionals and business people, civil rights activists and labour leaders. Berkowitz (1987) found heavy reliance on official and 'affiliated' sources in a study of local network television news, though about one quarter of sources were not identifiable by affiliation.

It is certainly the case that the powerful tend to be more satisfied with media coverage than the disadvantaged, with each group believing respectively that they receive adequate or insufficient media access (Donohue, Olien and Tichenor, 1985). It is not simply access per se that is important, but rather access at the most appropriate or advantageous times. For some events that are linked with negative connotations, such as industrial disputes and strikes, it may be better to have limited coverage. In British industrial relations reporting, research has shown there to be a tendency for union spokespersons to have a higher 'visibility' than management (McQuail, 1977), but also to be often associated with strikes portrayed as harming the public. Under these circumstances, managements may often prefer unions to take the limelight (Fiske, 1987).

Source bias is also manifest on those occasions when official sources are heavily relied upon for evidence about the important perspectives on an issue. This category of bias was observed in relation to media reporting of the United States' withdrawal from UNESCO in 1984 (Giffard, 1989). Most news derived from the main American news agencies which demonstrated considerable hostility towards UNESCO. As a result, much media reporting reproduced the anti-UNESCO imbalance, even though there were enough alternative reports and positions available for source 'balance' to have been achieved on the withdrawal issue, had this been the objective (Brown, Bybee, Weardon and Straughan, 1987). A similar pattern of reporting was noted in respect of discussion of American foreign policy on Central America, which relied principally on statements issued by the US government's State Department (Herman and Chomsky, 1988).

In some categories of events with a high immediate impact (e.g., a nuclear accident or a military action), it is first impressions which may shape public response to, and definition of, an event and 'expert' and official sources may inevitably play a disproportionate role (Walters, Wilkins and Walters, 1989). Use of unattributed sources may, in itself, be taken as an indication of lack of objectivity, partly because this breaks with the normal rules of evidence and is one way of introducing, or allowing in, partisan views (Shoemaker, 1983; Wulfmeyer, 1983). It also tends to disadvantage the less powerful, who are less able either to deploy (or to object to), this form of source support (Shoemaker, 1983).

Reese, Grant and Danielian (1994) examined television network newscasts and political interview shows to identify the range and connections between major sources of political news. Most of the sources comprised a single cohesive 'insiders' group – a band of élite, political figures, senior administrators, experts and journalists.

Their analysis was guided by élite theory, which directs attention towards the structure of power in society. This approach focuses upon individuals occupying the most senior positions in society. Mills (1956) traced the convergent interests of business, economic and military élites as forming an apex at the top of society's pyramid of power. Network analysis has found that these élite individuals represent a 'social circle' who frequently interact with one another (Alba and Moore, 1983).

This theoretical perspective has been applied to the study of news sources. Its value rests in the attention it pays to the interconnections among these sources. It has been observed, for example, that élites, both governmental and corporate, receive privileged access to news channels (e.g., Herman and Chomsky, 1988).

According to Reese *et al.* (1994): 'Locating a large, cohesive, interconnected group of sources, which addresses a number of issues, would support a conception of sources comparable to the 'higher codes' found by élite theorists. Alternatively, a pluralist view would predict a number of sets of sources, which group with little overlap around specific events and issues. Understanding this structure of news sources is important to understanding their power in the US media as expressed through news coverage' (pp. 85-86).

Reese *et al.* (1994) adopted the network paradigm to investigate and identify interconnections among sources of news. The approach had previously been used to identify structural characteristics of social systems such as cohesion, communication flows, and people most central to those systems (Monge, 1987; Monge and Contractor, 1988; Rogers and Kincaid, 1981).

In doing so, they took an in-depth look at source use across several programmes over a relatively short period of time (October-November, 1987). This period featured several key issues including the Persian Gulf Conflict, stock market crash, and so on. The programmes examined were 'CBS Evening news', 'Nightline', 'MacNeil/Lehrer Newshours', 'This Week with David Brinkley', 'Face the Nation', and 'Meet the Press'.

The emphasis of news sources as the basic building blocks of the structure departs from many content studies, which tend to organize news coverage by topics or issues. But sources play an active role in shaping the news (Lasorsa and Reese, 1990). 'When we look at who says what in the news, it helps get us beyond imprecise statements about what 'the media' say about an issue: the media express views by allowing newsmakers to express them' (Reese *et al.*, 1994, p. 87).

During the course of this analysis, it was assumed that the joint appearance of two or more sources in a television news story or public affairs show signified a 'relationship' between them. They were considered to 'go together' for the purposes of presenting the media treatment of an event or story. These sources were assumed to be more involved with each other than with others who did not appear, even though that relationship was largely symbolic.

In addition, these sources by their joint appearance are considered by writers, reporters or talk show producers to represent the essential players or range of

views on a topic. This selection of news sources confines the debate and carries with it implicit assumptions about who is important. Reese *et al* noted that certain news shows tended to select from a fairly limited range of news sources, some of whom appeared repeatedly. This point applied whether it was news broadcasts or public affairs shows featuring more in-depth or longer interviews which were being considered.

The news relied heavily on institutional sources – officials speaking through routine channels. The television networks have generally been oriented towards Washington news, with regular attention given to the President and Capitol Hill. In addition, two other categories of source were important: experts and journalists. The experts comprised academics, members of think-tanks, and political insiders.

Cooper and Soley (1990) confirmed the tendency in their study of 'experts' on network newscasts, noting that correspondents showed clear patterns of reliance on a homogeneous handful of the same experts to put events in context in an apparently neutral and objective fashion. These individuals were mostly men, scholars from the East Coast, Washington-based, or ex-government officials from Republican administrations. Steele (1990) argued that university experts are particularly attractive to television news producers, who usually have already decided what they want said before calling these sources to 'reinforce their own understanding of a story' and to create 'the illusion of objective reporting' (p.28). Hearing academics can create the impression that an objective analysis has been given.

As well as 'experts', journalists themselves – writers, columnists and commentators – have also become important sources. The use of print media journalists, commentators and columnists anchors the television world to the print media, encouraging group consensus.

The use of a limited range of news sources is pinned to the agenda-setting approach of media effects. While agenda-setting has customarily analyzed the range of discrete topics or issues to which the news gives emphasis – hence bringing these topics and issues to the top-of-mind of media audiences, the elitist news source approach reveals a more subtle, even hidden, form of setting or defining agendas. If news broadcasters tend to use the same news sources, over and over, regardless of the topic agenda, there will be a limited range of perspectives aired in consequence. Thus, the diversity of perspectives implied by an agenda-setting analysis which identified a variety of topics and issues to have been covered, might be misleading, given that the 'informed opinion' or 'expert knowledge' about these matters derive from a narrow range of news sources.

Analyzing the major news programmes on US network television, Reese *et al* (1994) found that the sources derived principally from a limited range of professional groups – Senators, administrators, corporate executives, journalists, and academic or think-tank analysts. Many of these individuals were symbolically interconnected. One major grouping of 237 news sources, who were

invited on air to discuss a range of overseas and domestic political matters, comprised an 'Insiders' group of Senators, representatives, and former and current administration sources.

The main point of this analysis was that one need not know what sources actually say on television to obtain an insight into the ideological framework they constitute. Just the selection of news sources and their combination within and across programmes and issues tells it all. The media restrict debate by organizing it primarily in relation to the government process, especially in the narrow political range defined by the two-party system.

Geographic bias. Epstein (1974) suggested that the 'geographic' bias in television news (i.e., that a disproportionate share of US news emanates from a handful of US cities) is (or was in the early 1970s) attributable to the networks' having film crews and reporters already stationed in these cities or to their owning and operating TV stations in them. In either case, news crews had access to dedicated telephone cables for transmission of stories from such places, and originating news was more convenient, cheaper and quicker than feeding news from other places. Thus the 'bias' of TV news will be toward metropolitan centres which are routinely, predictably part of the 'news net'.

A content analysis of 360 national network newscasts between July 1973 and June 1975 by Dominick (1977) showed that two-thirds of the domestic news emanated from three places -Washington, DC, California and New York. Moreover, when the Washington DC news was excluded, there were substantial regional variations with the northeast and Pacific states over-covered and the Midwest and Southwest substantially under-covered, and an interesting 'eclipse' effect, whereby over-coverage of a single state in a region generally meant under-coverage of other states in the region. The major point, however, is that the bulk of domestic news originated from very few places, primarily Washington, DC.

In a later study, following a similar design, Whitney *et al* (1989) found a decline by more than half in news emanating from Washington DC, and a tripling of news from no single domestic location. The authors suspect that this trend may have represented a deliberate attempt on the part of the television networks to broaden the definition of news and widen its appeal to a demographically diverse audience.

(b) Semantic and discourse bias. There has been much interest in the differential use of language as an indicator of underlying meaning, direction or ideology (and thus of bias). It is assumed that evaluative direction is always implicit in the choice of words and phrases in any kind of text, and that such direction is open to decoding (see Lasswell, Lerner and de Sola Pool, 1952; Osgood, Tannenbaum and Suci, 1957; Graber, 1976; Edelman, 1977; Porter, 1983; Geis, 1987; van Dijk, 1991).

Analysis of language use can be applied to reveal the precise nature of intended 'bias' or partisanship or to uncover unintended direction or 'slant'. Methods of analysis are varied, but all share an assumption that any culture organizes

meaning and allocates values, by means of symbols, in a consistent way so that what counts as positive or negative can be readily deciphered by those who share the culture (the relevant language or 'interpretative' community).

A simple method adopted by the Glasgow University Media Group (1985) in their study of television coverage of the Falklands War involved making an inventory of the words used in television news to report the sinking of an Argentine cruiser, the Belgrano and the loss of the British destroyer, the Sheffield. They found that, in the former case, the word 'killed' or 'killing' only appeared once in 249 separate statements in the news (implicitly modifying the gravity of what was a controversial action). In the Sheffield case, a much 'harder' terminology was used to refer to the Argentine deed, with much more frequent use of death and 'killing' word equivalents. A somewhat similar analysis was applied by van Dijk (1991) to reports of racial disturbances in Britain.

More systematic and elaborate methods have been based on Osgood and colleagues' (1957) work on the evaluative structure of texts and language usage. This approach depends on having some independent empirical evidence of the evaluative direction and intensity of commonly used terms, as these are usually interpreted by users of the language. The method of 'evaluative assertion analysis' (see Holst, 1969) was developed to measure evaluative direction and intensity of meaning in texts (see van Cuilenburg, de Ridder and Kleinnijenhuis, 1986).

In order to apply the method, texts are divided into units of analysis ('nuclear' sentences) and three main verbal elements are identified: attitude objects (references to persons, things, etc, which are objects of evaluation); words (usually adjectival and adverbial) referred to as having 'common meaning' – those whose evaluative direction (and relative intensity) will be widely understood in the language community (e.g., 'evil' and 'unreliable' are both negative in direction, but the former more so than the latter); and 'connectors' – language parts which supply the linkages between attitude objects and common meaning terms, thus establishing calculable patterns of evaluative direction.

Complete texts can be rendered in terms of directional scores for any attitude object referred to and also for the whole complex of evaluative relations between attitude objects. This step reveals 'networks' of attraction and dislike (see Westley and Higsbie, 1963; Lynch and Effendi, 1964; Holsti, 1969; Kanno, 1972).

(c) Frames of meaning. Some research approaches have attempted to analyze news reports according to large evaluative frameworks. This type of analysis includes consideration of ideology, narrative forms and the nature of news discourse (van Dijk, 1983, 1991). It may also involve an analysis of the conventions and practices of news organizations (Bell, 1991). A number of writers have argued that news is 'packaged' in standardized formats each with typical 'codes' for presentation which tell the receiver how to 'read' stories (Glasgow Media Group, 1976; Altheide, 1985; Altheide and Snow, 1979).

There are many variants of method for recognizing such structuring devices, but they all share the assumption that meaning and evaluative direction are likely to be differentially influenced by the wider context (of other information and opinion) in which event reports are placed, however factual, or balanced the event report itself. However, some theorists would put more emphasis on the possibilities of differential decoding and on the chance to apply an 'opposition' reading (Hartley, 1982). In other words, while a ready-made interpretation (a preferred meaning') may be 'offered', the offer may well be declined if it fails to match the situation and disposition of the receiver.

There are numerous examples of the shaping of news within larger frames of interpretation. Halloran, Elliott and Murdoch (1970) showed that news of an anti-Vietnam War demonstration in London in 1968 was shaped in actual reporting by advance definitions of the event as violent, confrontational and involving foreign 'agitators'. The news accounts were 'pre-structured' by certain 'news angles' which derived more from the culture of the news media and the climate of the times than from the specific reality of the event.

Both Hartman and Husband (1974) and van Dijk (1991) analyzed reporting of race relations in terms of dominant news themes which tended to define the very presence of immigrants as problematic for the host society. McQuail (1977) used a thematic classification of various categories of news (international; social welfare; industrial relations) in order to assess evaluative tendencies in content. Gifford (1989) analyzed coverage of the withdrawal from UNESCO in terms of 189 themes, ultimately reduced to three categories: pro-UNESCO; anti-UNESCO; and future-orientated. The approach sometimes drew on the notion of a news 'angle' or 'peg' which was likely to influence selection and shape treatment (Roshco, 1975). It was linked to the wider questions of news values and relevance.

Much critical theory and research on news sees news practice as inescapably ideological and tendentious, with balance itself serving only to emphasize what has by some writers been termed a 'preferred reading', or an interpretation preferred by the sources (usually favourable to the established social order). If balance in the news is the balance of the 'powers that be' then it is likely to have a conservative tendency, however unintended. The essence of the case is that news (and objectivity) ultimately rests on an assumed consensus (the sociocentrism mentioned by Hetherington, 1985) about the legitimacy of the established order and about national and institutional interests.

Meanings can be framed in subtle ways according to the reporting style adopted by news anchors and correspondents. In early observations on this issue, Lasswell and Leites (1949) distinguished between the communicator's style that sets a clear example for an audience to follow (called 'effect modelling') and one that sets the speaker apart from the audience, thus doing things audience members would not or in ways they would not follow ('effect-contrasting'). For instance, a news anchor's manner in reporting may arouse assurance or fear, thus inviting effect-modelling. By contrast, an anchor who is aloof and

indifferent in reporting the same event may provide a sense of detachment the audience cannot feel, a case of effect-contrasting.

Elsewhere, reporting styles have been differentiated on the basis of message clarity. Clear messages employ simplified language, simple visuals, and repetition, while ambiguous messages cloud intended meanings in vague images and metaphors (Gordon, 1969). The stylistic distinctions of reporter manner and message clarity offer a fourfold classification of news presentation according to which frames of meaning can be defined (Nimmo and Combs, 1981):

1 Effect modelling with ambiguous content wherein broadcasters are involved emotionally with their audience emphasizing emotion-laden cues over concrete information content.

2 Effect modelling and clear content, yielding a sense of audience involvement in the reporter's presentation yet providing informational rather than emotional cues.

3 Effect contrasting and clear content, with broadcasters detached and removed in manner and emphasizing specific information in reports.

4 Effect contrasting and ambiguity that combines reportorial detachment with no clear emotional cues and confusing or even conflicting information.

Independent, external source criteria

According to some writers, external source criteria can be applied to assess standards of balance in news reports. Such independent criteria may derive from the original documentary sources used by journalists themselves such as press releases, published reports, proceedings of meetings, and other official literature. Another possible source of external validation for news reports is the testimony of 'experts'. Comparisons can be made between news reports and the prevailing knowledge and opinion of the expert community within a particular domain, for example, science or medicine (see Lichter and Rothman, 1986).

Neutral presentation

The assessment of balance involves aspects of presentation including the prominence given to certain issues over others as influenced by placement in the programme or use of visual format features. Production features can also be examined in relation to the neutrality of news broadcasting. Neutrality can be affected by the use of language and by the way news is visually presented.

Where the use of language is concerned, neutrality may disappear if news stories are told in such a way as to over-dramatise or sensationalise what actually happened. There have been attempts to measure sensationalism in the news (Tannenbaum and Lynch, 1960, 1962; Lynch, 1968). Essentially, sensationalism amounts to high levels of personalization of stories, playing on the audience's emotions, and use of dramatic language. It can be further generated through production techniques such as liberal use of film material and mood music.

Content features and neutrality

The Glasgow University Media Group analyzed the output of British television news over a six-month period in the mid-1970s in order to assess its neutrality. Their view was that the news is not neutral, but a manufactured product whose design is shaped by a dominant ideology which governs the way news events are framed and presented to the public (Glasgow University Media Group, 1976, 1980). They argued, at the time of their study, that television journalists presented events and issues in terms favourable to the British establishment. Wage claims were presented as the cause of inflation; strikes as the cause of Britain's economic crisis; and workers as the cause of strikes. Television news was regarded as being biased towards industry's owners and biased against the workforce.

The Glasgow group conducted a content analysis of a large number of television news broadcasts to illustrate the agenda-setting function of television. They claimed to demonstrate through this analysis, that the bulletins of competing television services did not really compete as to the stories they were reporting, or the style in which they reported them. They showed a predictability in the ordering of news items and the use of a fairly limited range of presentational forms. Particular regularities were registered in the area of industrial reporting, which led to a consistent failure to cover the area thoroughly. Certain major factors in industrial life (e.g., industrial accidents) were under-reported, whilst others, such as worker-management disputes and strikes, were reported unsystematically.

The Glasgow University Media Group's (1980) analysis further showed that inferential and interpretive frames were used by news editors which reported strikes in such a way as to suggest that they were caused primarily by workers, with management being clearly placed in the role of the good guys. There was a failure on the part of broadcasters to explain these events fully and fairly. The so-called 'bias against understanding' in television's reporting of economic issues had already been noted by two of the television industry's own professional programme makers (Jay and Birt, 1975a).

The Glasgow analysis examined television news coverage not just in terms of story-type selection, and the way stories were packaged within programmes, but also in terms of more subtle features such as the linguistic frames deployed predominantly to interpret industrial events. The results of this analysis were interpreted to show that the dominant mode of interpretation of such events by television news editors appeared to be based mainly on current Treasury policy. This meant that as far as the news was concerned wages were the prime source of inflation and wage demands were the main cause of the economic crisis. This frame was found to characterize a wide range of stories.

> The public thereby was never presented as part of media institutions' interpretation of these events, with the possibility that other causes than wages and other solutions than the moderation of wage demands could relate to the crisis (Glasgow University Media Group, 1980, pp. 400-401).

One aspect of this distorted interpretation of events included 'a systematic partiality in the reporting and interpretative use of government statistics' (p. 401).

Focusing on the language of television news bulletins, the Glasgow group found that in the area of industrial reporting there was a general impression projected that industrial disputes spelled 'trouble'. More specifically, this meant trouble for managers of industry, trouble for ordinary people, and trouble for the country as a whole. A detailed analysis of the vocabulary used in reporting industrial disputes on television news, revealed a different lexicon being deployed in respect of actions by managers and actions by workers. The latter were generally described in more negative terms than the former. This was not necessarily manifest in the open usage of provocative, emotive language, but tended to be more subtle, being implemented through the repetitive use of a fairly restricted stock of descriptive terms. Differences were also found in relation to the way different categories of people were presented in news bulletins. A person's status was linked to the kind of presentational treatment they received. Managers were mostly interviewed in calm office surroundings, while workers tended to be approached at sites of confrontation or dispute, where the setting was more noisy and chaotic (Glasgow University Media Group, 1980). Although conceding that a content analysis methodology merely serves to describe television news output, the Glasgow University Media Group suggested that the repetitive and stereotyped content and presentational characteristics of news broadcasts which they had identified could have important implications for the understanding and impressions held about particular issues by the viewing public. The primary message of this research was that there was evidence, albeit of a purely descriptive nature, that television news systematically distorted events and issues through the production treatments it customarily accorded them.

Critics of this work argued that this analysis had not proved bias in the news at all, but merely that academic sociologists did not hold the same views about how the media should treat particular issues as did media professionals (Anderson and Sharrock, 1979). Critics from within the social sciences challenged not the methods but the conclusions of the Glasgow group, in some instances as being overly simplistic. Elsewhere, scholars have argued that television news often provides a diverse array of reflections on and accounts of contemporary issues (Hartley, 1982).

In the context of television's coverage of terrorism, Schlesinger, Murdock and Elliott (1983) noted that television provides diverse accounts of terrorism and the problems it poses for liberal democracies. News and current affairs on television did not all approach this topic in the same way, and some were observed to be more narrowly focused than others. Some were found to concentrate on the dominant official perspective on events to the exclusion of all other accounts. This was more often typical of the nightly news bulletins. In contrast, documentaries and current affairs programmes might examine events in more detail, exploring their root causes and providing an opportunity for different sides to a story to emerge.

The Glasgow University Media Group regarded television news as driven by the dominant classes. Later writers on this subject emphasized a different view according to which television provided space for representatives of different points of view to offer their diverse opinions about and explanations of events (Schlesinger *et al*, 1983). These different viewpoints compete for attention and the space to air their opinions. In no way could it be fairly argued that television is monopolised by any single group (Hartley, 1982).

McNair (1988) observed a similar pattern in the coverage given by television to the concept of a Soviet military threat. News programmes consistently reproduced a critical framing of this issue, whereas some current affairs and lengthier news programmes (such as *Channel Four News* and BBC2' *Newsnight*) presented more extended and detailed accounts, yielding the space to examine the issue from a number of different perspectives.

Presentation format and neutrality

On television, news is more than simply what is said in the words of the narrative. A significant aspect of television news production relates to how pictures are used. Indeed, a significant amount of information can be conveyed by pictures, moving or still, setting the news item in context and rendering, in the case of film, the audience as 'eyewitnesses' of news events as they happen.

The extent to which pictures actually add to the information value of the news has been hotly debated over many years. There is evidence, for example, that pictures may produce better audience recall of brief news headlines (Gunter, 1979, 1980a). At the same time, though, they may interfere with more detailed recall of news information where they fail to offer direct support for the narrative content of the news (Gunter, 1980b; Berry, 1983; Edwardson, Grooms and Proudlove, 1981). Even the use of graphics may impede recall of news story details unless the information contained in the news reporter's verbal report and the details contained in the graphic illustration are largely redundant (Edwardson, Kent, Engstrom and Hofmann, 1992). Although the much plainer talking head formats have been found to produce better audience recall of news narratives compared with news stories in which film footage has been presented, even this format can create problems for audiences where presenters engage in extensive chat with each other. According to some writers, this 'happy-talk' news format may reduce the information quality of a news broadcast (Dominick, Wurtzel and Lometti, 1975).

The difficulty for news broadcasters is that in an ever more competitive television environment, they are under increasing pressure to utilise entertainment-oriented techniques to attract and maintain the interest of audiences. While production formats which focus on the presentation of hard information without the other embellishments may appeal to those audience segments among whom interest in the news is already at a high level, for general audiences, where intrinsic motivation to watch hard news formats is lacking, other techniques are necessary.

73

It is generally recognised that when assessing television news in terms of its presentational bias, it is essential to examine the use of pictures, sound effects, captions, logos, and the positioning and packaging of news items. Some researchers have tried to describe in some detail the extent to which news presentation on television adopts certain stereotyped patterns (Glasgow Media Group, 1976, 1980, 1985). There has so far been no consistent approach to appraising the syntax of television news presentation (Frank, 1973; Adams, 1978). Focus on the use of pictures in the news, for example, has indicated that they frequently fail to convey or represent in any direct sense the details being reported in the verbal narrative. Often, visuals in the news contribute only ambiguity rather than clarity of meaning (Davis and Walton, 1983).

Television news style has been analyzed in detail on only a few occasions. One study distinguished four journalistic styles of television news: 'popular/sensational'; the 'elitist/factual'; the 'ignorant/didactic' (treating the audience as ignorant); and the 'pluralist' (treating the audience as very diverse) (Nimmo and Combs, 1985).

Attention has focused elsewhere on camera angles, timing, distance and shot framing as devices for conveying meaning (Tiemens, 1970; Frank, 1973; Mandell and Shaw, 1973; Zettl, 1973; Tuchman, 1978; Kepplinger, 1983). These production factors have been found to affect audience impressions of a performer on screen. Learning effects have been observed too. Viewers' retention of visual images can be affected by their position on screen. Viewers shown single-frame shots of a newsreader with still visuals placed either on the left side or right side of the screen, remembered the visuals better from the left visual field (Metallinos, 1980).

Visual biases. Kepplinger (1983) explored visual biases in television coverage of an election campaign in Germany between Kohl and Schmidt. Two sources of evidence were obtained: (1) the views of cameramen about the use of different camera shots to give a particular impression; and (2) a content analysis of television coverage which analyzed visual and verbal content, focusing on camera angles and the depictions of positive or negative audience reactions to the two candidates at public speeches and any verbal statements made by journalists on these reactions.

The cameramen indicated that a camera position held at eye level is preferred to achieve positive effects, while a full top or bottom view is mainly used to produce a negative effect. The only exception was the use of a full bottom view to create the impression of 'power'.

Reactions of the public showing approval of a candidate were categorized into six types:

1 acoustic (audible), nonverbal approval (clapping and other forms of applause).

2 acoustic (audible) verbal approval (cheers, approving statements).

3 visual (optical) approval (gestures, symbols, banners).

4 successful interaction between candidate and audience (conversations, hand shaking, gestures to which the audience responds in a friendly manner).

5 attention, interest among the audience (eager posture, conscious turning toward the candidate).

6 consent in the audience (gestures and statements expressing consent).

Six further categories of audience disapproval were used:

1 acoustic (audible), nonverbal disapproval (whistling, hissing, booing).

2 acoustic (audible) verbal disapproval (calls, disapproving statements).

3 visual (optical) disapproval (gestures, symbols, banners).

4 missing, failed interactions (attempt to converse with no response or unfriendly response, waving and other gestures with no or unfriendly response).

5 inattention, lack of interest in the audience (turning away from the candidate, conversations in the audience, disparaging gestures).

6 conflict in the audience (gestures and statements expressing differences of opinions).

The content analysis of the 1976 election campaign coverage on television revealed that Kohl was more frequently given a negative image on screen than Schmidt. Kohl was more frequently shot from perspectives that a majority of cameramen said they would use if they wanted to bring out the excitement, antipathy, tenseness, weakness, emptiness, or clumsiness of the candidate rather than rest, sympathy, ease, power, liveliness or skill.

Further, negative reactions of the public – acoustic verbal and nonverbal disapproval, visual disapproval, missing or failed interactions, inattention, or lack of interest in the audience and conflict in the audience, were displayed more often with Kohl than with Schmidt. There were no differences in verbal statements of journalists drawing attention to public reaction for each candidate. Hence, journalists were apparently striving to give a balanced presentation. Unfortunately, the visual presentation features indicated that television's coverage was biased.

Neutrality in News Interviews

News interviews represent a central aspect of the role played by broadcasting in the political communication process. They present opportunities for questions to asked about important issues of public concern in a public forum in which key decision-makers, political figures, business leaders and experts, can be probed for their opinions, plans or intentions relating to those issues. News interviews, in practice, involve a form of conversation among individuals to whom pre-designated roles are allocated. News interviews also follow certain rules and conventions which are designed to ensure that they achieve particular objectives on behalf of the audience watching them on their television sets at home. One key feature of news interviews is that they involve the use

of 'turn-taking' system which specifies that interviewees should confine themselves to answering interviewers' questions. One consequence of this simple form of turn-type pre-allocation is that news interviewers are effectively afforded sole rights to manage the organization of topics. In so far as they restrict themselves to answering, interviewees are limited to dealing with topical agendas which interviewers' questions establish for their turns and, as such, in contrast to interviewers, are not able to shift from one topic or topical line to another.

The way in which news interviews are conducted can have important implications for the degree of neutrality they achieve. Given that much of the power in regard to how they proceed rests with the interviewer, there may be opportunities for bias to creep in favouring one party to a conflict or one side to an argument even though there is rigid adherence to stopwatch criteria of balance. But how are interviews to be evaluated? Are there particular measures that can be applied to yield an objective assessment of the way interviews are conducted? More especially, are there criteria for the analysis of interview formats which can be applied to distinguish whether an interviewer has been fair or unfair to an interviewee or exhibited a more favourable disposition to one interviewee than another in a multi-interviewee interview? This section will address these questions and examine theory and research which has attempted to explain how interviews are conducted and, through such analysis, exposed ways in which bias may enter the frame.

News interview formats have not adopted a constant style or format over the years. Up until the mid-1950s, during which time the BBC operated as a monopoly in British broadcasting, this aspect of the news interview turn-taking system's operation was of little significance. Interviewees were largely able either to prearrange their interviews or else, in the context of impromptu interviewing, to shift away from, refuse to address or even ignore with impunity the topical agendas which interviewers' questions established for their turns.

The situation changed radically, however, in the latter half of the 1950s when, due to a large extent to the impact of the introduction of commercial television, newer investigative (and unrehearsed) modes of interviewing rapidly replaced the older deferential styles. Since that time, interviewers have sought to hold interviewees on a much tighter rein than was the case during the years of the BBC's monopoly and in so doing have shown a willingness both to press for answers to their questions and to resist attempts at subverting their rights in the management of a topic. In other words, whereas the deferential interviewers of the monopoly years customarily permitted interviewees a free hand not only to decline to answer their questions, but also to break the standard news interview format in order to accomplish topical shifts, the interviewers of the past 30 years, in adopting a more investigative posture, have displayed a willingness to resist, sanction, and thus draw attention to the accountability of such manoeuvres.

Key Characteristics of News Interviews

One theoretical framework which has been invoked to explain the speech protocols of news interviews is *conversation analysis*. According to conversation theory, news interviews exhibit a characteristic pattern of turn taking which is highly distinctive. The interviewer is expected to ask the questions and the interviewee is expected to respond to those questions (Clayman, 1989; Greatbatch, 1988; Heritage, Clayman and Zimmerman, 1988). According to Greatbatch (1988), interviewers and interviewees manage the interaction through the production of utterances that are 'at least minimally recognisable as questions and answers respectively'. Even when interviewers depart from the question and answer format, for example, by making a statement, they will typically follow the statement with a question or conclude it with a tag in the form of 'isn't it?' or 'wasn't it?' The question and answer format has been identified by some writers as the defining feature of the news interview (Schegloff, 1989), although there is also some recognition that interviewers may engage in other kinds of speech than simply asking questions, such as introducing the interview and then closing it (Heritage and Greatbatch, 1991).

While interviewers retain much of the control over the news interview situation, there are ways in which interviewees can subvert the normal question-answer format to steer the occasion to their own advantage. Greatbatch (1986) identified a number of strategies interviewees can deploy to shift the interview agenda.

One procedure which can be used by interviewees in endeavouring to exercise some control over the topical development of the news interview involves them in producing violative talk prior to answering an interviewer's question. Through a procedure which Greatbatch calls pre-answer agenda shifting an interviewee may create an opportunity to talk about an issue which falls outside the domain of relevance established by an interviewer's question. A second procedure is to engage in producing comments of a similar kind to the above, but after rather than before the production of an answer to a question asked by the interviewer. Thus, the interviewee answers the question put to them, but utilises their 'turn' to go on and make further statements which may depart from the theme or thrust of the original question.

Interviewees may also seek to exert some control over the topical focus of their remarks by ignoring the precise topic agenda established through a prior question, and by instead launching into an alternative line of discussion. In so doing, the interviewee may implicitly deny the relevance of the topic agenda being framed by the interviewer. In the context of multi-interviewee interviews, interviewees sometimes seek to influence the development of the discussion by speaking out of turn. They enjoin the remarks of another interviewee, responding to a direct question directed specifically at them, and create an opportunity to make their own points.

The use of these tactics can sometimes change the whole direction of the interview. Greatbatch (1986) observed that when an interviewee used a

post-answer agenda shift, the interviewer subsequently picked up on the new direction or new topic and focused upon that rather than returning to the question originally posed. On other occasions, an interviewer may return to the original question and sanction the interviewee for failing to address his answer to it.

The use of pre- and post-answer agenda shifting, however, tended to be sanctioned by interviewers far less often than other tactics for changing the subject to one which the interviewee would prefer to talk about. This may be the case because such agenda shifting arises out of or occurs along with apparent attempts to answer the original question. Interviewers may take a more critical line with interviewees who simply fail to produce an adequate answer or who completely ignore the question being put to them. Speaking out of turn also violates a central rule of conduct in interviews and is likely to be penalized.

To confirm the patterns of turn-taking which characterize news interview in British broadcasting, Greatbatch (1988) analyzed a selection of interviews broadcast between 1978 and 1983 by major British television and radio networks. These interviews included two-party, multi-interviewer and multi-interviewee interactions, and the interviewees ranged from public figures with some experience of news interviews to people appearing on air for the first time.

The news interview essentially constitutes a context in which a broadcast journalist seeks to elicit information from one or more newsmakers, experts, or eyewitnesses for the benefit of a radio or television audience. In Britain, this is reflected in the use of a system of turn-taking that differs from the one employed for mundane conversation in that it pre-allocates particular types of speaking turn to speakers with specific institutional identities. These constraints on the production of types of turns operate with respect to the institutional identities interviewer (IR) and interviewee (IE) and specify that the incumbents of these roles should confine themselves to asking questions and providing answers, respectively.

This simple form of turn-type pre-allocation has a number of important ramifications for the organization of news interviews. First, interviewers and interviewees systematically confine themselves to producing turns that are at least minimally recognisable as questions and answers, respectively. Even so, interviewers and interviewees do not invariably restrict themselves to a question-and-answer format. For instance, in interviews with politicians and other public figures, interviewers often challenge, probe and cast doubt upon things interviewees say, while interviewees are then drawn into responses designed to counter and resist such attacks (Greatbatch, 1985, 1986; Heritage, 1985b)

Second, interviewers systematically withhold a range of responses that are routinely produced by questioners in mundane conversation. In ordinary conversation, if somebody answers another's question, the other individual may reply by saying 'oh' indicating some kind of acknowledgement of receipt of

the answer given (Heritage, 1984). This sort of response is not generally found in news interviews. Once an answer has been given to a question, the interviewer will typically proceed immediately with the next question.

Third, Interviewers will generally restrict themselves to asking questions. Sometimes, though, they will issue statements of fact, but these are generally a prelude to a question dealing with the same topic. Thus, there is no radical departure from the question asking role of the interviewer. On those occasions when interviewers produce statements prior to asking questions, interviewees customarily restrict themselves to their designated role in answering questions, once they have been put to them. They will tend not to react to initial statements and will even refrain from the use of responses such as 'oh' or 'uh huh' in contrast to the way speakers would normally interact in ordinary conversation (Schegloff, 1982).

In ordinary conversation, the turns taken by two speakers will usually be determined by the flow of the conversation. One speaker will select when the other speaker can take a turn in saying something, and then the second speaker will allow the first speaker or a third speaker an opportunity to say something else. However, in news interviews, turn-taking does not operate in the same way and not all speakers will have equal access to the use of these techniques. By specifying that interviewees should confine themselves to responding to interviewers' questions, it largely restricts the management of turn allocation to the interviewer. This is the result of three general differences between questions and answers with respect to the use of turn allocation procedures. First of all, by virtue of the fact that they project and require the occurrence of answers, questions can be used to select the next speaker. Hence, by addressing a question to a specific party, a current speaker selects that party to produce an answer and so to speak next. Second, answers, by contrast, cannot be used to allocate a next turn. Thus, if recipients of questions confine themselves to answering, next turns are left to be allocated through self-selection. Third, speakers may self-select in order to produce a question without some other activity having had to have been done first by a co-participant. However, they can only self-select in order to produce an answer if a co-participant has first produced a question and done so without selecting a specific party to answer it.

A fifth point about news interviews is that they are generally opened by interviewers. Given the standard question-and-answer format, this arrangement must be so. The interviewer therefore gets the first turn. A further point is that news interviews are customarily closed by interviewers. While ordinary conversation may allow for any speaker to end a discussion, in news interviews, this role falls to the interviewer.

Finally, departures from the standard question-and-answer format may occur. Interviewee initiated departures fall into two broad categories. In the first of these, the interviewee declines to answer a question or shifts to a different agenda. In the second case, the interviewee speaks out of turn. Even when departing from the standard format, the interviewee usually subsequently

returns to it in that he or she will produce talk that will leave the interviewer free to ask further questions. Thus, departures from the standard format do not in general result in a complete breakdown of the interview. A more dramatic form of departure from the norm is when an interviewee rounds on an interviewer and asks a question of the interviewer, thus instigating a role reversal.

Despite the changes in certain aspects of news interview styles and formats over the years, Greatbatch (1988) noted that the news interview turn-taking system had remained unchanged since the earliest days of broadcasting in the United Kingdom. Two reasons were suggested for this. First, as presently constituted, the news interview turn-taking system places constraints on interviewers' turns that provide for interviewers maintaining the stance of formal neutrality which has been legally required of broadcast journalists since the inception of the BBC in the 1920s. Thus, by specifying that interviewers should manage whatever activities they undertake in and through turns that are at least minimally recognisable as questions, the current system does not allow for an interviewer proposing any overt commitment to the truth or adequacy of an interviewee's answers via the production of, for example, straightforward challenges, assessments, news receipts, or newsmarks. Rather, it provides for an interviewer taking up and sustaining the footing of an impartial questioner. This explains in part why interviewers tend to depart from the standard format rarely. If they did, they would be running the risk of undermining their legally required posture of formal neutrality.

The second reason for confining news interviews to a straight question-and-answer format is that it suppresses the 'oh's' and 'mmms' characteristic of ordinary conversation which may render the interview less clear cut and understandable, as well as tolerable for audiences. According to Heritage (1985a) the avoidance of such actions is a central means through which questioners in institutional contexts can 'decline the role of report recipient while maintaining the role of report elicitor', so as to permit an overhearing audience to view itself not as eavesdroppers watching or listening to a putatively private interchange, but rather as 'the primary, if unaddressed, recipients of the talk that emerges.'

The role of interviewees

The role of the interviewee in a news interview is to answer the interviewer's questions. The way in which interviewees are treated by interviewers may therefore depend upon the extent to which they fulfil this designated role. There are, as noted above, some implicitly recognised rules of thumb regarding permissible departures from this role. Public suspicion about politicians can be aroused by the impression that they seem often not to give direct answers to questions put to them in news interviews. Studies of television news interviews has indicated that this impression is corroborated by a close analysis of the way senior political figures perform in this situation (Harris, 1991; Bull and Mayer, 1993).

One detailed study of news interviews has focused upon the extent to which politicians fail to reply to questions and on the different ways in which they do this (Bull and Mayer, 1988, 1993). This research studied eight televised interviews from the 1987 General Election campaign with Margaret Thatcher (Conservative Prime Minister, 1979-1990) and with Neil Kinnock (Leader of the Labour opposition, 1983-1992). Questions from the interviewers were identified, and the responses from the politicians were coded as replies (if the information requested is given), as answers by implication (in that the politician makes his or her views clear without explicitly stating what those views are), or as what the researchers called 'non-replies' (in that either only a part or none of the information is given). The term non-reply was coined in preference to the more pejorative term evasion because in certain circumstances it was judged that it may have been perfectly reasonable for a politician not to reply to a question, if, for example, the question was ill-informed, unreasonable, or based on a false or highly contentious presupposition. Bull and Mayer (1993) distinguished 30 different ways of not replying to a question and found that Thatcher replied to only 37 per cent and Kinnock to only 39 per cent of interviewer questions.

There has been considerable debate on the reasons for equivocation. One explanation of politicians' apparent reticence is that they are frequently placed in what psychologists have termed 'avoidance-avoidance' conflicts in news interviews, where all of the possible replies to a question may have negative outcomes for them but in which a reply of some sort is nevertheless expected (Bavelas, Black, Bryson and Mullett, 1988; Bavelas, Black, Chovil and Mullett, 1990). There are many controversial issues on which there is a divided electorate. Hence politicians often seek to avoid direct replies supporting or criticising either position, in turn running the risk of alienating a section of the electorate. The political interview can therefore create pressures towards equivocation.

The nature of interviewers' questions

A thorough and systematic investigation of the kinds of pressures politicians may be placed under in news interviews requires a classification of question-types and an analysis of how often each type occurs. According to the rules of syntax, questions are utterances which take an interrogative form. This definition alone does not take us very far. Questions can have different functional uses and may use subtly different techniques for eliciting responses from interviewees. Requests for information can be elicited through declarative statements with a rising inflection at the end (e.g., You have spoken to the scientific advisory committee about the possibility of a link between eating beef and the human form of BSE, of course?'). The interrogative style of question can itself take on different forms. There are questions which require a yes-no type of response, open-ended questions which might invite a range of responses, and wh-questions which begin with what, when, why, who, how and which (Quirk, Greenbaum, Leech and Svartvik, 1985). In addition, to interrogative and declarative questions, two other categories have been found

useful in analyzing news interview styles: indirect questions and 'mood-less' questions. With indirect questions, the interviewer may infer the question he/she is getting at by quoting a statement made by someone else on an issue which is used as a lever to elicit an opinion from the interviewee (Bull, 1994). 'Mood-less' questions do not have a finite verb but follow on from an earlier question to which a reply was given (Jucker, 1986).

In an analysis of 33 television political interviews taken from the General Elections of 1987 and 1992, and also from television interviews that John Major, the British Prime Minister, gave in 1990 and 1991, Bull (1994) reported that the most commonly occurring form of question was the interrogative yes-no question. Over half the questions identified in these interviews (53.5 per cent) fell into this category. This was followed by the interrogative 'wh' question (23.2 per cent), the declarative question (18.0 per cent), with the 'mood-less' (2.4 per cent) and indirect types of question (0.8 per cent) being rare. Among the 'wh' types of questions, news interviewers were most likely to ask the prime minister 'what?' (8.9 per cent) and 'why?' (8.8 per cent) questions.

From the perspective of assessing the neutrality of television interviews with politicians, important insights might be gained from examining any subtle differences in the way an interviewer treats or responds to different political figures. A variety of different question and answer styles have been identified already in this chapter. With regard to the role played by interviewers, who control the interview, one important aspect of interview style which may have a bearing on neutrality is the extent to which they interrupt a politician during the interview. Any evidence that a political figure from one party is interrupted more than one from a different party could indicate that the interviewer failed to behave in a political impartial fashion through interrupting the smooth flow of an interviewee's answers disproportionately across representatives of different parties.

Research published in the early 1980s, for example, reported that Britain's Prime Minister at that time, Margaret Thatcher, was often interrupted in television interviews. The reason given for this was not located within any suggestion of political bias on the part of interviewers, but was the result of Thatcher's own speech style when answering questions, which tended to give misleading cues as to when she had actually finished speaking. The interviewer, assuming that she had finished speaking, would begin a further question only to find out that she had not yet completed her answer to the previous question (Beattie, 1982; Beattie, Cutler and Pearson, 1982). This work has since been challenged as having flaws (Bull and Mayer, 1988). It was based on a single interview of Thatcher with Denis Tuohy. Although a comparison was made between this interview and another between James Callaghan and Llew Gardner, there was a confound between the distinctive interviewee styles of Thatcher and Callaghan and the different interview styles of Tuohy and Gardner. Although Thatcher was interrupted more times than Callaghan in their respective interviews, this research should have controlled for the

amount of time both spoke while on screen. It is important to know not how many interruptions there may have been in total, but whether the rate of interruptions per unit of time on screen was different (Rogers and Jones, 1975; Roger and Schumacher, 1983).

Bull and Mayer (1988) studied four different interviewers who each interviewed Margaret Thatcher and Neil Kinnock (Leader of the Opposition) during the 1987 General Election. These interviews were video recorded and coded in terms of numbers of interruptions made by the interviewers in respect of these two political leaders and the rate at which the interviewees themselves interrupted the interviewer. It was found that Margaret Thatcher was interrupted at a slower rate than Neil Kinnock and tended to interrupt at a slightly quicker rate. None of these differences, however, achieved statistical significance. There was little evidence to suggest that the rate of interruptions of Margaret Thatcher were due to a lack of clarity concerning when she had finished speaking while answering questions. There was no marked difference between her and Kinnock in that respect. Where there was a difference between the two politicians was in the extent to which Margaret Thatcher explicitly protested at being interrupted. Thatcher was more likely than Kinnock to remark about being interrupted, even though neither one of them was in fact any more likely than the other actually to be interrupted. The impression therefore that she was badly treated in news interviews was compounded by her tendency to personalise issues, to take questions and criticisms as accusations and frequently to address interviewers formally by title and surname. This set of tactics had the objective of wrong-footing the interviewer and may have left viewers with an impression that she was being unfairly treated. The objective assessment of interruption rates tells a different story.

From Output to Audiences

A number of key indicators of bias in broadcast news have been identified which broadly divided into what have been termed 'cognitive' and 'evaluative' aspects of informational content. The cognitive aspects of news and other factual content of television refer to its *truthfulness* and *relevance*. The evaluative aspects refer to the degree of *balance* and *neutrality* in the news. The latter factors are regarded by some media researchers as the core components of 'impartiality' (e.g., Westerhahl, 1983). *Truthfulness*, which is defined in terms of the factualness, accuracy and completeness of news coverage, along with *relevance*, is concerned with the quality of information provision. In other words, does the audience learn all it needs to know in order to obtain a comprehensive understanding of what a particular story is about? When these factors are incomplete, distorted or fail to reach certain levels of achievement, they may also contribute towards 'bias' in the way news information is constructed and presented.

As we have seen in the chapters so far, the above performance criteria can be assessed through direct reference to news output itself and the processes underpinning the way that output was selected and presented. The decisions

taken by news professionals in regard to the selection of news items and their presentation and treatment in bulletins which determine the nature and form of the eventual news product, can be assessed as well. This type of analysis focuses upon the source(s) of broadcast news messages. There is, however, another angle from which bias in broadcast media can be examined – the perspective of the receiver, in this case the television audience. There is a range of subjective and objective indicators of audience-based assessment of bias. Subjective indicators include the personal opinions of audiences about the news product itself. Objective indicators comprise measures of the impact of the news product in terms of enhanced public awareness of issues and events, memory for the contents of news stories, and general knowledge and understanding of issues, events and people in the news.

In the chapters which follow, research evidence is discussed concerning a variety of subjective and objective indicators of bias in television news. These indicators are examined, in the first place, in relation to cognitive aspects of news bias, and secondly, in relation to evaluative aspects of bias.

PART THREE
THE AUDIENCE AND BIAS

Cognitive Aspects of Bias: Subjective Audience Perspectives

In assessing the quality of news coverage provided by television, one approach is to ask the audience. In this context it is relevant to place television alongside the other major mass media in order to see how it matches up. Research into why people watch television has repeatedly found that the public perceive it as a valuable source of information about what is happening in the world. Television news is trusted widely and is generally regarded as the first source of news about the world by more people than any other mass medium (Robinson and Levy, 1986; Gunter, Sancho-Aldridge and Winstone, 1994).

In the foregoing chapters, we saw that issues such as truthfulness, relevance, neutrality, and balance can be studied and assessed from a number of perspectives. While assessment of the output of television is one method, it was argued that it is also important to consider the perceptions of the audience about the way qualifying matters are covered and the impressions which viewers form of the nature of television's treatment of those matters. In the next two chapters we explore these elements of the quality of television news and factual coverage from the perspective of public opinion and understanding. Whether or not television is biased in particular aspects of its news coverage is an issue on which the subjective perceptions of audiences can be gathered. In addition, by examining the accuracy and balance of public awareness and understanding of news and current affairs topics covered by television, a more objective, audience-based assessment can be made of the quality and effectiveness of news communication.

Subjective versus Objective Audience Measures

Television is regarded as the primary news source by mass publics. This fact has been confirmed by public opinion surveys in a number of western industrialized countries (Gunter, 1987). This perception of television, however, should not be confused with actual information uptake or learning from this ubiquitous medium. While viewers will readily endorse the need for

information and learning as a primary motive for watching television (e.g., Rubin, 1984) and will equally readily endorse a variety of informational benefits from watching specific current affairs programmes (e.g., Levy, 1978), there is often a big difference between belief about informational benefits obtained from television and the extent to which members of the audience successfully learn from television or improve their understanding of public affairs as a result of watching (Gunter, 1987; Robinson and Levy, 1986).

Thus, in considering the quality of television coverage of events, issues and other aspects of public affairs, it is important to weigh in the balance the varying operational definitions of these concepts. Bias, for example, may be measured in terms of the allocation of coverage time to different points of view, or via the kinds of impressions or understanding about an issue that are imparted to audiences. It may be defined by an analysis of the style of treatment given to an issue, over and above the amount of coverage afforded, or by audience perceptions of treatment style. Bias may be defined by direct audience response to television coverage, or by measures of learning and shifts in opinion about issues being covered.

In this chapter, evidence is reviewed on subjective reactions audiences have to different aspects of television's factual coverage. The next chapter will review research findings from studies which have used objective measures of audience learning from television news. Both types of measurement have been utilised at various times as indicators of bias on television.

Television: The Primary News Source?

Before considering perceptions of specific elements of television news and current affairs coverage, it may be worth setting the scene by examining findings which relate to general perceptions about television as a medium, compared with other mass media. We can then begin to narrow the focus by examining the perceptions which viewers hold of television channels and of specific broadcasts.

Over the past 40 years, television has evolved as the major news medium. Public opinion surveys have tracked the esteem in which different mass media are held as sources of news information. In 1979, a Gallup poll found that only a minority of people in the United States felt confident about either television or newspapers. The question in this case, however, referred to television and not specifically to television news (Bogart, 1980).

Television news is seen as a highly credible information source and thus traditional distrust of overt political mass media messages may be reduced. The significance of television as an information source, even 30 years ago, was illustrated by the fact that while 87 per cent of Americans learned of Franklin D. Roosevelt's death by personal communication (Miller, 1945), only 50 per cent learned of John F. Kennedy's death in this way (Hill and Bonjean, 1964). Moreover, those who did learn of Kennedy's death through personal contacts immediately turned to the mass media for more complete information (Greenberg, 1964).

Later survey evidence from the United States further confirmed the high regard in which television is held by the public as a trustworthy information source. An Opinion Research Corporation poll in August 1972, conducted with a nationwide probability sample, found that 63 per cent of respondents felt television was most complete in its reporting, while only 19 per cent selected newspapers, seven per cent favoured magazines, and only five per cent chose radio. In the same survey, 53 per cent felt television was the most objective source of news, while newspapers ran a distant second with 15 per cent of the sample. The other sources of news lagged even further behind. The most startling results of this survey came when the question was asked: 'When you feel that TV political bias does exist, what direction do you feel it takes?'. One third of the respondents had no opinion, that is, they were apparently unable to discern enough bias in television news to be able to identify the direction that such bias was taking (Youman, 1972).

The longest running tracking survey on perceptions of news sources in the United States has been conducted by the Roper Organization. The key question in this survey asked people to say where they usually get most of their news about what's going on in the world today. Respondents were allowed to mention more than one medium. The first Roper survey in 1959 found that 57 per cent of Americans claimed that their main source of news was newspapers, 51 per cent mentioned television in this respect, and 34 per cent named radio (Roper, 1983). By the mid-1960's, however, television began to move ahead of newspapers and over the next 20 years, the gap continued to widen.

More recently, survey evidence has confirmed that the American public continue to rely heavily on television as their primary source of news, with other media trailing far behind (Stanley and Niemi, 1990). Television was identified as a main source by 65 per cent of a national US sample, compared to 42 per cent who mentioned newspapers in this regard, and much smaller proportions of the population naming radio (14 per cent), magazines (four per cent), or other people as sources of news (five per cent).

Similar surveys have been carried out in the United Kingdom. From 1975, nationally representative samples of British viewers who were interviewed for an annual survey sponsored by the Independent Broadcasting Authority, and latterly by the Independent Television Commission, were asked to name their major sources of news and from among these sources, to nominate one main source. Throughout the 20-plus years that this question has been asked, television has been acknowledged by proportionately more viewers than either newspapers or radio as their 'first source' of world news. The most recent surveys expanded this question and found that television was also identified as the primary source of news about Europe, the United Kingdom and their own region within the UK. Only on the most local front was television surpassed, and here newspapers were endorsed as the main news source, with television in second place (see Gunter and McLaughlin, 1992; Gunter and Winstone, 1993; Gunter, Sancho-Aldridge and Winstone, 1994) (see Table 5.1). Although regarded by most of the general public as their primary news

source, this does not necessarily mean that people in fact get most of their news from television.

Table 5.1 Primary Sources of Different Types of News

	Television	Radio	Newspapers	Magazines	Talking to People
World					
1994	72	10	15	*	1
1993	69	11	19	*	1
1992	71	10	17	*	–
1991	70	11	19	–	*
Europe					
1994	66	9	14	1	3
1993	71	9	12	1	3
1992	64	6	11	*	4
1991	71	6	9	–	2
Whole of UK					
1994	66	11	20	*	1
1993	68	12	17	*	1
1992	62	10	17	1	2
1991	67	7	17	*	1
Own Region					
1994	57	13	26	*	3
1993	59	13	24	1	3
1992	55	11	26	1	4
1991	54	12	26	*	5
Local Area					
1994	36	12	42	*	9
1993	34	12	41	*	11
1992	24	11	51	*	11
1991	25	13	48	1	11

Notes: 1.Don't knows excluded
 2.* Less than 0.5%
 3.Percentages based on 'first mentions' of each source
Source:Gunter, Sancho-Aldridge and Winstone, 1994

The findings reported in surveys such as those conducted by Roper in the United States and the commercial television regulator in the United Kingdom have not been universally accepted. As an indicator of the public's reliance on television as a news source, the veracity of answers to a Roper-type question has been challenged on the grounds that regardless of what people may think about television, it may not be the place from where they get most of their news (Robinson and Levy, 1986).

There has been growing evidence that television may be less useful than news-papers or word of mouth at conveying information to the public. Television

has inherent limitations as a news medium: (1) a television newscast has fewer words and ideas per news story than appear in a front page story in a quality newspaper; (2) attention to a newscast is often distracted and fragmented compared to attention when reading; (3) television newscasts provide little of the repetition of information, or redundancy, necessary for comprehension; (4) television viewers cannot 'turn back' to, or review, information they do not understand or that they need to know to understand subsequent information; (5) print news stories are more clearly delineated with headlines, columns and so on; and (6) television has more limited opportunity to review and develop an entire story.

Robinson and Davis (1990) reported results from regional and national surveys of the information gleaned by typical American news audiences from a typical week's exposure to various news media. By examining news people recollected over a seven-day period, it was possible to assess learning about established and continuing stories as well as breaking news. There was also an opportunity for studying the influence of interpersonal discussion of the news upon knowledge about current affairs. It also increased the likelihood that this period of news coverage would contain enough news to interest everyone, whereas a single bulletin or single day's news might have been of interest to only certain segments of the audience.

Among American audiences, the amount of televised news individuals reported watching was not a major contributor to levels of comprehension of the previous week's news coverage. Newspaper readership and conversations with other people about the news were much stronger predictors of how much people knew about current events. Indeed, Robinson and Davis (1990) found that not only was claimed amount of television news viewing largely unrelated to news comprehension, when these two variables were linked, it was in the 'wrong' direction – that is, those people who reportedly watched larger amounts of news had poorer news comprehension scores.

There is no question that people perceive that they obtain most of their contemporary news information from television. These perceptions, however, do not seem to match very well with more direct measures of what people actually learn from televised news coverage. Such findings should not be interpreted as demonstrating that public learning from television newscasts is nonexistent or, indeed, only marginal. Other research on the impact of a specific evening television newscast has shown that viewers may learn a considerable amount of what has been broadcast, and that they have learned what they know from an identifiable television news source rather than from some other news medium to which they have been exposed on the same day (Robinson and Levy, 1986). Moreover, other media researchers have noted specific news stories for which television may have been a primary information source (Graber, 1987; Patterson, 1980). These tend to be major events or incidents for which extensive eyewitness coverage was available, such as President Nixon's first visit to China or the Challenger space shuttle disaster. These stories may provide clues as to what people really mean when they say that

television is their main news source. In other words, it could be that television is the most significant news source for mass publics on those special occasions when an event commands almost complete public attention and people depend on television to make them eyewitnesses to history in the making.

It has been noted elsewhere that newspaper readership outstrips television news viewing in terms of the amount of time people spend with each news medium, Thus, contrary to what they themselves believe, people may actually spend more time reading newspapers each day than watching news on television (Tunstall, 1983). News reading may also be more attentive and concentrated than news viewing (Gunter, 1987). As a result, more information may be consumed from newspapers than from television news (Gunter, 1987, 1991). One caveat should be added to this last point, however, which is consistent with the big event hypothesis presented earlier. Television and newspapers may exhibit different capacities for effectively communicating different types or aspects of news coverage. Research in Britain which examined reported news consumption levels from television and newspapers among British media consumers, found that claimed newspaper reading was significantly linked to knowledge from the previous week's news about news issues and causes or explanations of news events, while claimed viewing of televised news coverage was significantly related to awareness of major personalities in the news (Gunter, 1985). The inherent features of news presentation style may 'bias' audience attention towards people in the news either instead of or at the expense of any focus among viewers upon factual issue-related information (see Findahl and Hoijer, 1976).

The public's perception does, nonetheless, underline the perceived salience of television as a news medium in respect of most kinds of news. There is little doubt that television is held in high regard. Quite apart from the fact that people endorse it more often than any other news medium as their main source of most kinds of news, there is a degree of trust placed in televised news that it not attached to other news media. This phenomenon has been observed in different parts of the world.

Subjective Indicators

Factualness Attributes of TV News

One important aspect of the quality of news provision on television, in terms of the absence of any significant biasing features, is its factualness. This means that the news is presented accurately, completely and comprehensively and strives to impart information concerning the truth of a matter as honestly and straightforwardly as possible. One measure of the extent to which this objective is perceived to be achieved by broadcast news on television derives from public opinion. While viewers' perceptions of news content and presentation may be coloured by personal prejudices, it is nevertheless pertinent to take them into account when assessing the quality of news provision. The extent to which audiences accept the news on television as offering a completeness of coverage and credible accounts of events may affect what they learn and

remember from it, and the extent to which they may subsequently utilise its information in any decision-making they may be required to make on certain issues as citizens. Moreover, certain sections of the audience may have 'expert' knowledge and will therefore be qualified to judge whether or not television news broadcasting has done justice to an issue or event in the way it has been covered.

Determining the factual completeness, accuracy, and credibility of news in terms of audience reaction can adopt a number of different focal points. Assessment can be made of perceptions of the medium as a whole, of different television channels, of particular programmes broadcast on television, or of the coverage given to certain topics or stories. To date, the evidence from public opinion is that television is a trusted medium. To what extent though does this position change as attention becomes more sharply focused on specific areas or aspects of television's factual broadcasting?

Perceptions of the medium

In the broadest sense, television taken as a whole has enjoyed a positive public image as an information provider. Research in the United States has, for a long time, found that television is believed to report events accurately by many more people than believe newspapers, radio or magazines do so. In 1980, when faced with conflicting or different reports about the same event from different media, 51 per cent of Americans said they would be most inclined to believe the television version, whereas only 22 per cent would believe the newspaper version (Rubin, 1983). This result confirmed an earlier finding, also from the United States, in which 76 per cent said they would believe television against 24 per cent who placed greater faith in the press when faced with conflicting reports of a major national or international event (Lee, 1975). On other scales (honest, trustworthy, reliable, expert and substantive), television was judged significantly better than newspapers. Only on the matter of accuracy was the newspaper judged slightly better, but both media were on the low end of the scale.

Assessing the credibility of news media from the point of view of the general public requires carefully thought out questions. One frequently used question, typically employed by the Roper Organization in its tracking surveys of public opinion about news, asks: 'If you got conflicting or different reports about the same news story from radio, television, magazines or newspapers, which of the four versions would you be most inclined to believe – the one on radio, or television or magazines or newspapers?' Some media researchers have cast doubt on the ability of this question to provide a fair measure of public opinion about news media credibility. Carter and Greenberg (1965) questioned the methodological purity of the Roper item claiming it favoured television over newspapers. Television's added visual dimension seemed particularly valuable given the special case of conflicting reports across the media. Instead of measuring credibility only as the selection of one medium when confronted with conflicting reports, Carter and Greenberg also assessed

credibility in the absence of comparisons and conflicting reports; that is, each medium was examined in isolation. They did this by asking: 'We would like your opinion about the reliability of (e.g., radio) for news. If perfect reliability is 100 per cent, what per cent of the news on (e.g., radio) do you believe (from 0 to 100 per cent)?'

Data collected from over 500 residents in the San Jose area indicated that respondents tended to choose television over newspapers by a two to one margin when faced with conflicting reports across the two media. However, this gap narrowed considerably when each medium's news credibility was rated separately. In this case, television was accorded 82 per cent reliability, radio 77 per cent, and newspapers 68 per cent. Using the comparative form of question again, a more recent American survey found that, faced with conflicting reports of the same story, television stories would be most believed by nearly one in two people (49 per cent), while one in four (26 per cent) said they would believe newspapers, with far fewer still saying they would believe radio (seven per cent) or magazines (five per cent) (Stanley and Niemi, 1990).

In a report commissioned by the American Newspaper Publishers Association, Greenberg and Roloff (1974) stated that an element of ambiguity in this kind of question further biased responses towards television. Specifically, they argued that the Roper Organisation's question provided no cognitive reference point (e.g., local or national channel/network/newspaper operation) for respondents to utilize when selecting which medium's report they would be most likely to believe. Without being told to focus either on local or national news operations, Greenberg and Roloff suspected that respondents based their evaluations on national network television news organisations and programmes on the one hand and local newspapers on the other. This, they said, 'approaches a mangoes and zucchini comparison' which would favour television.

In addition to lacking a cognitive reference point, Roper's credibility question in and of itself seems limited in a number of ways. First, assessing credibility in the special case of conflicting reports provides little information about the credibility of each medium in the more general case of consistent reports (or viewer/reader unawareness of cross-media discrepancies). Second, selection of one medium as the most credible does not address what may be the more important questions,'How credible are the news media?' 'Are the media generally credible or not credible?' 'What is the magnitude of credibility across media?' Third, news media credibility may be a function not only of whether the story originates from a local or national broadcaster or publisher as suggested by Greenberg and Roloff, but may also depend upon whether the story itself is of local, regional, national or international significance and upon the particular news topic (politics, sport, weather). Thus, local news channels may be more credible when covering local news events than when dealing with national news events. Fourth, news credibility may be dependent on the particular station or network watched. A station's presentation format and presenters may enhance or have a deleterious effect on news credibility evaluations.

Other researchers began to address several of these issues by providing a cognitive reference point and assessing comparative as well as non-comparative measures. Roper's conflicting reports question was modified to focus on a local news story in a respondent's favourite local newspaper and favourite local television station (Abel and Wirth, 1977) or favourite local television station's local evening newscast (Reagan and Zenaty, 1979). In both studies, significantly more respondents chose the local television version.

These approaches were subsequently developed further by asking survey respondents to indicate believability of local and network television news and local versus state newspapers in relation to local and national news (Gantz, 1981). Television news fared well across all measures utilized. Individual local station and major network newscast coverage of local, state, national and international events were perceived as highly believable. When given conflicting reports, the television version was more likely to be chosen than the one offered by newspapers. Nonetheless, television's supremacy was a function of researcher operationalizations. When assessed individually, television's rating was only very slightly higher than that of newspapers. When pitted against newspapers given a hypothetical conflicting report, television's lead was more substantial, being greatest for national news stories aired on a network newscast as against those printed in a local newspaper. The gap was smallest in comparisons between local news story offerings of local television news and local newspapers. These differences in audience perceptions of the credibility of news reporting across different frames of reference point to the inadequacy of single item measures.

Other studies have examined public opinion about television with regard to how its news coverage deals with particular categories of news. Research in the United Kingdom, conducted annually, has invited viewers to evaluate television news in comparison with radio and print news coverage in terms of five attributes, while distinguishing broadly between news of international or national significance and news of regional or local significance (Gunter and Winstone, 1993; Gunter et al., 1994). Respondents were asked to say which medium they generally trusted to give 'the most fair and unbiased news coverage', 'the most complete' news coverage, 'the most accurate' news coverage, 'to bring the news most quickly' and to give 'the clearest understanding of the events and issues'. The last four attributes are the ratings of key importance in the current discussion.

In respect of national and international news, television was afforded the highest opinion on all attributes. It was rated as providing the most complete, most accurate, quickest and clearest account of news. Newspapers and radio competed for second position throughout. Radio was rated more highly than newspapers on one dimension, that of bringing the news most quickly. Newspapers were perceived more often (than radio) as offering the most complete coverage of events as well as offering the clearest understanding (Table 5.2).

Table 5.2 Perceptions of Sources of News Concerning Events
of National and International Significance

	Most Complete %	Most Accurate %	Most Fair %	Clearest Quickest %	Understanding %
Television	75	76	71	72	78
Newspapers	15	9	7	3	7
Radio	8	11	12	17	9
Teletext	2	2	3	7	3
Magazines	*	*	1	*	*

Source: Gunter, Sancho-Aldridge and Winstone, 1994

With respect of news events of regional and local significance, television was, once again, the most highly rated news source. The gap between television and newspapers on most dimensions, however, was much narrower here than it had been for news of international and national significance. Newspapers were rated higher than radio for completeness, accuracy, and clarity of coverage. Radio scored more highly than newspapers only in terms of the speed with which it was perceived to relay news of local and regional events (see Table 5.3).

Table 5.3 Perceptions of Sources of News Concerning Events
of Regional and Local Significance

	Most Complete %	Most Accurate %	Most Fair %	Clearest Quickest %	Understanding %
Television	49	53	55	60	61
Newspapers	33	25	21	10	18
Radio	15	17	15	24	16
Teletext	1	1	1	4	2
Magazines	–	–	–	–	–

Source: Gunter, Sancho-Aldridge and Winstone, 1994

In the United Kingdom, a survey reported by Collins (1984) for the BBC, among a nationally representative sample, found that television (41 per cent) was endorsed more often than either the press (21 per cent) or radio (seven per cent) as the most accurate and detailed source of news in respect of three issues – the police, unemployment and the Common Market (see table 5.4).

For the average news issues about 40 per cent named a television channel as their *most* accurate source of information, while only about 15 per cent named a television channel as their *least* accurate source. Mentions of the press, in contrast, were evenly balanced; just under 20 per cent said that newspapers or magazines had been their most accurate source and a similar proportion said they had been the least accurate. It is this pattern that suggests that people would be, if anything, more likely to distinguish between information and influence in respect of the press than they were in respect of television.

Table 5.4 Perceptions of Sources of News about Issues

	Any TV Channel	Newspapers/ Magazines	Radio	None/ Don't Know	
Most Accurate					
Police	%	41	15	7	37
Common Market	%	37	16	6	41
Unemployment	%	45	19	7	29
Average	%	41	17	7	36
Least Accurate					
Police	%	15	23	9	53
Common Market	%	15	14	8	63
Unemployment	%	16	18	12	54
Average	%	15	18	10	57
Most Detailed					
Police	%	42	25	6	27
Common Market	%	37	23	6	34
Unemployment	%	45	27	6	22
Average	%	41	25	6	28

Source: Collins, 1984

About 40 per cent also mentioned a television channel as providing the most *detailed* coverage, compared with about 25 per cent mentioning newspapers or magazines. While this is a smaller difference between the media than that seen in terms of perceived accuracy, it is perhaps surprising that the press – with greater opportunities to deal with current issues in depth – is not better regarded.

The perception of television as an accurate source of news, however, was not unconditional. While most respondents claimed to have been informed by television on the three issues, much smaller numbers (about 35 per cent) said they had been *influenced* by it. As many as 46 per cent considered that news and current affairs programmes were sometimes deliberately misleading (compared with 38 per cent thinking they were generally honest). Collins noted that this scepticism was consistent with earlier literature reviews which had cast doubt on the power of television as a creator of public opinion (McQuail, 1977; Goodhardt, Ehrenberg and Collins, 1975).

Perceptions of channels and issues

To reiterate the principal performance criteria of interest in this context, the factual quality of news provision comprises truthfulness and relevance of coverage. Truthfulness can be judged by the factualness, accuracy, credibility and completeness of news coverage. Television, as a medium, scores favourably on these criteria relative to other media in terms of audiences' subjective impressions. How well does it perform as far as its audiences are concerned, in respect of the coverage it gives to selected topics, issues and events? The answer to this question is far from simple. Much seems to depend on the

particular topic, issues or events being addressed and upon how focused is the line of enquiry.

Collins (1984) compared the perceptions of a nationally representative UK sample in respect of different television channels' coverage of various news issues. The line of questioning began by asking respondents for their opinions about the amount of coverage afforded each issue by television in general. It then focused on whether any channel(s) had shown too much or should have shown more about the issue.

In general, few respondents said that any channel(s) had shown too much about an issue; just over 10 per cent for the police and unemployment; just under 10 per cent for the Common Market. More people said that one or more channels should have shown more about the issues, from 23 per cent for the police up to 42 per cent for the Common Market.

There was a tendency for those who said one issue should have received more coverage to say the same about other issues. This, however, was not very marked. For example, one-third of this smallest group – those saying there should have been more coverage of the police – did *not* say the same in respect of the Common Market. Nearly two-thirds of those critical of coverage of the Common Market were not critical of coverage of the police. There was, therefore, a degree of discrimination between issues in terms of perceptions of the adequacy of television coverage.

Those claiming an interest in an issue were more inclined to say that television should have shown more about it. This does not explain the marked differences seen in this research between the issues. The Common Market, about which the largest number of people said that television should have shown more, was actually rated as the *least* interesting of the three issues. It seems, therefore, that people were saying that the issue was under-reported, not that their interest was not satisfied.

Collins reported that those who said that television had shown too much about an issue mentioned, on average, about two channels each. For the issues of the police and unemployment, about 33 per cent of the criticisms were of each of the two major channels, BBC1 and ITV, and about 15 per cent of each of the two smaller channels, BBC2 and Channel 4. The distribution of results for the Common Market was out of line with the other results and was based on a small number of comments. This may therefore be a result of a sampling fluctuation. Collins suggests caution before reading into the results any particular criticism of BBC1 and ITV. The results for the minor channels meanwhile were derived from very small numbers of respondents.

The larger number of people saying that television should have shown more about an issue tended to mention more channels – about three on average. There was a remarkable stability in the way these criticisms were distributed across the four channels: just under 30 per cent to each of the two major channels, about 25 per cent to BBC2 and 20 per cent to Channel 4. This regularity occurred despite the large differences in the number of critical

mentions involved: more than twice as many for coverage of the Common Market as for coverage of the police.

This stability seems to imply, according to Collins, that people are mostly inclined to criticise television as a medium, making only fairly superficial distinctions between the channels. These distinctions cannot be based on the specific output of each channel, or we would expect to find more variation from one issue to another. They seem to be based on more general experience and opinions. People tend, perhaps, to criticise either all the channels or all those with which they are familiar.

Election coverage

Evidence concerning the factual quality of television coverage has derived from special studies conducted into audience reactions at times of political elections. The key questions in this context concern the amount or thoroughness of coverage to different aspects of an election. During the 1980s and 1990s a number of such investigations were carried out into public perceptions of television's coverage of general elections in Britain.

Across different election campaign studies, questions have been asked about the status of the overall amount of coverage devoted to elections as well as about the comprehensiveness of coverage given to different aspects of the election under the spotlight. In the latter case, attention was focused on viewers' personal opinions about the amount of coverage given to specific issues, topics, parties or personalities.

The typical pattern of public opinion during British general elections is characterized by a feeling that television devotes too much attention to elections during campaign periods. Furthermore, there is generally an increasing trend towards believing that television coverage is excessive across the duration of a political campaign (see Table 5.5). Although differences between the survey methodologies used on these three occasions mean that comparisons between these campaigns should be treated as tentative only, they nevertheless serve to indicate certain patterns of opinion during and across successive general elections in Britain.

Table 5.5 Perceived Amount of Television Coverage during General Elections in 1983, 1987, and 1992

	per cent saying too much coverage of General Election on television		
	1983	1987	1992
2 weeks before polling day	50	65	63
Just before polling day	57	72	64
Week after polling day	62	74	66

Source: BBC/IBA(ITC) general election surveys

The above figures indicate an increasing trend of thinking that television provides too much coverage overall of general elections. This perception is more pronounced at the end than at the beginning of campaigns, probably

indicating that after four weeks or so of constant news attention to the election and events linked to it, the public become jaded with and cynical about the media coverage.

Of more significance to the current analysis than perceptions of overall amount of coverage given to general election campaigns by television, are the subjective perceptions of viewers about the factual quality of television's coverage of more specific aspects of campaigns. Various election campaign surveys conducted by the broadcasters have examined audience perceptions of the thoroughness of television's coverage of specific topics and issues, policies and personalities.

Television has been increasingly accused of providing political coverage which focuses on personalities rather than policies. This is regarded as an American phenomenon which has spread across the Atlantic to infiltrate and characterise the way campaigns are fought in Britain. Yet, electorates need to know about parties' policies and politicians' stances on various issues and not simply whether a politician has a telegenic image and projects himself or herself as a decent person.

In a survey commissioned by the Independent Broadcasting Authority of public attitudes towards television coverage of the general election in May 1979, about half the respondents in a London sample thought that both BBC and ITV news bulletins and documentaries tried to concentrate on 'showing what politicians say they will try to do'. One fifth said the news and documentary coverage showed 'a personality for some parties, policies for others'. Both channels were thought by more people to have dwelt on personality in the case of the Conservative Party than in the case of the Labour or Liberal parties (Wober, 1979).

Research conducted during the 1983 general election revealed that, on the whole, the majority of television viewers in Britain at that time felt that television had got the amount of coverage devoted to personalties (53 per cent) and policies (66 per cent) about right. Among the still substantial minority who disagreed with this viewpoint, the balance of opinion was towards the belief that personalities received too much (25 per cent) rather than too little coverage (eight per cent), while policies received too little coverage (14 per cent) more than too much coverage (10 per cent) (Gunter, Svennevig and Wober, 1986).

Furthermore, there was an apparent link between how well informed viewers felt themselves to be about party policies and their satisfaction with its coverage of policy matters. Respondents who felt that they already knew plenty about party policies and election issues were more likely to say that television provided too much coverage of policy issues as compared with those who felt themselves less well informed.

More recently, a survey of public opinion concerning television's coverage of the 1992 general election in Britain compared viewers' perceptions on an expanded range of aspects of coverage. Here members of a national viewing

panel were asked for their opinions about the amount of coverage devoted to six aspects of the election, during the early part of the campaign and then again after the election (see Table 5.6).

Viewers felt that more than anything else too much coverage was given to reporting the results of opinion polls. This was a source of additional sensitivity subsequently when the election outcome predicted by these polls turned out to be incorrect. Secondly, and corroborating earlier observations and opinions, there was a widespread view that excessive coverage had been devoted to the personalities of politicians and politicians attending staged publicity-seeking events. Another group of 'personalities' had emerged as causing some degree of dissatisfaction among viewers in the overall television 'staging' of the election campaign, in the form of television's own political commentators, analysts and experts. Well over half the respondents surveyed across the early campaign and post-campaign waves felt that too much coverage had been given to press conferences or walkabouts by politicians and to analysis by outside (non-TV) experts. Viewers were least likely to say there had been too much coverage by television of the policies of parties; this was the item on which they were most likely to say there had been too little coverage.

Table 5.6 Perceptions of Amount of Coverage of Different Aspects of 1992 General Election on Television

	Too much		About right		Too little	
	Early	**Post**	**Early**	**Post**	**Early**	**Post**
	%	%	%	%	%	%
Results of opinion polls	74	81	24	18	1	1
Analysis by TV's own political correspondents	62	64	34	34	4	2
Personalities of politicians	63	55	33	33	5	6
Press conferences or walkabouts by politicians	63	53	34	41	4	6
Analysis by outside experts (no politicians or TV journalists)	58	57	32	33	10	10
Policies of parties	40	33	40	37	20	30

Note:Early campaign:minimum base size = 2776
Post campaign:minimum base size = 2452
Source: BBC/ITC, 1992

The further significant point to highlight from these results is the extent of opinion change over time during the election period which was more marked in respect of some items than others. As the election progressed, viewers became increasingly concerned about too much coverage being devoted to opinion polls results. At the same time, they became less dissatisfied with the amount of coverage given to political personalities and press conferences and walkabouts by politicians. Perhaps the most significant result of all, however, was the increasingly widespread feeling that party policies received inadequate attention.

Relevance of news

One of the major roles of the news media is to identify and provide types of information most needed by the public in order to make decisions, develop opinions and assume an active political life. News media practitioners presume to know what the public needs to know about news events. They have been trained to report the 'who, what, where, when, why and how' of an event. By providing these basics, many journalists consider that they have done their job. This may not be entirely true, however. Members of the public may possess a variety of news needs. Specific needs may incline them to tune into particular news programmes or stories more than others.

News Interests

One key factor may be the audiences degree of interest in serious and routine news. Serious news constitutes news providing in-depth reporting of an issue. The significance of news needs has been recognised for many years. Westley and MacLean (1957) proposed that an individual needs to be oriented in his or her environment. Information need is impelled by an exploratory, purposive drive (Harlow, Harlow and Meyer, 1950; Montgomery, 1954; Tolman, 1932) to find order and meaning (Cohen, 1957; Cohen, Stotland and Wolfe, 1955). Other researchers have conceptualised information need as proceeding from a series of cognitive processes driven by the need 'to know', and can be observed in the form of questioning behaviour (Churchman, 1971; Horne, 1983; Wilson, 1989). Depending on the situation, individuals will need various types of information while they attend to information (Carter, 1978; Reynolds and Flagg, 1977).

Chew (1992) followed through the process of how individuals inform themselves via the viewing of television news, comparing their reactions to 'serious' and 'routine' news. Results suggested that individuals ask a repertoire of questions with varying frequency as they view different news topics. When processing routine news, viewers more frequently engaged in finding out about what was going on, possibly because routine news programmes are designed primarily to provide news events for the day. Also, perhaps because little else is offered by network news, this may be the optimal questioning behaviour in what viewers of routine news can engage. Overall, they tended to acquire news information and became aware of news events and ideas.

In contrast, during serious news processing, viewers more frequently articulated a wider range of information needs. They tended to assess information for decision making more frequently, followed expert opinion, obtained information to develop an opinion, and checked their understanding for accuracy. This seemed appropriate given the news programme to which reactions were being assessed, namely the MacNeil/Lehrer News Hour, which featured experts and opinion leaders, subject and technical specialists, congressional representatives, judicial and executive branch officials, and news columnists. The finding was consistent with previous research which reported that viewers watched news interview programmes to develop opinion and refine

opinions on issues, as well as to compare their opinions with those being offered by experts in these programmes (Levy, 1978).

As routine news programmes provide information that viewers relate to, primarily in terms of 'finding out about the day's events', such programmes could also provide information to help viewers engage more in behaviours related to reasoning and decision-making, idea construction, and opinion formulation. A study by Wenner (1982) found that viewers of network news had higher expectations of news programmes – to help them make up their minds about important issues and to help them find issues affecting people like themselves – than had been met. Therefore, routine news provision on television could do more for viewers. It is clear that in a democratic society, news media organizations have a responsibility to help their viewers become better informed citizens. The network newscasts could assist in this enterprise by including more connecting and analytic perspectives on issues.

In general, individuals do seem to ask questions that go beyond the basic 'who, what, when, where, why and how' of issues. In order to create a more informed public, Chew (1992) suggests that news media practitioners also articulate the inquiries that viewers of serious news more frequently have in order to help viewers of routine news better inform themselves. These include providing expert opinions, various viewpoints for decision making, and opinion formation in addition to issue specifics.

McDonald and Reese (1987) described three categories of news ranging from a blend of entertainment and features through the traditional headline approach of broadcast news to issue-oriented news providing more than just the news headlines. But serious news also relates to news associated with prestige news sources. Conversely, routine news refers to: (1) traditional headline news (McDonald and Reese, 1987); and (2) the 'typical daily sources that Americans rely on for the bulk of their everyday news' including the major networks, local television news, and the daily newspapers (Robinson and Kohut, 1988, p.184).

Many journalists have recognised that whatever affects and interests the public should have most influence on news selection. For performance assessment purposes, therefore, a chief requirement is to have a scale of news interests based on the views of the audience, which can be applied to what the news media actually do offer. Measures of interest can be taken for radio and television news bulletins (Robinson and Levy, 1986). The results can be processed to show relative interest in different topics and types of content, according to any chosen category system.

News interest research has been carried out more among newspaper readers than among broadcast news viewers and listeners and a number of question techniques have been employed. Even so, it is informative to make some mention of these findings here. Lehman (1984) asked 1,200 readers about 36,000 items on sampled newspaper pages in two media markets in the United States. Results showed that an average of 35 per cent of all items were read, with a

range of 22-51 per cent for 18 categories of news. High-scoring categories were news summaries (51 per cent), personal advice columns (47 per cent), crime (48 per cent), war, rebellions (44 per cent), and environmental news and general interest topics (36 per cent each). Low-scoring categories were unsigned editorials (27 per cent) and government actions (30 per cent). The results from this methodology, however, are likely to vary markedly with the specific events covered during any period of news output sampled. British data derived in a similar way (Curran *et al*, 1980) indicated a consistent, across-the-board, reader preference for 'human interest' subjects over hard news.

Another American survey asked readers to say which items they looked at in 'today's paper' with particular interest, using the copy as an aid to recall (Burgoon, Burgoon and Atkin, 1982). The results divided roughly equally between national news stories (30 per cent) and state or local news (31 per cent), with 23 per cent mentioning international news items.

Perceived Importance of News

There are other ways in which news audiences can be investigated in terms of what they find to be relevant in the news. In addition to news interest indicators, other measures, including what they best remember, can be used. Memory for news, however, can be influenced by factors other than interest in the topic, as we will see later in this chapter. Members of the public can be asked which events they consider important over a given spell of coverage, with a view to comparing the audience's perception of news values with that of news professionals (Ogan and Lafky, 1983). This type of enquiry tends to reveal higher audience ratings for major international and national events than conventional news decisions often make allowances for.

Sparkes and Winter (1980) systematically tested whether supposed journalistic news values such as those outlined by Galtung and Ruge are the same values the audience places on the news. Galtung and Ruge (1965) suggested that two principles operate in the reporting of news. First, the more characteristics or news values an event possesses, the more likely it is to be selected as news (the *additive hypothesis*). Second, the value of stories is enhanced by stressing (or indeed overemphasising) aspects of an event that are judged as particularly newsworthy (the *complementary hypothesis*).

Sparkes and Winter began by drawing up a list of eight basic news values that they condensed from a review of literature on news selection criteria (see Table 5.7). The list is not exhaustive, but it does represent those news values previous research had indicated to be most important in the news selection process. In particular, the values of impact and conflict had previously been singled out as the qualities of an event that will most certainly ensure attention by the news media. Furthermore, those two news values were found to be related also to newspaper readers' story preferences (Atwood, 1970).

Table 5.7 News Values

1.	Duration: short time span events are more likely to receive coverage than continuing developments. They can be quickly investigated and reported. (Galtung and Ruge, 1965; Sande, 1971)
2.	Simplicity: simple events will be reported before complex events which might be difficult to understand or explain. (ibid.)
3.	Impact: items which are thought to have relevance for the audience will be selected more often than matters which have no immediate bearing (ibid, Hester, 1976).
4.	Prominence: large-scale events will be covered more often than similar developments on a smaller scale. Prominence could also involve the importance of the persons or countries involved (élite persons and nations). (ibid, Rosengren, 1977)
5.	Conflict: included here are the areas of violence, crime, confrontation, catastrophe, etc. Such matters will be more often reported than peaceful developments. (Galtung and Ruge, 1965)
6.	Novelty: unusual occurrences or oddities will receive press attention far beyond their actual importance. So-called human interest stories would fall in this category. (ibid.)
7.	Affinity: events socially or culturally familiar will receive more attention in the news than the unfamiliar. (ibid, Hester, 1976; Lent, 1977)
8.	Personification: events with strong personal dimensions will receive more attention than broader social or natural events. (Galtung and Ruge, 1965; Sande, 1971)

Source: Sparkes and Winter, 1980 . Reproduced with permission.

Sparkes and Winter conducted interviews with 201 households in Syracuse, New York. Respondents gave an interest rating on a selection of news stories. The stories themselves were fictitious accounts written and prepared to look like actual stories that had been clipped from a newspaper. These stories covered six event topics supposedly occurring in four countries and were presented under four treatment conditions. One condition called the 'straight' treatment, was designed as a control condition against which three special treatments could be compared. The latter were 'conflict emphasis', 'impact emphasis', and 'personification' in each of which the appropriate news values had been stressed.

The main aim of the study was to investigate the significance of journalistic news values for levels of audience interest in news stories. Which news values, among those identified as the major criteria of news selection, were related to interest in the news? To answer this question, an average interest score was computed across all stories contained within a particular news value category.

The violence factor emerged as a news value important to story interest, despite previous expressions against too much violence in the news. Respondents were also more interested in foreign stories if the events in them had a direct bearing on the political or economic situation in their own country. Whether or not stories featured 'élite' nations made a difference to interest level. Stories from élite nations were rated as much more interesting than those from non-élite nations, provided respondents had no special affinity with the non-élite nation. In this study, for example, Canada was rated as a non-élite nation, but respondents who lived close to Canada exhibited an

interest in stories from this country, perhaps because of its geographical proximity.

Another approach is to assess people's information needs by asking, not about what they read or saw, but what they would miss if no longer covered (Weaver, 1979). The reason given for this approach is that conventional measures of audience news needs or interests are too strongly shaped by what is currently on offer and readily available. Consequently, reference to the audience will not necessarily produce an independent assessment of relevance. Such alternative methods of assessing the relevance of news in terms of correspondence with empirical measures of audience interest imply a standard of consumer sovereignty which conflicts with some claims of journalistic professionalism, as well as with the 'absolutist' or expert approaches discussed in earlier chapters.

According to McQuail (1992):

> In general, it has to be concluded that any audience-based approach to assessing performance in terms of relevance is subject to several limitations. Different methods of research (and forms of questioning) can produce quite different results and thus different versions of what the audience expects. Secondly, the results of audience research always reflect current media practice to some degree and are, consequently, not fully independent of actual performance. Thirdly, there remains an unresolvable conflict between the professional viewpoint which claims autonomy of judgement about selection and the pressure to please an audience by giving them what they appear to want. (p.220)

Cognitive Aspects of Bias: Objective Audience Perspectives

The subjective impressions of audiences represent one type of indicator of the factual quality of televised news. Changes to the news environment have modified the kind of objective news broadcasters should be targeting, however. The supply of news has increased significantly, while the time available to attend to it has remained roughly constant. This simple logic of the information society (van Cuilenburg, 1987) as well as other evidence of saturation (Hicks, 1981) on the part of the audience, suggests that the appropriate criterion should be, not so much completeness of information provided, as the effectiveness with which information on key topics is delivered to those who need to know about it. This criterion of achieved informativeness requires more objective indicators of performance. This means that news information quality is determined through measures of how much audiences learn and understand from the news broadcast to them.

Objective performance indicators based on memory and comprehension of news have shown that informational effectiveness can be selectively biased by presentation and content features of the news itself. In the current context, these indicators should be applied to reveal the extent to which knowledge and understanding of an issue or a story are accurate and complete. Where they are not, to what extent can this shortfall in performance be attributed to the way the news was transmitted, as distinct from factors which reside within audiences themselves?

Any distortion or limitation in the quality or the presentation of information on television can lead to a bias in the audience's awareness, memory and understanding of news events and issues. It may also produce warped or inaccurate impressions of people, events or issues being featured. Output factors linked to the factual qualities of news on television, whether linked to the content of news or format of news presentation, can influence what audiences take from the news, whether in terms of hard information or softer impressions. The latter will be examined in Chapter Six. This 'biasing' of public perceptions and understanding can be measured, and such measures, in turn,

used as performance indicators to corroborate or disconfirm output measures of bias derived from analysis of the production process or news discourses.

The key objective audience-based indicators of the factual quality of news include:

1. Measures of memory and comprehension of news content.

2. The framing of news stories and topics.

Thus, regardless of whether or not viewers, subjectively, believe that television is accurate, complete and relevant in its selection and presentation of news, do they develop a complete and valid set of memories, understandings and impressions about the topics being covered? These criteria can be assessed by measuring viewers' awareness and retention of factual details of news topics and their perceptions of issues, people and events in the news as a function of their exposure to television coverage. The systematic manipulation of production and content features of televised news, under controlled experimental conditions, can also be used to indicate the extent to which production aspects of television news broadcasts can distort news awareness and understanding.

Memory and Comprehension as Bias Indicators

Television is subjectively rated by most people who are regular viewers as their major source of most types of news. It is also rated as a highly credible news source in general terms, which can deliver the quickest, clearest and most understandable news messages available. The personal opinions of viewers concerning the informativeness of television news, a factor which for many is a key motivating factor underpinning their viewing, have not invariably been supported by more objective indicators of learning from televised news broadcasts. Quite the contrary, in fact, much research on memory and comprehension of television news content has indicated that the news audience often learns less from television than from other major news media (Gunter, 1987; Robinson and Levy, 1986). It is not unusual to find that viewers will remember little more than five to ten per cent of the news items presented in a standard 15 to 20-item news bulletin even when tested within an hour or so of watching it (Neuman, 1976; Robinson, Davis, Sahin and O'Toole, 1980; Stern, 1971). Although the way in which news recall is tested can make a difference to overall memory performance (Berry, 1983), even with prompts to assist viewers in remembering the news stories a particular bulletin contained, recall performance may still struggle to exceed 20 per cent (e.g., Linne and Veirup, 1974; Stauffer, Frost and Rybolt, 1983).

When readers and viewers have been left, following exposure to either a newspaper or television news broadcast, to think about the stories covered, their memory for the news has been found to improve upon immediate post-exposure levels of recall – an effect known as hypermnesia. However, this memory recovery tends to be more pronounced after a story has been read about in a newspaper than seen on the television (Wicks, 1992).

The reasons for such poor performance in remembering broadcast news on television have been linked to characteristics of viewers themselves and the way they watch the news and perhaps more significantly in the context of the current discussion to the way news is constructed and presented by television producers and journalists. According to some observers, the early promise that television might even out the flow of information to all quarters of society has hardly been realised (Davis and Robinson, 1989).

There is not much news broadcasters can do about viewers and listeners who fail to pay attention to news bulletins or exhibit a lack of interest in news generally. In contrast, if attentive and interested viewers are disadvantaged because the information they receive from news broadcasts is poorly delivered or presented in such a way that key points are swamped by less relevant production techniques, this is a problem for which news professionals are directly responsible.

Some critical analysts have observed that one of the problems inherent in television news is the absence of narrative codes in its structure. According to this line of argument, television news has a disjointed structure that makes it hard to follow or understand. The narrative story telling of broadcast news tends to place emphasis upon certain ideas which reflect the ideological status quo of authority institutions. Its reports deal with events but offer little historical context within which they will be more fully understood (Lewis, 1994). This analytical view has been corroborated by empirical evidence which derives from the work of a number of communication researchers and cognitive psychologists who have studied relationships between television news presentation features and viewers' retention and comprehension of broadcast news content.

Biases against effective audience learning can be found in the pace at which televised news is presented, the lack of clear separation between one story and the next (vitally important where two stories are about similar topics), inappropriate and distracting application of pictures, and a failure to emphasize key aspects of stories in the way news narratives are written (Berry, 1988; Gunter, 1987; Robinson and Levy, 1986). The ineffectiveness of many television news bulletins in imparting news to their audiences illustrates their failure to provide a basic public information service (Davis, 1990).

There are a number of key production features which can 'bias' or restrict memory and comprehension of television news. Three main production factors stand out, however, in this vein: sequencing effects; visual presentation effects; and text structure effects. Bias, in this context, represents the distortion of audience learning and understanding of news issues and events.

Sequencing effects

Television news programmes comprise more than simply a haphazard collection of news stories. There are certain aesthetic criteria which influence the way a news bulletin is arranged. The first two or three stories represent the most significant news events of the day, while stories judged by news

broadcasters as less significant in terms of their presumed public interest or impact, are placed lower down in the running order (Green, 1969). As we noted in earlier chapters, there are certain features which can result in a news story being judged worthy of inclusion or sufficiently important to figure high up in the running order. Working in a visual medium, television news editors value items with film. If a story is accompanied by or lends itself to film treatment, its chances of inclusion are much improved.

News is often presented in packages. There is a tendency to run together stories about similar topics. In some news broadcasts, sections of the programme will be reserved for a 'round-up' of news from particular categories, such as foreign news, the economy or sport. Even without such formal structures within programmes, stories from the same category may be regarded, intuitively, by news professionals as belonging together (see Glasgow Media Group, 1976; Schlesinger, 1978).

Some news producers believe that it is important to present a blend of serious or hard news, and light-hearted or soft news. There is a common pattern that is characteristic of news programming in a number of countries of finishing on an up-beat note with some 'good' news or with a light, human interest story. These practices can often result in a stereotyped sequencing of news on television whereby certain categories of news tend predominantly to occur in particular parts of the programme, or are disproportionately more likely to be presented in a package of similar news items. These practices have implications for audience learning. Viewers' memory and comprehension of news stories can be influenced by sequencing effects within news programmes.

The most basic of sequencing effects is the *serial position effect* which experimental psychologists have known about for many years. In any sequence of written or spoken linguistic material, comprising a number of discrete packets of information or items, the information presented at the beginning (*primacy effect*) and the end (*recency effect*) of the sequence will be better remembered than that presented in the middle parts of the sequence. Evidence that this effect extends to learning from broadcast news has emerged from several studies.

One early study of story placement effects on news recall was carried out with a 12-item radio news bulletin. When listeners were tested for all they could remember immediately after listening to it, around 70 per cent recalled the first item in the sequence compared with just 40 per cent who could remember the seventh item. The best recalled of all was the last item in the bulletin which was remembered by around 90 per cent of listeners (Tannenbaum, 1954). A similar pattern of recall from radio news was found much later in a study which investigated recall from radio news broadcasts in Kenya and the United States (Stauffer, Frost and Rybolt, 1980). Serial position effects have also been found to occur with television news, although the presence of picture material and especially of film footage with an item can to some extent offset the disadvantage to an item of being in a middle position in a sequence of news stories (Gunter, 1980). The influence of pictures can be critical, as we will see in the

next section. If the pictures fail to support the meanings conveyed by the story narrative, even lead stories might be seriously affected when viewers try to remember details from them (Davis and Robinson, 1985).

The importance for clarity and comprehensibility in television news is paramount. One production technique that is frequently deployed, in the belief that audience learning of the news will be enhanced, is the packaging together of news stories about similar topics. Several broad topic domains, such as politics, economics, foreign affairs, science and sports, can dominate the way in which news items appear in television bulletins (Glasgow Media Group, 1976). News producers apparently believe that the sequencing of news stories within packages can render isolated events more meaningful and therefore easier to learn about (Schlesinger, 1978).

So far, the research evidence on the advantages of story packaging by subject matter is weak. One early attempt to find out whether a topically organised news bulletin would be better remembered by viewers than one in which the order of story presentation was not linked to topic type found no differences in subsequent news recall between the two types of programme (Klein, 1978). Elsewhere studies of basic news recall have attempted to explain some of the information losses and misunderstandings in terms of confusions which might have occurred between items about similar topics which were run together (Stauffer, Frost and Rybolt, 1983). This explanation was demonstrated subsequently in an experiment designed to test retention from radio news. On this occasion listeners were found to confuse the details from different stories about similar topics when they occurred close together in the same bulletin (Findahl and Hoijer, 1985).

The most powerful story packaging effects occurred in a series of experiments concerned with measuring viewers' retention of televised news items in which story topic and sequence length were systematically manipulated. When presented with a succession of news stories from the same topic type (e.g., politics, economics), recall of story details became progressively and significantly poorer with each item. By the fourth item in a sequence, recall performance was at about half the level for the first item in the sequence. When, on the fourth item, a shift was made to a different topic, recall level returned almost to that measured for the very first item (Gunter, Berry and Clifford, 1980; Gunter, Clifford and Berry, 1981).

Berry and Clifford (1986) reported an experiment in which a television bulletin was prepared in two versions from items prerecorded from an earlier live television broadcast. In one version four out of five items were domestic (UK) stories, whereas the middle (third) item was a foreign story. In other version, a domestic story was surrounded by four foreign stories. Small groups of viewers watched one of these bulletins, after which they filled out a personality questionnaire for about 15 minutes before being tested on depth recall on information contained in the spoken narrative of the news stories. Results showed that information was recalled significantly better from the isolated item than from the surrounding (topically similar) items.

111

Sequencing effects can occur not only as a result of news stories having similar subject matter. More recent research has indicated that news stories with powerful emotionally-arousing properties – whether about a very happy or a very sad event – can overshadow news items which occur immediately before and after them. The result was that those less exciting items tended to be less well remembered by viewers afterwards (Mundorf and Zillmann, 1991). Indeed, after watching a news story about either a highly exciting or disturbing event, viewers seem to be unable to attend properly to and learn from subsequent items for up to three minutes (Mundorf, Drew, Zillmann and Weaver, 1990). In another experiment, Zillmann, Gibson, Ordman and Aust (1994) examined the effect on viewers of the inclusion in a television newscast of humorous items and human interest items. These researchers were especially interested to find out what impact such stories might have in counter-acting the depressing effects of bad news. Viewers' pessimism about the future and perceptions and worries about the seriousness of social problems contained in many news items were somewhat alleviated by the presence of a humorous item at the end of a bulletin. Human interest items in this position, however, failed to produce the same effect. The implications of such findings are that audiences recall of news from television can be selectively biased towards a highly arousing items, while their attention is, in consequence, directed away from surrounding material.

Visual presentation effects

While much of the meaning of the news on television is contained within story narratives, it remains essentially a visual medium. A great deal of information can therefore be contained within the pictures it shows. These pictures can be either still or moving; some contain only images, while others also contain verbal information. Whether or not a story is accompanied by pictures or can, at least, offer the opportunity for pictures to be produced, can influence its chances of being featured at all. Pictures are strongly favoured by news editors because they can create an impression of allowing audiences to witness events as they happen (Schlesinger, 1978). Pictures can also arouse emotional reactions in viewers (Green, 1969), though, as we saw in the last section, news broadcasters need to be aware of the wider implications of such reactions for audience learning from the bulletin.

In examining the 'biasing' effects of pictures on audience memory and comprehension of news information, researchers have compared learning from television with learning from other news media and examined the impact of the different applications of pictures within televised bulletins. The findings to date have been far from consistent. Nevertheless, some interesting lessons have been learned. Some studies have found that. compared to talking head items, learning can be enhanced by the use of still photographs (Findahl, 1971) or news films (Berry and Brosius, 1991; Brosius and Berry, 1990; Edwardson, Grooms and Proudlove, 1981; Gunter, 1979; Renckstorff, 1977). Other studies have found no significant differences between different formats of news presentation on audience recall of items' verbal contents (Edwardson, Grooms and Pringle, 1976; Gunter, 1980a).

Efforts have been made to explain these different results (Berry, 1988; Brosius, 1989a) and to establish under what conditions the use of pictures and visual illustrations in television news broadcasts can be beneficial rather than detrimental to audience learning. One factor which may play a crucial part in underpinning the beneficial effects of pictures in television news is the degree to which pictures and words are mutually supportive in the sense of conveying the same meanings. As the level of redundancy between information carried by the story narrative and any accompanying pictures becomes greater, so viewers' retention of that information should be enhanced (Drew and Grimes, 1987; Findahl and Hoijer, 1976; Reese, 1984). One view is that at a high level of informational redundancy, audio and video modalities effectively become transformed into a single unit of meaning. In non-redundant presentation conditions, the visual modality is generally dominant as evidenced by viewers exhibiting a better level of performance on visually presented material than audio material in recognition tasks immediately after watching a television news report (Grimes, 1991).

Even picture-word redundancy does not always guarantee effective learning, however (Drew and Cadwell, 1985; Winterhoff-Spurk, 1983). Even more confusing was one set of findings which indicated that while viewers' ability to recognise the items they had just seen in a news bulletin could be enhanced by greater picture-word redundancy, their ability to recall central story information in response to prompts was not improved by this production feature (Son, Reese, and Davis, 1987).

The level of redundancy between pictures and words per se in television news broadcasts may not be sufficient to determine how equitably audience attention is spread across these two modalities of information presentation. The patterning or organization of audio soundbites and video 'image bites' within a news report or across a news programme may represent a further crucial variable (Davies, Berry and Clifford, 1985; Geiger and Reeves, 1989). Audiences look for connections between discrete information chunks whether they were presented in the audio or video modality. On-screen graphics such as bar charts accompanied by visually presented textual information have been found to divert viewers' attention away from what a newscaster or reporter is saying. In view of this, it has been recommended that there may be certain benefits to audience learning in ensuring that any audio-presented material immediately after such graphics is maximally redundant with the preceding visual information (Edwardson, Kent, Engstrom and Hofmann, 1992).

The biasing effects of emotional content

Other research has found that the emotionally arousing nature of pictures can have a significant effect upon audience recall of story content. News stories accompanied by violent film footage, for example, may be less well recalled than when that footage is removed (Furnham and Gunter, 1985; Gunter and Furnham, 1986; Gunter, Furnham and Gietson, 1984; Mundorf, Drew, Zillmann, and Weaver, 1990). Emotionally arousing and interesting pictures

can be expected, on the basis on psychological research into emotion and memory, to raise the level of attention to particular stories, thus potentially increasing the likelihood that it will subsequently be recalled (Taylor and Thompson, 1982). More emotionally arousing items can become more vivid to viewers (Reisberg, Heuer, Mclean and O'Shaughnessy, 1988).

Visual elements in televised news stories, particularly film footage of events, can add significantly to the drama of news. Dramatic scenes within news stories can significantly decrease how much detail viewers are able to recall from them afterwards. Furthermore, such scenes may also cause viewers to think about the events reported in a much more superficial way (Milburn and McGrail, 1992).

Television news tends to cover negative events more often than positive events (Stone and Grusin, 1984; Stone, Hartung and Jensen, 1986), covering material such as violence, damage or threatening circumstances which generate negative emotional reactions among viewers. Research on the differential impact of negative and positive information suggests that negatively-toned content has a stronger impact on learning as well as upon the judgements and attitudes of audiences (Donsbach, 1991; Garramone, 1984; Peeters, 1991; Weinberger, Allen and Dillon, 1984). Within the television news broadcast context, the emotional qualities of news pictures could influence the comprehension and recall of information from the news narrative in a fairly general and unspecific way. However, emotionally-toned pictures may also operate to focus viewers' attention onto particular parts of news stories – those accompanied by the emotional visuals. In a study designed to investigate this point, Brosius (1993) found that emotionally-arousing pictures had no overall effects upon the probability of news item recall, but certain pictures did enhance the vividness of particular facts within the story in the minds of viewers. These facts were better recalled afterwards. Thus, the effect of emotionally-arousing pictures in television news stories may be to narrow down viewers' attention to certain parts of a story. When tested for recall later, viewers tend to reconstruct their own version of events during which errors may occur, particularly with regard to those facts which were overshadowed during presentation by others rendered more vivid by accompanying pictures. Recall and understanding of stories can thus be selectively biased by the use of emotionally-arousing images.

Pictures can cause informational biasing not just at an emotional level but also at a cognitive level by drawing viewers' attention disproportionately towards specific informational elements of a new story. Crigler, Just and Neuman (1994) compared people's learning from and opinions about television news stories presented audio-visually, in audio-only, or as visual-only without any soundtrack. Four news topics were used which dealt with the Strategic Defense Initiative or Star Wars project, concerning the development of orbital anti-nuclear missile systems; apartheid in South Africa; drug abuse in the USA; and AIDS. Simulated television news bulletins were edited together comprising these stories. Two versions of each story were deployed across

114

different edited news sequences. Assessments of learning indicated that most of the information in these television news stories was conveyed via the audio-channel or spoken news narrative. Even so, varying amounts of detail were also learned from the visuals in the story, which proved capable of biasing learning in certain directions and shaping impressions that were formed about the stories themselves.

A great deal more was learned following visuals-only presentation of the stories about the Strategic Defense Initiative and South Africa, for example, than about the other two stories. In both cases, the visual information was conveyed in a narrative sequence. In one Star Wars story, an animated cartoon showed how the proposed defense system would work. In the second story on this subject, a pro-Star Wars cartoon advertisement was shown along with a dramatic anti-Star Wars advertising sequence showing an innocent little girl going to sleep under an exploding star.

In a qualitative assessment of what viewers understood about the stories in each condition, a general understanding about Star Wars materialized, even with the visuals-only version. With the visual track only, however, viewers focused more on general statements about military technologies. In all three presentation conditions, comments were made about the bias of the stories, but the perceived direction of bias varied with the particular presentation version. Those in the visuals-only condition described a pro-Star Wars bias, whereby the 'pro' visuals were seen as outweighing the 'anti' visuals. In the audio-only and audio-visual conditions, the stories were interpreted to mean that politicians and advertisers were trying to persuade the public by using children as emotional bait and credited the stories with an anti-Star Wars bias.

The South Africa stories contained visual narratives of violent clashes between blacks and whites. On the streets of Johannesburg, blacks were shown rioting and then being forcibly subdued by white police; then, in Athlone, white uniformed men, hidden in a truck, emerged to fire shots on crowds of stone-throwing black youths. Viewers in the visuals-only condition described the main points of the South Africa stories as being violence, rioting, police physical force, press censorship, a battle against the blacks and the vandalisation of stores in Johannesburg. The audio group also concentrated on government oppression and censorship but commented as well on possible motivations for restricting press coverage. Those who only heard the audio-track made fewer references to violence and police brutality than those who had seen the pictures. Those in the audio-visual condition with both words and pictures, talked about the violence, but concentrated to a much greater extent on government oppression of blacks. Thus, there may be variations in the effectiveness of different kinds of visuals to convey information. The informational value of pictures will depend upon the nature of the story and how central they might be to conveying details about the topic being reported. Some topics lend themselves more readily to visual treatment than others, and can therefore be more effectively conveyed through that modality.

A further factor which may impact upon the relative benefits of pictures in television news is the extent to which they are used throughout a bulletin. Research has found that a newscast with all items being presented as news films leads to less recall compared to a newscast with a mixture of talking head and film items (Berry and Brosius, 1991; Brosius, 1989, 1991). Thus, while under some conditions, learning from the news can be enhanced by the presence of film footage, if there is no variation across news items in the nature of the visual format, recall of news stories may ultimately be impaired. This finding is consistent with results from news sequencing work in which the deterioration in memory performance for news content that can occur across a sequence of news stories with similar subject matter can be reversed to some extent by changing the format of presentation of those items (Gunter *et al.*, 1980).

Text structure effects

Although the presence and application of pictures can significantly affect how much viewers learn and remember from news narratives, the construction of the narratives themselves can also play a key part in relation to how much information is effectively absorbed by audiences. A clear writing style is crucial when producing news journalism, whichever news medium is being used. Broadcast news writing styles evolved out of press journalism. The traditional inverted pyramid model of news writing specifies that the most important facts are told first, followed by lesser facts in descending order of importance. News reports should also take care to present information which deals with the who, what, when, where and why of a story. The news headline represents an initial primer, containing a central facet of the story. The first sentence then establishes other key ingredients in the form of the 'five W's'. With the emergence of broadcasting, news styles evolved so as to adapt to the requirements of radio and television. The more conversational style of news presentation on television, for example, has meant that the form of writing is different too. With television, of course, the production process has to make allowances for the use of film or other visual illustrations. It is important for the writing and the images to support each other, thus the narrative content may sometimes be built around the pictures resulting in a different type of account from one which would have been produced in the absence of pictures.

Psychological research into the way people process prose materials has indicated that narratives may have different structures, and that some structures can be more easily and effectively processed than others, even though the contents of the narratives are essentially the same. Another important finding to emerge from this work, however is that understanding news narratives efficiently often depends on having a certain amount of relevant background knowledge of the world. News production is characterized by complex sets of processes and professional routines that govern the selection of stories and the way they are written and presented (Altheide, 1976; Schlesinger, 1978). News journalists and editors may be more influenced by their awareness of professional expectations in news production than by a proper understanding of

116

how audiences learn (Robinson and Sahin, 1984). The news derives from a number of sources, such as eyewitnesses, press conferences, official statements, interviews or news input from other news agencies. Each of these sources creates its own discourse of events. The way news editors and reporters place their own interpretations on these discourses has an important bearing on the way the news is structured and presented to the public, which in turn may have important implications for how well audiences are able to understand and learn from the finished product.

The way a news story is told can affect the level to which it is remembered and understood. In this sense, then, it represents a news production factor which can play a part in biasing the way the news is absorbed by members of the audience. Thorndyke (1979) demonstrated that by re-writing news stories to emphasise certain features within them, recall levels could be improved. In his initial study with newspaper stories he observed that the standard format was to present the most important information first to catch the reader's attention. Information of gradually decreasing importance followed. Readers, he reasoned would become conditioned into acknowledging this format as the standard way to organise news stories. Yet, it did not necessarily represent the optimal structure for learning all the key facts in the story.

Thorndyke therefore experimented with a condensed version of the standard news narrative in which important information was retained and less important background embellishments were eliminated. In two further different versions again (a 'narrative' version) the sentences in the condensed format were re-arranged into a chronological sequence or sentences were organised topically, under topic headings and subheadings (a 'topical' version).

The re-arranged formats were found to produce better recall of story details among readers than the original newspaper version. The preserved information in the condensed versions was recalled nearly twice as well as when it appeared with various other embellishments in the original newspaper copy. Thorndyke hypothesized that people possess sets of mental schemata or ready-made frameworks within which comprehension of informational texts can effectively take place. The schemata that are optimal for most effective processing of new information, however, may vary from text to text. But it seems that learning from narrative passages will be at its best when they are organized so as to convey clearly the essential or central ingredients of the story being told. This may not always be true of the news as it is told by the mass media.

The text structure principles developed by Thorndyke for improving the comprehensibility of written texts were applied by Berry and Clifford (1986) to broadcast news narratives. These researchers reported two experiments designed to investigate the effects of narrative structures on memory for television news items. A news item was selected for study which provided clear background as well as central details, had a clear causal chain of events and which also had film accompaniment which had probably influenced the way it had been constructed for broadcast.

117

A three-item news bulletin was created with the key item presented in second place. Two versions of the bulletin were created with the narrative of the key item presented as originally written for television broadcast purposes. The second version consisted of a rearrangement of the same sentences according to the principles of Thorndyke's story grammar, with the setting and theme set out clearly at the outset and the various plots that made up the story presented as coherent units in an appropriate narrative order. When these two versions of this news bulletin were presented to groups of adult viewers, the revised version produced markedly better recall of story details.

Further corroboration of these text structuring effects derived from a study by Berry, Scheffler and Goldstein (1993) who conducted two experiments in which original and re-written texts transcribed from television newscasts were presented to separate groups of listeners. The revised stories were re-written according to specific story grammar rules in which factual details were re-ordered to render them easier to remember. Text restructuring was again found to improve learning from news stories. It also affected listeners' judgements of bias, and this is discussed in more detail in Chapter 7.

Current views of text processing suggest that received messages are assimilated by establishing coherences between such text elements as theme, setting, plot, and resolution of events, and the contents of working memory, which may vary according to the thematic content of the news narrative. Individuals possess schemata constituted by existing knowledge relating to particular topics or themes which may sometimes be extremely well developed. If the way details are ordered in news stories are consistent with the way they tend to be ordered by people in their world knowledge stores, learning from news broadcasts will be rendered much easier (Berry, 1983, Berry and Clifford, 1986; Brosius and Berry, 1990; Berry and Brosius, 1991).

The significance of existing general knowledge in this context stems from findings in social psychological research which indicates that when people embellish the verbal and visual facts they have just heard or seen in a news story, with verbal facts that are absent from the story (Graber, 1990), this extraneous information tends to come from schemata stored in memory (Lachman, Lachman and Butterfield, 1979). When learning from news stories, viewers and listeners are very often using the latest news to update existing knowledge about the topics being covered (Larsen, 1981). Thus, learning is enhanced the more connections that can be made between what is known already by viewers and what a news story reports about. By the same token, if news stories arouse schemata, or memories about a topic, there is a chance that some viewers will introduce facts from their existing memories when they are tested for recall of a new story which may not have actually featured in the particular report. In this way, errors can occur in tests of memory for broadcast news.

What has also emerged from research on this subject is that the visual elements of television news may be processed schematically as well as the verbal aspects of stories. However, visual information appears to give rise to fewer

errors during recall which could be attributed to the wrongful introduction of facts from pre-existing knowledge stores about that topic (Graber, 1990). Indeed, the presence of pictures in news stories seems to produce a reduction in such schematic processing errors. Viewers make more errors when recalling information from television news stories without visual illustrations. At the same time though, the presence of pictures can militate against viewers effectively picking up the gist of a story, which is generally contained in the verbal part of the report (Graber, 1990).

The Framing of Stories and Issues

The presentation of the news on television can influence the extent to which information is learned and also, perhaps more significantly, the aspects of stories to which viewers pay the greatest attention. A variety of presentational devices on television newscasts can subtly 'bias' what audiences learn from these programmes. Pictures in the news can convey a different story from the news narrative, or at least draw disproportionate amounts of attention to specific story elements. The textual construction of the news itself can have a profound influence on the amount of information that audiences retain from items and on the balance of audience comprehension of issues or events that are covered. The way the television news frames events, however, can produce a lasting impression on audiences, shaping or, according to some observers, misshaping their knowledge and beliefs. This effect may be particularly important where it concerns the public's knowledge and opinions about key political issues.

Framing refers to the selective emphasis of certain parts of a story over others. News frames represent characteristics of news texts and provide ready-made cognitive frames of reference within which the information from news stories is interpreted (Entman, 1991). News frames can be internalised and may then influence the way other news stories are processed by audiences (Pan and Kosicki, 1993).

Research into the nature of news coverage has utilised many different definitions of framing (e.g., Gamson, 1989; Goshorn and Gandy, 1995; Hornig, 1990; Iyengar and Simon, 1993). According to Entman (1993): 'To frame is to select some aspects of a perceived reality and make them more salient in a communicating text, in such a way as to promote a particular problem definition, cause interpretation, moral evaluation, and/or treatment recommendation for the item described' (p.52). Elsewhere, Pan and Kosicki (1993) distinguished between a topic, which they defined as 'a summary label of the domain of social experiences covered' and a theme or frame, which 'connects different semantic elements of a story.. into a coherent whole.. and has the capability of directing attention as well as restricting the perspectives available to audiences' (pp.58-59). Thus, a theme or frame connects ideas within a news story in a way that suggests a particular interpretation of an issue.

Research on framing indicates that news frames can shape the way the audience interprets issues, affect the perceived legitimacy of particular groups, and

119

influence the outcome of public policy debates (Edelman, 1993; Entman and Rojecki, 1993; Herman, 1985; Iyengar, 1990; Iyengar and Simon, 1993). Consequently, political or advocacy groups often strive to influence the frames employed in news coverage (e.g., Dionisopoulos and Crable, 1988; Wallack, Dorfman, Jernigan and Themba, 1993).

One important function of framing is to characterize or define a problem (e.g., Dionisopoulos and Crable, 1988; Edelman, 1993). What aspects of the issue are most important, and how are they presented? Another function of framing is the assignment of responsibility for social problems (Goshorn and Gandy, 1995; Iyengar, 1990, 1991). The notion of responsibility involves both cause (who/what caused the problem?) and treatment (who should solve the problem?).

One important analysis of how television news news deals with political issues has identified two broad categories of treatment, which have been labeled 'episodic' and 'thematic'. According to this analysis, television news provides one or other of these types of frame of reference when reporting on political issues (Iyengar, 1994). The episodic news frame takes the form of a case study or event-oriented report and depicts public issues in terms of concrete instances (e.g., the bombing of an airliner, a murder, a political coup). The thematic frame places public issues in some more general or abstract context and examines general outcomes or conditions (e.g., changes in government policy about airport security, the impact of new policing policies on crime detection, or the role of western third world policies on the political stability of developing countries). The essential difference between episodic and thematic framing is that episodic framing depicts concrete events that illustrate issues, while thematic framing presents collective or general evidence.

Episodic and thematic stories differ in other ways too. Usually episodic reports make 'good pictures', while thematic reports feature more 'talking heads'. In practice, few news reports are exclusively of one type or another, but tend to combine both episodic and thematic elements. The balance of these two types of ingredients, however, can make a difference to the cognitive impact of a news report on the audience.

The dominance of the episodic frame in television news has been well established. For example, television news coverage of mass protest movements generally focuses more closely on specific acts of protest than on the issues that gave rise to the protests. This characterised US network television news coverage of the protests against the Vietnam War and of the development of nuclear energy (Gitlin, 1980; Gamson and Modigliani, 1989). An identical pattern was observed in television news coverage of labour-management disputes, where scenes of picketing workers received more airtime than discussions of the economic and political grievances at stake (Halloran, Elliott and Murdock, 1970; Glasgow Media Group, 1976; Cumberbatch *et al*, 1986).

Event-oriented stories also account for more news coverage of international terrorism, information about specific terrorist acts is not accompanied by

information about their underlying historical, economic, or social antecedents (Altheide, 1987). The networks' preference for episodic reporting also emerges in the coverage of election campaigns, whereby a campaign may be described as a 'horse race'. Stories on the latest standings in the polls, delegate counts, and the size of the crowd at a public rally tend to appear far more often than coverage of the ideological stances of the candidates and the policy platforms they advocate (Buchanon, 1991; Hallin, 1990).

Iyengar (1991) examined the impact of news framing of six political issues – international terrorism, crime, poverty, unemployment, racial inequality, and the Reagan administration's 'Iran-Contra' dealings – on attributions of political responsibility. Results indicated that the use of either the episodic or thematic news frame affects how individuals assign responsibility for political issues. The episodic frame tends to elicit individualistic rather than societal attributions of responsibility, while thematic framing has the opposite effect. Since television news is heavily episodic, its effect is generally to induce attributions of responsibility to individual victims or perpetrators rather than to broad societal forces, and hence the ultimate political impact of framing is pro-establishment.

Iyengar ran a series of experiments in which small samples of volunteer viewers watched sequences of television news items among which was an item that had been experimentally manipulated. One group of viewers watched a version of the item which adopted an episodic framing of the story being reported on, while a second group watched a thematic framing version of the same story. The news stories had been pre-selected following an extensive content analysis of network television news items over a six-year period. After viewing the news items, all viewers completed a detailed questionnaire which contained questions probing their attributions of causal responsibility for the events and issues covered.

Looking first at the coverage of crime and terrorism on television news, Iyengar's initial search located around 1,100 news items on ABC, CBS and NBC news between 1981 and 1986 on crime and more than 2,000 on terrorism. Three in four stories (74 per cent) on terrorism were episodic, comprising live reports of some specific terrorist act, group, victim or event. The remaining terrorism items discussed the subject in a more thematic way as a general political problem. Thus, there was a strong event bias in network treatment of terrorism. An even larger proportion of crime items (89 per cent) were episodic, many of which dealt with violent crimes. Crime elicited a higher number of causal and treatment attributions of responsibility than any other new category. Causal responsibility for both crime and terrorism news was assigned to individuals who commit criminal or terrorist acts, to a variety of societal conditions, and to a lack of adequate punitive policies.

Framing was more powerful when terrorism was the target issue. Episodic versus thematic manipulations yielded strong results for terrorism, but only weak results for crime. The dominant episodic frame on network coverage encouraged viewers to attribute causal responsibility for terrorism to the personal

qualities of terrorists and to the inadequacy of sanctions. Episodic framing also made viewers more likely to consider punitive measures rather than social or political reform as the appropriate treatment for terrorism.

In the case of crime, the dominant episodic frame did increase attributions of individualistic causal responsibility and of punitive treatment responsibility, but these effects were contingent upon the subject matter focus of the news. Episodic framing made viewers more individualistic in their causal attributions when the news was directed at either white crime or the criminal justice process. Episodic framing of crime also dramatically reduced references to societal treatment responsibility when the news focused on black crime. These, however, were seen as quite modest effects given the widespread concerns about crime.

Attention was next turned to the framing of stories about poverty, unemployment and racial inequality on television news. These topics featured much less often on network television news in the United States than did stories about crime and terrorism. Iyengar found 300 stories about unemployment and racial inequality and fewer than 200 stories about poverty. Coverage of these social welfare stories was mixed in terms of the way stories were framed. Poverty was the only issue which had a dominance of episodic framing (66 per cent) over thematic framing (34 per cent). Coverage of unemployment was primarily thematic, featuring the release of the latest unemployment figures or interviews with economists, businessmen and public officials commenting on these data and general economic activity. Racial inequality coverage was more complex and multifaceted. Three major subject matter subcategories emerged; racial discrimination, afformative action, and economic inequality. Thematic news stories, in general, outnumbered episodic stories by a slight margin.

Four models of causal and treatment responsibility attribution were identified:

1. *Societal model:* societal conditions cause the problem; societal efforts are the treatment.

2. *Individual model:* individuals are responsible for both cause and treatment.

3. *Guardianship model:* individuals are causally responsible; society is responsible for treatment.

4. *Compensatory model:* to compensate for handicaps imposed by society, individuals must extend increased efforts (Buckman *et al*, 1982).

Five experiments, conducted by Iyengar (1991), indicated that network television news tories can affect how people attribute responsibility for poverty and racial inequality. Episodic framing of poverty increased attributions of individualistic responsibility, while thematic framing increased attributions of societal responsibility. News coverage of different types of poor people may raise or lower societal attributions depending on the personal characteristics of the poor person depicted. News coverage of black poverty in general and episodic coverage of black poverty in particular increased the degree to which viewers held individuals responsible for racial inequality. News coverage of racial discrimination had the opposite effect.

Attribution of responsibility for unemployment was unaffected by the manner in which the networks framed the issue. Citizens understood unemployment primarily in economic terms under conditions of both thematic and episodic framing.

When placed in the context of actual network coverage, the experimental results suggested that the predominant news frame for poverty had the effect of shifting responsibility from society to the poor. Were the networks to increase the level of thematic framing in their coverage of poverty, the public might be more apt to consider society or government rather than the poor responsible. The prevailing direction of network news coverage of racial inequality – racial discrimination – had the opposite effect, namely, that of increasing societal attributions. When news editors decide to present stories on black poverty, however, the effect may be to shift responsibility from society to poor blacks.

Finally, Iyengar examined network television news coverage of the Iran-Contra affair. Between November 1986 and September 1987, the three main US networks broadcast more than 1,200 reports, amounting to more than 60 hours of airtime, on the story surrounding the disclosure that the Reagan administration had secretly supplied arms and equipment to Iran. Since the sale of arms to Iran and the resulting effort to finance the Contras were specific government decisions (rather than ongoing government policy) news reports about these decisions typically focused on daily events, statements, or press briefings. Virtually all the reports were episodic. But the content analysis revealed that the networks consistently employed either of the two frameworks when reporting Iran-Contra news – events were either portrayed in the context of foreign policy objectives or as the source of political controversy.

Four news frames were identified:

Political framing – negative tone: questions about presidential leadership conveying an impression of disarray at the White House.

Political framing – neutral tone; describing daily flow of events in a non-evaluative way.

Political framing – hostages: transferred viewers' attention from questions of inadequate presidential leadership to the political situation in the Middle East, in particular, issues surrounding the holding of American hostages in Lebanon.

Policy framing – specific policies: dealing with tension in the Gulf, Iran-Iraq war, US counter-terrorism policy, political in-fighting within the Iranian regime, and so on.

Results indicated that attributions regarding the Iran arms sale were moulded by the style of television news coverage. More often than not (66 per cent of all stories) the networks covered the escalating political conflict and opposition to the president generated by the arms sale, which encouraged viewers to hold President Reagan personally responsible. In contrast, news coverage that focused on the ostensible policy objectives behind the arms sale led the

123

viewing audience to consider situational antecedents of the decision by which the arms sale became a governmental response to foreign policy problems.

More generally, these results meant that when individuals are called upon to explain a significant political decision, rather than some trial episode of every-day social behaviour, their attributions of responsibility are sophisticated rather than naive. Instead of exaggerating the impact of the president and focusing exclusively on his personal traits, citizens tended to give due consideration to institutional and contextual factors beyond the president's control.

Implications of episodic framing

The public's failure to see interconnectons between issues may be a side effect of episodic news coverage. While most would agree that social problems such as poverty, racial inequality, drug usage and crime are related in cause and treatment. Television typically depicts these recurring political problems as discrete instances and events. This tendency may obscure the bigger picture and impede the process of generalisation.

The use of episodic framing by television news may result in viewers develop-ing domain-specific explanations of the causes and remedies for particular social problems. According to Iyengar (1991): 'By simplifying complex issues to the level of anecdotal evidence, television news leads viewers to issue-spe-cific attributions of responsibility, and these attributions tend to shield society and government from responsibility. Following exposure to episodic framing, Americans describe chronic problems such as poverty and crime not in terms of deep-seated social or economic conditions, but as mere idiosyncratic out-comes. Confronted with a parade of news stories describing particular instances or illustrations of national issues, viewers focus on individual and group characteristics rather than historical, social, political, or other such structural forces' (pp. 136-137).

In its principal effect therefore the dominant episodic news frame illustrates what some media scholars have termed the 'hegemonic' model of public com-munication. In this model, the dissemination of information is considered part of an elaborate 'code control' process through which existing power structures are monitored. That is, news organizations in general and television in particular tend to be spokesmen for dominant groups and their ideologies (Gitlin, 1980, Edelman, 1977; Jensen, 1987; Glasgow Media Group, 1980). Not only does episodic framing divert attention away from societal responsi-bility, but because attributions of responsibility proved to be such potent opinion cues, network news also tends to preserve the image of public offi-cials (at least those who are not the subject of scandal). Television is thus a significant resource for political élites; event-oriented and case study news coverage effectively insulates incumbent officials from any rising tide of dis-enchantment over the state of public affairs.

Objective indicators of biasing effects of television news have been covered in this chapter. These factors derive largely from research which has investigated the sensitivity of the audience's memory and understanding of news content

to the ways the news is produced, packaged and presented in news broadcasts. In addition to production techniques deployed in the construction of news programmes, other more subtle features, concerned specifically with the way stories are written about, have been found capable of shaping the impressions and opinions audiences form about various events and issues. While earlier chapters' discussion of different methods for identifying and assessing news 'biases' which comprised largely of descriptive analyses of broadcast news output had revealed a number of potentially biasing influences upon public news awareness and understanding, output measures alone cannot demonstrate any ultimate impact of televised news upon the public. The research discussed in the current chapter, in contrast, employed direct measures of audience impact and indicated, in many instances, that some of the production techniques and styles of reporting which repeatedly characterize broadcast news, may influence what audiences learn and the beliefs, opinions and impressions they develop about current events and issues. It is true, of course, that the things to which audiences pay most attention and remember best in news broadcasts, and the opinions they hold about particular issues may often be affected by factors which reside within them as individuals or the environment in which they are exposed to the news, all of which lie beyond the control of news editors and reporters. Equally, there are many ways in which what audiences take away from televised news broadcasts are directly affected by the way the news is presented, and by sets of factors which are under the control of those producing the news. The current chapter has reviewed evidence which has indicated the ways in which such biasing effects can occur in respect of the audience's acquisition of factual knowledge and understanding. The next chapter turns to evidence derived from research with audiences which has indicated how their evaluations of people, groups, events and issues in the news can be shaped by media attributes.

Evaluative Aspects of Bias: Audience Perspectives

Audience Perspectives on Balance and Neutrality

News broadcasts are shaped by a range of social, ideological and institutional factors which govern the way the news is selected, edited, packaged and presented. As well as reflecting certain dominant political ideologies which can influence the way particular events are interpreted, broadcast news incorporates an ideological notion of some form of balance between widely accepted political frameworks and a requirement to present stories which are worthy of presentation in terms of their socio-political significance and likely degree of interest to the public. Bias may be perceived where, for example, a story is selected or a position adopted which runs contrary to the widely accepted cultural, societal or national norm or expectation, and not only where the details are selectively constructed, or there is a failure to take into account different points of view to an equal or appropriate extent.

Thus, when considering evaluative dimensions of bias at the level of audience perceptions, any analysis must consider the mediating influence of pre-existing societal and individual positions on an issue, category of event or specific event, as well as the way it may have been treated by journalists and news editors. Do perceptions of underlying bias, like a pro-Conservative bias attributed to BBC news, arise from images held of the organization deriving from recognition of its position as an establishment institution funded via government, from perceptions of the general nature of its news output, or from incidents which happen on air? Can bias perceptions therefore be linked to the way news stories are constructed and presented in BBC news bulletins? Or, can any perceptions of bias which do occur be attributed to audience characteristics, such as levels of knowledge about or interest in issues, or personal political allegiances?

The question of whether or not broadcast news can be judged to be impartial from the perspective of the audience can be addressed via a number of distinct methodologies and measures. These range from subjective judgements audiences may make about news channels or news content through to more

objective indicators of news media performance in terms of the amount of information and understanding they effectively impart to their audiences. The latter can be measured through assessing audience memory for broadcast news content, knowledge gain, and shifts of beliefs or opinions contingent upon exposure to media news messages.

Objective measures of learning from the news may provide valuable insights into the role and effects of subtle 'biasing' features resident within broadcast news production practices. A growing body of sociological and psychological studies have examined social and cultural attributes as well as news production attributes in relation to the public's comprehension of broadcast news. In general, memory and comprehension levels for broadcast news programmes tend to be low (Berry, 1988; Gunter, 1987; Robinson and Levy, 1976).

It does not follow automatically that this poor news learning stems from a lack of prior audience interest in the news in general or in specific topics covered by news bulletins. Although audience interest is a factor which can affect the amount that is learned from broadcast news, it is not a sufficient condition to guarantee that effective learning will occur. Furthermore, there is evidence that broadcast news must arouse interest in the audience during its presentation, rather than depend upon pre-existing levels of news interest among viewers, in order to ensure effective learning (Berry, 1987). Indeed, prior interest may be much less important than prior knowledge of a news topic in predicting how much members of an audience will learn and remember from a news bulletin (Berry and Clifford, 1986).

Background knowledge about a topic is therefore a highly significant factor underpinning any learning of new information from a broadcast news story. If members of the audience are to effectively utilise what they know already, however, when processing the news, any new information must ideally be presented in a manner conducive to learning. There has been concern among some observers, though, that journalists and editors working in television newsrooms allow amateur psychologising about viewers to result in news construction and presentation practices which impair rather than enhance audience learning (Schlesinger, 1978). In other words, professional news production practices result in news packages which contain inherent biases against audience understanding (Berry, 1988, 1990; Robinson and Levy, 1986).

What the media bias debate has overlooked is the way the cultural product of broadcast news is processed by the viewer or listener; this is a psychological question. There are a number of distinct methodologies which can be applied to examine evaluative aspects of broadcast news bias. Objective measures of memory and comprehension of news are important, but so too are subjective perceptions of bias, if they can be properly demonstrated (Berry, 1990). Indeed, a balanced assessment of evaluative biasing effects in television news should probably include measurements of viewers' personal opinions about news content and of what they learn and understand from it.

128

Audience-based assessments can take place in an abstract context with members of the public being invited to provide personal opinions about the news provision of television as compared with other media, or can be focused on the balance of coverage and styles of presentation of particular parties, events or issues on television. Subjective perceptions of television may be idiosyncratic with one section of the audience expressing different opinions from another because they have judged television according to distinct frames of reference. The perception of political bias on television, for example, may depend upon the political allegiance of the individual viewer, rather than on some universally-agreed judgement about television coverage. The behaviour of news presenters and specific on-air features of programme presentation can influence both direct perceptions of broadcast news content and the kinds of beliefs, knowledge and understanding which viewers glean from exposure to such news output.

The principal audience indicators of biasing effects can be laid out as follows:

* General perceptions of news media
* Impact of news coverage on impression formation linked to people in the news
* Impact of news coverage on perceptions and opinions linked to events and issues
* Memory and understanding of topics and issues

General Perceptions of News Media

In assessing the global impressions held of news media by the public, much attention has been paid to the general question of *credibility*, a quality which is related to accuracy, as well as to the perceived independence and neutrality of the news. According to one commentator, the neutrality of broadcast news is dependent upon the attribution of credibility to it on the part of the audience (Smith, 1973).

In the early days of research into persuasion and propaganda, the question of whether it was better to present 'both sides' of an argument rather than one in order to achieve some persuasive purpose was investigated. At issue was the possibility that 'bias' (even when used with good intentions) might always be counter-productive, because it would undermine credibility. The news situation, however, differs from that of planned persuasion and the findings are not likely to be interchangeable. In general, research into the effect of bias has to be of a quasi-experimental or intensive nature, yielding results concerning particular content and events.

While more will be said about the measurement of audience reactions to specific news content categories or news stories in due course, some researchers have explored audience perceptions of bias at a macro-level in relation to news sources – media and channels. In one such study, Robinson and Kohut (1988) reported ratings of 'believability' for a number of US news 'sources' such as news presenters as well as specific programmes or television channels. Findings indicated that these subjective ratings varied within a narrow range.

On a scale of zero (low) to four (high), for example, the MacNeil/Lehrer News Hour came second (average score = 3.22) and *US Today* was in eleventh place (2.94). Only the President, Ronald Reagan, and the sensationalist weekly, *The National Enquirer*, received lower scores.

Morrison (1986) found perceived political favouritism on British television to be a complex phenomenon and not entirely due to views or attitudes attributed to broadcasters. Viewers in his study saw BBC1 and BBC2 as least likely to criticize the Conservative government (19 and 12 per cent respectively), and ITV and BBC1 as the most likely to (22 and 18 per cent respectively). The seeming contradictions concerning BBC1 are clarified somewhat by the differing reasons given as an explanation for the alleged inclinations.

Few viewers in Morrison's study attributed any perceived tendency of BBC1 to be critical of the present government or to anti-government motives or left-wing sympathies; but rather they singled out journalistic virtues of honesty and independence. On the other hand, a large proportion attributed perceived reluctance on the part of BBC1 to be critical of the government to pro-Conservative sympathies. Still more attributed such reluctance to government control of licence fee increases. In any event, much of the attribution of bias appears to be based on general political impressions about the BBC as an institution rather than upon specific judgements about or experiences with aspects of broadcast content.

Channel Image

Comparisons have been made of public perceptions of impartiality and bias in coverage of various groups, events and issues on television in respect of different television channels and different types of programmes. The extent to which television audiences perceive bias on television depends upon the way they are asked about it and with the generality or specificity of the frame of reference. Scales of concern about lack of impartiality on television can vary widely among viewers according to whether they are asked to consider their impressions of television as a whole, their opinions about particular television channels, or even more specifically their experiences with particular programmes. Broad-based opinions about bias associated with particular television stations may reflect a generalized image which viewers have of the channel rather than representing some measured indication of their reactions to specific broadcasts or sequences of content which have been transmitted.

Following a survey of British viewers, Menneer (1989) reported that, in the context of viewers' self-solicited concerns about television, charges of bias or inaccuracy were not widespread. Few viewers criticised the BBC on the basis of perceived bias within its programmes when asked whether they had seen anything on television the previous day that they had 'strongly disapproved of'. Indeed only one per cent of programmes were criticised by five per cent of the viewers on this basis.

More heavily prompted questions, however, can give rise to apparently wider concern about bias on television. Menneer (1989) reported that in

nationwide surveys in which respondents were asked, 'Do you ever feel the BBC – and for that matter ITV – News is in any way biased or unfair?', around one in five (18 per cent) said they sometimes felt that the BBC was in some way biased, with around one in ten (10 per cent) saying the same thing about ITV news. Further evidence from the same research indicated that among those who did perceive some bias or unfairness, more than three out of four (77 per cent) nevertheless thought that BBC news was, in general, fairly (66 per cent) or very (11 per cent) trustworthy, and seven in ten (70 per cent) thought that ITV news was fairly (63 per cent) or very (7 per cent) trustworthy. Only between one in five and one four respondents who perceived any bias at all, also felt that BBC and ITV news programmes were general untrustworthy (Bunker, 1988).

A slightly different line of questioning shed light on public perceptions of televised news in an earlier study carried for the BBC. Collins (1984) examined public opinion about whether the television channels were thought to be likely or unlikely to reflect a government view on an issue, and whether any such bias was seen to be partisan (either 'for' or 'against' the government of the time) or to reflect a more general relationship with the establishment ('for' or 'against' *any* government).

About half the respondents from a national UK survey sample of over 1,100 people aged 16+ thought that one or more channels were *likely* to reflect the government's view, and about one third of them thought that one or more channels were *unlikely* to reflect the government's view. In each case, most of these people thought that the bias would arise whichever government was in power; and perceptions were not linked to particular issues. The BBC, and especially BBC1, was seen to be pro-establishment; ITV was not clearly associated with either position.

Research reported by Gunter *et al* (1994) examined perceptions of the fairness and unbiased nature of television coverage on the four major terrestrial channels in Britain (BBC1, BBC2, ITV and Channel 4) given to groups, interests and events within five categories of programming: news, current affairs, drama (series, plays and films), entertainment (comedy, quiz, variety and talk shows), and drama documentaries. Respondents who claimed, in respect of any of these programme types, that television exhibited favouritism towards or discriminated against any particular groups, interests or events, were asked to indicate the nature of this bias. Further questions were then asked in the same survey about the fairness and unbiased nature of news and current affairs programmes on satellite and cable television channels.

Results showed that UK viewers thought the major terrestrial broadcast channels in general provided a fair and unbiased view of the world across a range of different programme types – news, current affairs, drama, entertainment, drama documentaries and documentaries. Averaged across all these programme types, around one in six respondents (16 per cent) thought that some groups, interests or events received favourable coverage whilst others were discriminated against. This opinion was most frequently mentioned in relation

to news and current affairs programming. Entertainment programming was least often perceived to contain any biased material.

Television and political party coverage

Another indication of the 'political image' of television channels has been obtained from research into the public's perceptions of the impartiality of coverage devoted to particular political parties. Annual public opinion research conducted by the UK's commercial television regulator over many years has provided a regular assessment of public perceptions of bias on television in relation to the coverage given to the major political parties (see Gunter and Svennevig, 1987; Gunter and McClaughlin, 1992; Gunter and Winstone, 1993; Gunter *et al.*, 1994). Each year respondents have been asked if they believe that television has provided fair and unbiased coverage of all political parties or whether some parties have received more favourable treatment than others. Trends in opinions over many years provide an intriguing insight into how the public's impressions of major television channels have altered over time.

Among the main terrestrial channels, ITV has been the channel most widely regarded as impartial in respect of coverage given to major political parties in Britain. In recent years, it has been followed by Channel 4, BBC2 and then finally by BBC1 (see Table 7.1). Gunter *et al* (1994) also reported that respondents who could receive satellite television channels and cable television channels were, in addition, asked if they had perceived any political party favouritism on these channels. In 1993, in respect of Sky News (72 per cent), other Sky channels (67 per cent) and CNN (58 per cent), the majority opinion among those respondents who said the received each channel was that these channels did not exhibit any political party bias. Few respondents indicated any perception of party bias (Sky News: three per cent; other Sky channels: less than 0.5 per cent; CNN: two per cent). Evidence that many viewers were still undecided about these channels or were not yet sufficiently familiar with them to have established in their own minds what kind of political stance the might have emerged from the high level of 'don't know' responses (Sky News: 25 per cent; other Sky channels: 32 per cent; CNN: 40 per cent).

Among respondents who claimed a particular channel had shown favouritism towards a political party, a further question probed to find out which party his was thought to be. The trend observed over many years has indicated a perceived pro-Conservative bias on both BBC channels. Year-on-year, the 1993 results revealed a slight decrease in pro-Conservative bias perceptions on both BBC channels and a decrease also in pro-Labour Party bias for BBC1. Perceptions of ITV exhibited slight downward shifts in perceptions of both Conservative and Labour bias, and continued to show an even split between these perceptions. On Channel 4, perceived pro-Conservative bias remained stable, while perceived Labour bias decreased (see Table 7.2). It is notable that, during a General Election year such as 1992, increased numbers of viewers showed sensitivity to pro-party bias across all the mainstream television channels.

Table 7.1 Viewers' Perceptions of Party Political Bias on Television

	85	86	87	88	89	90	91	92	93	94
	%	%	%	%	%	%	%	%	%	%
Do channels tend to favour any political party?										
ITV										
Don't know	14	16	14	19	5	18	15	17	19	17
Does not favour any party	71	73	68	65	76	66	71	66	66	69
Does favour a particular party	15	11	18	16	19	15	13	17	15	14
BBC1										
Don't know	14	14	12	14	5	14	14	13	14	14
Does not favour any party	58	62	56	59	58	55	57	56	56	57
Does favour a particular party	28	26	32	27	37	31	29	31	30	29
BBC2										
Don't know	22	21	23	22	7	2	18	19	19	18
Does not favour any party	62	61	62	63	72	58	64	63	63	62
Does favour a particular party	13	12	14	15	20	17	18	18	18	19
Channel 4										
Don't know	27	28	25	27	9	30	22	26	25	23
Does not favour any party	64	64	64	64	78	59	68	63	65	68
Does favour a particular party	10	8	11	9	13	11	10	12	10	9

Source: Gunter, Sancho-Aldridge and Winstone, 1994; ITC, 1995
Note:percentages are of all television viewers

Respondents who alleged that particular television channels had been biased towards certain political parties were asked to explain in more detail why they thought this. These responses were given in their own words to open-ended questions. The responses were then placed into categories. The most common explanation was simply that the channel in question had a 'leaning towards that party' or a reiteration of the perceptions that a party 'gets more coverage on that channel'. BBC channels were perceived more often than Independent Television channels as being 'government controlled' or 'government funded'. The BBC was also perceived somewhat more often than Independent Television as 'always pro-Government or for the party in power'. Other respondents referred to a more generalised 'impression given by programme content', an opinion which characterized perceptions of BBC2 and Channel 4 more often than BBC1 or ITV. It is worth underlining, however, that these opinions were given only by very small numbers of respondents.

Table 7.2 Viewers' Perceptions of Favoured Political Parties on Television

	85 %	86 %	87 %	88 %	89 %	90 %	91 %	92 %	93 %	94 %
Which party favoured?										
ITV										
Conservative	6	4	8	9	8	7	6	8	7	5
Labour	8	6	8	7	9	6	6	8	7	7
Liberal Democrat	1	1	*	*	1	1	1	*	1	1
BBC1										
Conservative	22	18	24	22	27	22	18	24	23	22
Labour	4	5	8	4	9	6	10	7	5	6
Liberal Democrat	1	*	*	*	*	*	–	*	1	*
BBC2										
Conservative	11	10	12	13	16	12	11	14	14	16
Labour	2	2	1	4	3	6	3	3	3	3
Liberal Democrat	1	*	*	*	*	1	1	1	1	*
Channel 4										
Conservative	1	1	2	3	3	3	2	3	3	2
Labour	6	5	7	6	7	4	6	7	5	4
Liberal Democrat	1	*	1	1	1	1	1	1	1	2

Source: Gunter, Sancho-Aldridge and Winstone, 1994; ITC, 1995
*Notes:percentages are of all television viewers; * Less than 0.5 per cent*

Impact of News Coverage on Impression Formation

The evaluations audiences place upon news broadcasts can be examined at the level of the kinds of impressions they form about people appearing in the news. Impression formation is an important aspect of our social interactions with other people. We form judgements about people on the basis of their appearance, the way they act, what they say and how they say it. Impression formation is not restricted to occasions when we meet people face-to-face, however. We also reach judgements about people we see on television.

When the news media choose to emphasize certain political attributes of politicians or political parties, for example, they may influence the way members of the public think about these political figures (Paletz, Reichert and McIntyre, 1971). The news media can confer status upon politicians and other public figures; equally, they can operate to denigrate and undermine reputations.

The credibility of the news itself can depend vitally on the opinions viewers form about news presenters and reporters. Equally, impressions that are formed about people featured in news stories can be shaped by the way they are treated by journalists and news editors. Subtle production techniques can have significant effects upon audience perceptions of the news, which sometimes operate through their influences upon viewers' perceptions of people in the news. The form of news presentation can, in this way, represent an important indicator of subtle biases in televised news.

The significance of these presentation effects is manifest not simply in the impressions viewers form as a direct result of exposure to a particular television depiction of a public figure, but also in relation to the ability of television coverage to activate pre-existing knowledge, impressions or opinions audiences may hold about that figure. This so-called 'priming' effect of television coverage was observed to occur among viewers exposed to political news stories and political advertising during the 1988 United States presidential elections, featuring the two candidates Dukakis and Bush (Schleider, McCombs and Wanta, 1991). This study found that exposure to television stories or advertisements for Dukakis primed public knowledge and opinions about this candidate, while those televised messages featuring Bush had a similar effect for that candidate causing individuals to remember things about the candidate himself and his politics beyond the information presented on television. This priming effect was candidate specific, however. Viewers who watched a news story about one candidate were not helped to remember more things about the other candidate.

Presenter factors

The focal point of any television newscast is the anchorperson. He or she introduces the programme, reads or introduces the main stories, and is responsible on screen for the smooth running of the show. Since the 1950s, when newscasters first emerged, they have become recognised as one of the most important ingredients of a successful news programme. In many cases they are celebrities in their own right who can command huge salaries on the same scale as showbusiness personalities. Television stations in the USA these days spend vast sums on research to find out if their current presenters are the right ones for the job, and often physical appearance is given more weight than journalistic ability in selecting a news team.

Performer variable research can be conveniently discussed in two parts. The first area of research has focused upon the presenters themselves and their personal attributes. The second area has been concerned with the way presenters are presented on screen. Among the major performance characteristics investigated have been the dress, facial expressions, gaze (or eye contact), and sex of the presenter. Although audience perceptions of a news presenter may be significantly affected by his or her physical appearance, the evidence for effects on learning has been far from consistent. Even so, if audience impressions are affected by presenter attributes, this leaves open the possibility that memory and comprehension of news may also be influenced and that studies conducted so far have failed to use techniques sensitive enough to measure such learning effects.

Using a teleprompter, a newsreader these days usually looks straight into camera; eye contact with the viewer is therefore direct. Sometimes, however, newsreaders still use notes when reading the news and occasionally lose eye contact with the audience while looking down at their script. A number of studies have indicated that the impression viewers form about a newsreader

may be influenced by the degree of eye contact he or she has with them. It has been found, for example, that straight looking may be seen as less pleasant than looking to the side, while a downward gaze may be perceived as less alert, less interested, and less confident (Tankard, 1971). The latter results, however, were based on judgements of single shots rather than on a continuous performance by the presenter. During a news programme in which notes are used, it may not be so much the fact that eye contact varies, but the extent to which it is directed in a certain way that matters most for audience response. There is some indication that medium eye contact (55 per cent of the time on screen) adds more precision to a speaker's delivery than high eye contact (85 per cent of time on screen) (Baggaley, 1980).

In a comparison of a desk script format (about 70 per cent eye contact) versus a teleprompt format (about 95 per cent eye contact), a newsreader with a script is rated as stronger and more organised (Coldevin, 1979). Working with a script appears to provide a more compelling perception of the presenter in that he or she is seen to be 'working' at his/her craft rather than merely delivering a monologue. Both the latter two studies call into question many television networks' reliance on maximum eye contact in news delivery. Unfortunately, neither of these studies investigated the effects of eye contact on learning. Results from early studies of eye contact effects found no significant impact on learning when viewers watch television presenters displaying high, medium, or low eye contact (Connolly, 1962; Westley and Mobius, 1960).

Eye contact does not work in isolation to affect audience perceptions of a news presenter. Julian (1977) found that a television newscaster's credibility was enhanced when he wore casual dress. Contrary to other findings, maximum eye contact also enhanced credibility ratings, and combined with casual dress, newscaster credibility was improved still further. It should be further noted that only 16 per cent of total variance in audience evaluations of the newscaster were accounted for by these nonverbal factors. Credibility of the news read by the newscaster was affected even less.

Audience reactions to a news broadcast may depend on the professionalism with which the news is presented. Normally in news programmes, events run smoothly and mistakes are rare. This is probably just as well because research has indicated that although audiences may be forgiving of minor errors in presentation, repeated and glaring upsets in the delivery may be met with harsh criticism.

Coldevin (1979) reported that following a period of monitoring news broadcasts in Canada, he had observed a number of different types of errors in news programmes including slurs in pronunciation, repeated words or phrases, hesitation in responding to an on-camera cue, or looking off to one side of the screen when the shot returns to the studio from a report from elsewhere (e.g., a film report). He subsequently conducted an experiment to examine the effects on audience response of the latter 'missed cue' error. Results showed that when this type of error occurred once or twice during a programme, viewers' opinions were not soured, but when the newsreader missed his cue

more often and took a long time to rectify his mistake, not only the news-reader but also the programme suffered a severe loss of credibility. Unfortunately, memory performance was not measured in this study. Coldevin reported, however, that viewers were conscious of the errors made by the newscaster which suggests also that they may have been distracted by them and had their memory for information in the news narrative impaired.

Production factors

In addition to the effects of presenter attributes on audience responses to tele-vision news, some researchers have also examined characteristics of the way the newscaster is himself (or herself) presented. Studies of camera angle vari-ations and visual setting have indicated that the audiences' opinions about the presenter and about the programme can be influenced by subtle variations in presentation format.

Camera angles have been found to affect audience impressions of a performer on screen. A high camera angle has been found to reduce the perceived effec-tiveness, competence, and credibility of a presenter, whereas a low camera angle has the opposite effects (Tiemens, 1970; Mandell and Shaw, 1973). The low-angle shot can be especially effective at strengthening a presenter's per-formance when used sparingly during the programme (McCain, Chilberg and Wakshlag, 1977). There is no evidence, however, that camera angle affects factual recall from a newscast (Tiemens, 1970).

The on-screen presentation can also be varied by changing the background against which the newscaster is seated. A relevant pictorial background has been found to increase the newscaster's credibility when compared with plain sets (Baggaley and Duck, 1974, 1976; Coldevin, 1978a, 1978b). The effects of visual background may be more effective with highly professional presen-ters (Baggaley, 1980).

The effectiveness of different visuals in the background behind a newscaster may also depend on the type of information they convey. Visuals designed to establish the location of an event, for example, produce the best impression when displayed in full screen behind the presenter (Coldevin, 1978a). On the other hand, visuals depicting some form of symbolic or schematic representa-tion of the theme of a news item are best located in a corner placement behind one shoulder of the presenter (Coldevin, 1978b).

The placement of background visuals may not only affect audience impres-sions of the performer and the presentation, but may also influence learning. Metallinos (1980) reported that viewers' perception, retention and preference for visual images depended on their placement or position on the screen. Viewers were shown single-frame shots of a newscaster with still visuals placed either on the left side or right side of the screen. In tests of memory for these images afterwards, Metallinos found that retention was more accurate when the visuals were placed in the left visual field.

Elsewhere, it has been observed that visual cues in the news are used to appraise the credibility of news personnel and, indeed, of any other

spokespersons who might be presented on television. If the individual speaking on screen appears to be credible, the impact of their message increases and will be more likely to bring about measurable changes in public opinion (Page, Shapiro and Dempsey, 1987). The high credibility (and resulting influence) enjoyed by anchors, reporters, and many high-level officials who appear on the news is largely a function of their television images (Graber, 1990).

The interview style of a presenter on television can influence the impressions viewers form about disputes reported in the news and of the opposing parties involved in those disputes. The way spokepersons for different sides are treated by news reporters and interviewers can affect the opinions viewers form about those individuals. Cumberbatch *et al* (1986) conducted parallel content analysis and audience perceptions studies of the way opposing parties were treated by television news interviewers during the 1984-85 mining industry dispute in Britain. The content analysis showed, for example, that there were differences in the way miners union leader Arthur Scargill and Coal Board chairman Ian MacGregor were treated on screen. Scargill tended to be interviewed in a more critical fashion than MacGregor. One explanation for the difference in treatment of these two figures may have been due to their personalities. MacGregor was not easy to interview, whereas Scargill was a skilled television performer and able to withstand sharp questioning. The latter therefore may have 'invited' more critical treatment from journalists.

Turning to viewers perceptions of the way these two figures were treated, many more respondents overall felt that miners' leader Arthur Scargill was dealt with in a critical fashion than was the case for industry leader Ian MacGregor (62 per cent versus 29 per cent). Around three times as many respondents thought that television interviewers were supportive of Mr MacGregor's position (22 per cent) than Mr Scargill's position (seven per cent). There were also differences in the perceptions of Conservative and Labour supporters. Labour voters were more likely to see television interviewers' as adopting a critical style with Mr Scargill (77 per cent) than were Conservative voters (52 per cent).

Impact of News Coverage on Perceptions of Events and Issues

An audience perspective on the tendency of television to produce biased coverage of particular events or issues can be examined in two parts. The first concerns research which has systematically investigated public perceptions of television's coverage of different events. A significant point to note about these perceptions is that they may represent a reaction driven as much by idiosyncratic properties or prejudices in members of the audience as by independent and objective judgements of television's treatment of particular events or issues. This research has tended to involve survey methodology and has focused on political events or events involving some kind of conflict. This work is best illustrated by studies of television's coverage of election campaigns and industrial disputes. The second category comprises investigations of the impact of specific textual features of news on viewers' perceptions and

understanding of issues. This area of research has involved the application of controlled experiments in which news texts have been systematically edited to emphasize or reduce the presence of particular discourse attributes.

Television and election coverage

Newsrooms and news editors take extra special care to ensure that political coverage is fair and balanced during election campaigns, through close attendance to the allocation of airtime to political parties in minutage terms. The question of how such election coverage is *perceived* by the audience requires separate assessment. The equitable allocation of airtime to politicians and political parties might testify to the impartial motives of journalists, but viewers' judgements of the coverage may be influenced by more subtle factors.

Chapter Six indicated that the extent to which television's news and current affairs broadcasts are perceived as unbiased, particularly during election campaigns, may depend on the specificity of the issues on which public judgements are requested, and on the salience of those issues for the public at the time of questioning. During an election campaign, for example, people may pay more attention to political matters than they do normally and be more critical of the way such matters are reported and discussed by the media. Furthermore, as the day on which a voting decision has to be made approaches, there is the possibility that people think even more carefully about relevant issues and the way they are covered by television.

Public opinion surveys concerning television's coverage at different stages of the 1983 British general election campaign examined the issue of impartiality towards the major political parties (Gunter, Svennevig and Wober, 1986). There were two key questions: the first concerned the allocation of party election broadcasts to parties and whether any party should have had more or fewer such broadcasts; and the second dealt with overall fairness of television coverage to different parties throughout the campaign period. Amongst the three major parties, the allocation of party election broadcasts was not equal. The Conservative and Labour parties received five slots each, and the Liberal/SDP Alliance received four slots.

Results showed that half the viewers surveyed over the duration of the campaign thought that the allocation of party election broadcasts on television was *not* fair, with under half saying it was fair. Over 70 per cent of viewers thought that television coverage generally had been fair to all parties and candidates. The allocation of party election broadcasts was most likely to be thought fair by Conservative Party supporters, and least likely to thought fair by Liberal/SDP Alliance supporters. Amongst viewers who thought that the allocation of party election broadcasts was unfair, around 60 per cent thought that the Alliance should have got more spots, whilst only a very small percentage felt the same way about the other two major parties.

Across surveys conducted just before the campaign got started, just before and just after polling day, large majorities of those interviewed said they thought that television coverage on all channels had been generally fair to all

political parties. There were differences in the extent to which supporters of different parties perceived bias in television's election coverage, however, and there were variations in the extent to which this perception was held by different party supporters. The most marked finding here was that Labour supporters became increasingly dissatisfied with the coverage given by all television channels as the election campaign progressed, and were most likely to perceive favouritism in television's treatment of certain parties after the election was over. With regard to the performance of particular channels, the majority of supporters of all parties perceived that both BBC1 and ITV had treated all parties fairly. The more significant note of dissent came from Labour supporters when judging the coverage of BBC1, where nearly one in three felt that this channel had tended to favour some parties over others (Gunter *et al.*, 1986).

Perceptions of bias in the way the major television channels had treated different political parties was examined again during the 1987 British general election campaign. This survey combined the coverage of the two BBC channels, but examined separate perceptions relating to the two commercial channels (ITV and Channel 4). As in 1983, three surveys waves were deployed just prior to the campaign, and pre and post polling day (McGregor, Ledger and Svennevig, 1987).

The proportion of viewers who thought ITV was biased remained fairly constant over the election period at around 16 per cent, but an increasing number of viewers felt BBC coverage to be partisan as time progressed. Two weeks before polling day, 18 per cent of viewers said the BBC's coverage was biased (not many more than thought the same about ITV at that stage) but after the event over one in four viewers thought BBC coverage of the election campaign had favoured some parties over others, many more than retrospectively felt the same about ITV's coverage. There was also a corresponding decrease in the proportion of people who considered the BBC to have treated all parties fairly (see Table 7.3)

Table 7.3 Levels of Perceived Bias in Different TV Channels'
Coverage of the 1987 General Election Campaign

	BBC			ITV			Channel 4		
Wave	1	2	3	1	2	3	1	2	3
	%	%	%	%	%	%	%	%	%
Favoured some parties over others	18	22	27	15	16	17	11	10	4
Treated all parties fairly	71	68	62	71	72	69	68	78	79
Don't know	11	10	11	14	13	14	20	12	17

Source: McGregor, Ledger and Svennevig, 1987

Comparatively few viewers (around one in ten) claimed to have seen anything about the general election on Channel 4, and of those who did a relatively larger proportion seemed to have no particular opinion about the fairness or

otherwise of its coverage. Nevertheless, among its viewers who expressed an opinion, Channel 4's coverage was seen to be the fairest of all. By the end of the campaign, and after the election, more than three in four viewers thought Channel 4's coverage had been fair to all parties, a significantly greater proportion than for BBC or ITV.

Labour voters were more likely to feel that BBC and ITV coverage was biased than either Conservative or Alliance voters. Such was also the case during the 1983 general election. During the 1987 election the proportion of Labour voters claiming bias on BBC increased from 29 per cent to 38 per cent between the second and third survey waves, while the respective figures for ITV was 18 per cent and 28 per cent.

Although a significantly greater proportion of viewers felt BBC, rather than ITV, coverage to be biased, the perceived direction of that bias on both services was very similar. Of those people at the end of the campaign who felt BBC-TV or ITV coverage to have been unfair, the greatest proportion felt that there had been *too much* coverage given to the Conservative Party, and that the tone and approach had been too favourable towards the Conservative party. Between two and three in ten felt either that coverage of the Labour party had been too much or too favourable; but less than one in ten felt the same about coverage of the Alliance. At the same time, very few viewers (less than one in ten) felt that either the Conservative Party or the Labour Party had been given *too little* coverage on BBC and ITV.

Overall therefore it is clear that most people (two-thirds or more) thought that television treated all parties fairly. Among those who felt that the broadcast media showed some favour, the Conservative Party was felt to be the most favoured party, and the Alliance least favoured. This paralleled viewer opinions of coverage of the 1983 election campaign.

Research conducted by the BBC and Independent Television Commission explored public perceptions of bias in television's coverage of the 1992 general election. In addition to asking about overall television coverage of the major political parties a key aspect of election coverage on television, once again, was the allocation of party election broadcasts. As in earlier elections, the allocation issue was not agreed without controversy. The allocation proposed by the broadcasters based on a long-standing formula has as its main criteria the proportion of votes cast in the previous general election, with due allowances for by-election results and changes in party allegiances during the course of the ensuing parliament. In the 1992 election, the Liberal Democrats objected, refusing to accept their allocation of four broadcasts, against the two larger parties' five broadcasts each. Legal action was threatened but not pursued, and in the end the broadcasters imposed a settlement on the parties without formal agreement.

Of more significance than the allocation issue is the use to which the parties put the broadcasts. Originally intended to give them access to the airwaves to put across their arguments unmediated by journalists, they have now become

almost exclusively vehicles for image building. Advocates of this approach argued that party election broadcasts have become more professional productions, and therefore more likely to appeal to viewers. Whether or not this is what voters really expect or want from these broadcasts, however, is a matter which remains open to question. Image-making may influence the electorate's impression formation in relation to political candidates' personalities, but reveal little about where parties stand on key electoral issues.

The movement towards high production values in 1992 was accompanied by other developments in the character of part election broadcasts which were not universally regarded as desirable. The first was the use of dramatic reconstructions. This technique was employed most notoriously in the Labour Party election broadcast on the health service, where actors were used to impersonate two little girls with ear ache. One was able to have her problem cured privately and the other was forced to wait in pain because of the queue for national Health Service treatment (which became known as the case of 'Jennifer's ear'). The identity of the real life little girl was leaked to the press and, on investigation, the story turned out not to be quite so straightforward as the party election broadcast had claimed. The row about this broadcast dominated the campaign for several days, ending with a feeling that the broadcast had backfired on Labour. The argument over who leaked the name obscured the unease many broadcasters felt about the use of drama-documentary techniques in a party election broadcast. Their own programmes using such techniques are subject to tight guidelines. No such guidelines bind the parties, who are given the airtime on trust.

There was unease, too, about the growing use of 'dirty tricks' in party election broadcasts. There was an attempt, in this series, to make unauthorised use of copyright material which showed the Labour leader, Neil Kinnock, in an unfavourable light. This was headed off by the threat of legal action, but should never has arisen in the first place. Another 'dirty trick' which was employed in the 1992 campaign was the use of the opposing party's telephone number, resulting in that party's switchboard being plagued with nuisance calls.

Public opinion research was carried out by the BBC and ITC throughout the campaign using a national television viewing panel, which was supplemented by a series of BBC-commissioned surveys with a national telephone omnibus survey, and pre/post-polling day face-to-face interviews with national survey samples sponsored by the ITC.

Throughout the election campaign between seven and eight out of ten respondents said that they felt both the BBC and ITV had been fair in their coverage of the major political parties. The issue of perceived fairness of television's election coverage was also pursued in respect of the campaigns run by the major political parties in the ITC's UK-wide panel of viewers of voting age who were interviewed by NOP a few days before and again a few days after polling day (Wober, 1992). Opinions were also separated out for supporters of different parties. All respondents in the post-election wave were asked for

their general assessment of television election coverage of different parties' campaigns (see Table 7.4).

Table 7.4 Perceived Fairness of Television Parties' Campaign Coverage in the 1992 General Election

	Television coverage of campaigns by:			
Weighted base:	All 742 %	Conservative 742 %	Labour 723 %	Liberal Democrat 723 %
Very fair	18	19	18	16
Fair	60	60	58	62
Sometimes unfair	9	8	10	10
General very unfair	3	2	4	3
Don't know	10	10	10	9

Source: Wober, 1992

Overall, over three out of four respondents (78 per cent) felt that television's election coverage had been fair. This view was firmly in place in respect of the Conservative party campaign coverage (79 per cent), and clearly so for the Labour campaign (76 per cent) and Liberal Democrat campaign (78 per cent).

Differences in perceptions of the fairness of television's coverage of each major party's campaign were separated out on the basis of respondents' pre-election voting intentions (see Table 7.5). As can be seen, while the overwhelming majority of respondents, regardless of who they supported, felt that television had been fair to all parties' campaigns, there were some marked differences in the minorities who perceived party coverage to have been unfair, which were related to partisanship. These differences of opinion were most pronounced in respect of the campaigns run by Labour and the Liberal Democrats.

Table 7.5 Perceived Fairness of Television Campaign Coverage: Partisan Views

	Perception of Campaign Coverage of:								
	Conservatives			Labour			Liberal Democrats		
Pre-election voting intention:	Con	Lab	L/D	Con	Lab	L/D	Con	Lab	L/D
Weighted base:	298 %	203 %	145 %	296 %	198 %	141 %	296 %	198 %	141 %
Fair	80	85	75	78	77	73	80	84	69
Unfair	11	9	12	11	20	13	9	3	20
Don't know	19	5	11	11	3	14	11	3	11

Source: Wober, 1992

Labour supporters were twice as likely as Conservative supporters to say that television had been unfair to Labour's campaign. Liberal Democrat

supporters were substantially more likely than either Conservative or Labour supporters to say that television had been unfair to their party's campaign. Liberal Democrat supporters also exhibited easily the smallest majority who believed that their party had been treated fairly by television.

Respondents who said that television had been unfair to the major political parties were asked to identify the channel(s) on which they perceived this to have occurred. In respect of all three major parties – Conservative, Labour and Liberal Democrat – BBC1 was nominated more often than any other television channels, followed by ITV. BBC1 was twice as likely to be mentioned in respect of unfairness to the Labour Party as was ITV (47 per cent versus 23 per cent). Around one in three respondents on average replied that all of the channels had been unfair to the major parties (Wober, 1992).

TV coverage of industrial disputes

Broadcasters are required to observe requirements for due impartiality not only in relation to coverage of political matters but also when covering stories about industrial controversies and disputes. One of the most significant contributions to the topic of television's coverage of industrial conflict in terms of stimulation of debate is the collected works of the Glasgow Media Group (1976, 1980, 1982). Beginning with a standard form of content analysis, the Group moved progressively away from pure reliance on this methodology towards a greater emphasis upon literary or textual analysis, structuralism and semiotics.

From such in-depth analysis of news messages, not only do we gain a quantitative assessment of news provision by topic and by positioning of stories in programmes, but also a qualitative impression of certain other subtleties of news production processes, the ideologies which lie behind them, and the message which may arise out of them. The combination of 'hard' and 'soft' forms of content analysis yields a rich assessment of television news texts from which valuable pointers to audience research can be derived.

Content analysis is not audience research and the 'messages' explicit or hidden which it identified may or may not have reality in terms of an audience's experience of the news. Accusations of bias on the basis of content analysis are not invariably substantiated by audience perceptions. This is not to say that content analysis is wrong under such circumstances, but rather to underline the fact that there are different perspectives from which media representations of reality can be judged.

One analysis of audience evaluations of an industrial conflict examined public reactions to television coverage of the mining industry dispute which occurred in the mid-1980s. Cumberbatch, McGregor, Brown and Morrison (1985) carried out three public opinion surveys, two with members of the general public and a third with a sample drawn from a small mining community in Yorkshire. Among the issues examined were general perceptions of television news bias in the coverage of this long drawn-out dispute. The findings are particularly interesting for their demonstration of how opinions can

vary among different communities whose different standpoints lead them to judge the same television content in different ways.

In keeping with the results of general attitude surveys about television, a clear majority of national survey respondents in this study (around 60 per cent) considered television news to have been impartial in its coverage of the dispute. This impression was not held with equal force across the television audience. There were marked differences among people in their perceptions of BBC and ITN news coverage which were associated with their own political inclinations and leanings. With respect of BBC news coverage of the dispute, for example, Labour voters (32 per cent) were four times as likely to regard this coverage as biased against the miners as were Conservative voters (eight per cent). This difference did not change over the one year duration of the miners' strike. In respect of ITN coverage, Labour voters (31 per cent) were considerably more likely than Conservative voters (five per cent) to perceive bias against the miners. Fewer than one in two Labour voters felt news coverage on the two main channels had been impartial compared with two in three of Conservative voters.

Further insights into general perceptions of bias in television's coverage of the mining industry dispute were obtained from the survey of the mining community in Yorkshire. Being more closely involved with events, opinions were more extreme among this sample. Very few respondents, and none who were employed by the mining industry, felt that television in any way showed favouritism towards the miners. Nearly three out of four respondents (73 per cent) felt that BBC television news coverage and two in three (67 per cent) thought that ITN news coverage was biased against the miners, with between one in six and one in five (15 per cent for BBC and 19 per cent for ITN) saying it was impartial. Even more extremes of opinion were found among striking miners themselves in this mining community. Nearly nine out of ten (89 per cent) claimed that the BBC was biased against the miners and eight out of ten (80 per cent) said the same about ITN. Non-miners in this mining community were somewhat less intolerant with just over half (54 per cent) saying that BBC and ITN were biased against the miners.

It was clear that those individuals embroiled in the dispute held more critical opinions about television's coverage of the striking miners than anyone else. Cumberbatch *et al* (1986) argued that people close to events may know much more about their history or at least are closely attached to a version of history. It is important that media coverage should measure up to this history and give a full rather than a condensed account. The nature of broadcast news is such that this is an objective which is difficult to achieve. There is also the possibility, of course, that individuals who are committed to a particular side in a dispute become extra sensitive to any criticisms of that party and may perceive a greater unfairness than is in fact warranted.

News Exemplars and Viewers' Perceptions of Issues

Public opinion surveys of bias in television news and other factual programme output depend on the subjective judgement of viewers about television

broadcast material in its natural form. There is no attempt by the researcher to manipulate the content or form of the broadcasts. Moreover, viewers' opinions may reflect personal dispositions as much as sound judgement about the nature of broadcast output or intentions of those who produced it. Another approach to the investigation of biasing in issue presentation on television has been to adopt an experimental methodology in which television content is systematically manipulated by the researcher to produce subtly different versions of the same news story. The style of story telling is varied especially with respect to the way certain key points in the story are illustrated. The effects that such manipulations have are measured through assessments of respondents' memory and comprehension of story content and their opinions on relevant issue-related points. Respondents are unaware of how a story has been manipulated in terms of its text features, however, and merely react to the story version they are given.

Journalistic reports of social phenomena contain two major types of information : (1) baserate information indicating the status of the issue under consideration, and (2) exemplifying information, or exemplars, about individuals whose experiences illustrate the scope of the phenomenon. Journalists combine the two types of information in news reports as a means to explain often complex social issues in language that is both understandable and interesting to their readers or viewers (Garrison, 1992; Izard, Culbertson and Lambert, 1990; Newson and Wollert, 1985).

Baserate information, which refers to general descriptions of the number of people or things involved in a given social phenomenon, may vary substantially in precision of quantification, ranging from ratio-measurements involving minimal error to intuitive appraisals expressed in ordinal comparisons (Fiske and Taylor, 1984; Nisbett and Ross, 1980).

Exemplars or case descriptions, on the other hand, are judged in terms of typicality rather than by quantified precision. Assuming that the outright fabrication of exemplars is rare in journalism (Abel, 1984; Peterson, 1956), case descriptions are presumed to be veridical and, to qualify as exemplars, to define incidents that fall within the realm of a social phenomenon under consideration. Ideally, such exemplars should feature frequently occurring typical cases. Yet typicality is not always the criterion used by journalists in selecting exemplars. Instead, case descriptions are frequently chosen for their dramatic, entertaining, or sensational qualities rather than their accurate reflection of the topic of the news report (Bogart, 1980; Haskins, 1981; Rothbart, Fulero, Jensen, Howard & Birrell, 1978).

Atypical exemplars are often selected in preference to more drab, typical ones. Moreover, such atypical exemplars are often aggregated, one after the other, forming series of highly entertaining but nonrepresentative case descriptions (eg, a report on carjacking victims is liable to focus on individuals who were brutally harmed, in spite of the fact that few carjacking victims suffer any type of serious injury).

146

Such aggregation of atypical exemplars, while possibly appealing to the imagination of readers or viewers, has been found to distort their perceptions of, and beliefs about, particular social phenomena (Brosius and Bathelt, 1994; Zillmann, Perkins and Sundar, 1992). It would appear, then, that distorted exemplification is neither in the public interest nor in the interest of journalists committed to informing the public in the most veridical, accurate way possible.

Nevertheless, the journalistic practice of selective exemplar usage is justifiable to some degree. Variation within a defined population of events of interest can be such that a subgroup in focus constitutes a small minority, and that the majority of events cannot possibly be exemplified in proportional terms. For instance, if the risk of complications from a particular vaccination is one out of three million, it would be absurd to consider proportional exemplification with persons who suffered complications and persons who did not – in an effort to be fair to the representation of the risk. Limiting exemplification to a subgroup of events thus seems unavoidable, even appropriate. Problems only arise to the extent that the subpopulation is poorly or not at all defined, leaving the impression that a larger than actual group is represented.

The practice of using series of atypical exemplars raises enticing questions about consequences for the perceptions and evaluations of the social phenomena addressed in news reports. If it were safe to assume that readers or viewers attend to all news stories with great concern and interpret the acquired information critically and cautiously, it would seem reasonable to conclude that these news consumers recognize the selective use of exemplars and are able to put the information appropriately into perspective. It appears, however, that such well-informed and motivated readers or viewers are small in number. Social-cognition research (e.g., Fiske and Taylor, 1984; Gunter, 1987; Kahneman, Slovic and Tversky, 1982; Nisbett and Ross, 1980; Tversky and Kahneman, 1971, 1974) suggests a more realistic model of the typical news consumer, one for which the absorption of news information is far less than perfect. Information intake, storage, and processing, as well as the formation of impressions and judgments, are subject to distortion by cognitive shortcuts. Forced to deal with massive amounts of information in limited periods of time, individuals become 'cognitive misers' and employ paradigms of reasoning known as heuristics (Kahneman *et al.*, 1982; Sherman and Corty, 1984; Taylor, 1981; Tversky and Kahneman, 1974). Such shortcuts often override the application of basic statistical considerations and allow for proficiency primarily at the expense of thoroughness.

The availability heuristic (Tversky and Kahneman, 1973) applies most directly to the consequences of selective exemplar distribution in news reported. Individuals employing this heuristic evaluate the frequency or likelihood of events in relation to the ease and quickness with which pertinent instances or associations come to mind – or more specifically, are retrieved from memory and avail themselves in information processing that services the formation of judgment. Although this method is skewed by storage, search, and retrieval

biases, the heuristic produces relatively reliable judgments in cases where a fair number of randomly aggregated events have been witnessed within a relatively short period of time. Such precision is lost, however, when the conditions for attention are less ideal, which they usually are (Kahneman and Tversky, 1972; Paivio, 1971; Rothbart *et al.*, 1978).

Ease of retrieval of pertinent cases then exerts a strong influence on judgment and is capable of biasing it in predictable ways. More specifically, the frequent and recent activation of atypical case memories appears to lead to the misjudgment of the frequency and likelihood of the population of cases, making case-related events appear more prevalent than they actually are (Sanbonmatsu and Fazio, 1991; Srull & Wyer, 1979, 1986; Wyer and Srull, 1981).

It might be suggested that the projected misperception of issues caused by the selective use of exemplars in news reports could be readily corrected by the inclusion of reliable baserate information. The combination of general information and multiple exemplars – the predominant pattern for news reports of social phenomena – should enable readers or viewers to grasp the overall scope of an issue and place exemplars in perspective as simple illustrations of individual manifestations of a broader, pluralistic phenomenon. The research evidence on this point, unfortunately, is not encouraging. It has been observed repeatedly that readers pay comparatively little attention to abstract baserate information about population characteristics, but that they attend more strongly to, and are more influenced by, concrete anecdotal, but usually less valid and reliable information (Bar-Hillel and Fischhoff, 1981; Fiske and Taylor, 1984; Manis, Avis and Cardoze, 1981; Manis, Dovalina, Avis and Cardoze, 1980; McArthur, 1981).

Hamill, Wilson and Nisbett (1980), for example, found that readers of reports about welfare recipients formed their impressions on the basis of colourful, yet atypical, case descriptions rather than precise baserate data. The effect was present even when readers were specifically told that the exemplars were not typical of welfare recipients. The inclusion of extreme exemplars, often involving sensational accounts of shocking acts, appears to enhance this dominant influence of exemplars (Rothbart *et al.*, 1978).

It should be noted, however, that instances exist in which baserates are considered. When baserate information is the only information provided, respondents do form their judgments on the basis of it (Hamill *et al.*, 1980; Manis *et al.*, 1980; Nisbett and Borgida, 1975). Also, respondents are more likely to use baserate information if its causal relevance to a judgmental task is made salient than if it is not (Ajzen, 1977); and if exemplars are presented so as to appear less relevant to a judgmental task, they are ignored in favour of baserate information (Ginosaur and Trope, 1980). Overall, however, when placed in competition with vivid exemplars, the usually more pallid baserate information is largely disregarded.

The dominant effect of the aggregation of exemplars in news stories has only recently received scholarly attention (Brosius and Bathelt, 1994; Zillmann,

Perkins and Sundar, 1992). The initial investigations addressed implications for issue perception of dichotomous distributions of exemplars featuring distinct events in populations of interest. Specifically, they sought to determine (a) whether the distribution of exemplars in a sample of exemplars representing distinct events influences presumptions about the distribution of these events in the population, and (b) whether in news reports exemplar distributions dominate baserate information in their effect on issue perception the way they do outside journalistic endeavours.

Zillmann *et al* (1992) examined this issue by presenting different versions of a news magazine report on weight regaining by dieters. Baserate information about the percentage of people who regain weight after participating in a diet programme (about one-third) was combined with varying distributions of exemplifying case descriptions. In a first condition, exemplar distribution was selective, featuring only cases consistent with the focus of the report – that is, people who had regained their weight (nine minority exemplars). The second, representative condition involved a distribution of consistent and inconsistent cases in proportion with their actual distribution in the population (three minority versus six majority exemplars). Mixed exemplification, in a third condition, featured a distribution of consistent and inconsistent cases that gave recognition to the majority of cases, but over-represented the focal minority of cases (six minority versus three majority exemplars). The news stories were also manipulated to create versions differing in the degree of precision of general information (precise and imprecise). Respondents were asked to estimate the proportion of weight-regaining dieters either immediately after exposure to the report or two weeks later. Accuracy of estimates was found to be higher for reports presenting precise general information than for reports presenting imprecise information, an effect which was stable over time. Exemplifications, however, produced markedly stronger effects immediately after exposure. Results indicated that exposure to selective exemplification led to a gross overestimation of the relative frequency of weight regainers, compared to the effect of mixed and representative exemplar distributions. Although baserate information stated that an average of only one-third of dieters regain their weight, respondents who had read stories featuring only selective exemplars estimated that 75 per cent of dieters were unsuccessful in keeping off their weight. Over time, respondents regressed toward initial beliefs, removing the effect of exemplification.

A series of four experiments by Brosius and Bathelt (1994) further explored the impact of exemplar distributions on impression formation and extended it to persuasion. In these studies, the researchers varied the number and the ratio of exemplars representing majority and minority positions, the vividness of the exemplars, precision of baserate information, the medium of presentation, and time of measurement. All studies utilized stories about four topics: the replacement of coin telephones by card telephones in a small town, the quality of university cafeteria food, the quality of traditional apple wine in Frankfurt, Germany, and the introduction of obligatory personal-computer

courses. In the first experiment, it was found that stories with exemplar distributions consistent with the baserate information were perceived as more professional, informative, and credible, and also as less biased. Moreover, even for the inconsistent versions, respondents did ascribe the stories an average credibility and journalistic quality. In this first experiment, the researchers found a strong main effect of exemplar distribution on perceived majority and minority opinions. Students asked to recall majority and minority opinions stated in the news reports thought them to be proportional to the ratio of majority and minority exemplars presented. For example, the baserate information in the first story indicated that the large majority was against the use of card telephones. In the consistent exemplar version, the perceived distribution of opinions reflected exactly the distribution of exemplars with four against and one in favour of card telephones. In the inconsistent exemplar version, the perception of majority and minority opinions was equally influenced by the exemplar distribution, although in the opposite direction. This was despite the presence of baserate information to the contrary.

Additionally, the exemplar distribution had an effect on respondents' own opinions about the four issues mentioned in the news reports. With independent baserate information, respondents showed a tendency to follow the majority opinion suggested by the distribution of exemplars. No evidence was found to support the notion that vividness of language had an influence on the respondents' estimates of opinion distributions or of their own opinions.

In their second study, an extension of the first, the baserate information was presented in relative terms. Again, results revealed a strong effect of exemplar distribution and no appreciable effect of vividness of language. However, the effects on subjects' own opinions were weaker than in the first experiment.

The third study systematically varied the distribution of exemplars. The experimental versions varied from exclusive exemplification of the baserate information (ratio 4:0) through complete contradiction (ratio 0:4). Results indicated that despite the baserate information, which was identical in all conditions, the perceived distribution of opinions in the population reflected the distribution of exemplars nearly perfectly.

In their final experiment, the researchers used both print and radio versions of the stories (the first three projects utilized only radio versions). Results showed that the effects of exemplar distributions were also strong for the print versions, although the effects were slightly weaker than those found in the radio versions. The final study also investigated the delayed effects of exemplar distribution. It was found that the effect of exemplar distribution was present a week after exposure to the news reports. Although consistent and inconsistent exemplar distributions were less polarized after the week, the effects were still apparent.

News Memory, Comprehension and Perceptions of Bias

A primary objective indicator of bias in the news is the extent to which the audience is able to obtain an impartial understanding of the stories, topics,

issues and events that are presented in news broadcasts. In the last chapter, we saw that there were various factors within the presentation of the news itself on television which could 'bias' the way audiences acquire information from news broadcasts. The factual quality of the news, in terms of its accuracy and completeness, is an essential prerequisite of a balanced, comprehensive and unbiased learning experience. The fact that a news story contains all the key details of an event, however, is not enough to guarantee that this information will effectively get through to viewers. Research into what people remember and understand from broadcast news transmissions has consistently shown significant levels of learning failure. While this can be explained in part by audience factors, memory or comprehension breakdown among viewers tested on their retention of content from a televised news programme cannot be fully explained in this way. The way the news is put together can affect not just how much news is remembered and understood, but more significantly which stories are selectively retained at the expense of others.

The current chapter is concerned with the measurement of bias in television news from an evaluative rather than a cognitive perspective. This means that it is concerned with qualitative aspects of the audience's experience of the news itself rather than simply with subjective impressions about the accuracy, completeness and relevance of the factual content presented and objective indications of the extent to which that content is absorbed. Thus, whether or not the news is factually correct, does it cover all aspects of a story or all sides to a dispute in an equal or duly appropriate fashion?

The last chapter reported a study by Berry *et al* (1993) which demonstrated how the way a news story is written can significantly affect how effectively it is learned by viewers. Berry (1990) had earlier argued that the ability of audiences to learn from broadcast news items could be severely impeded by poor story construction which placed a greater strain on the cognitive information processing capacities of viewers. This strain could be eased and, in turn, learning assisted by re-writing news stories according to certain rules which could render the information in a story more readily understood. Any misunderstanding of news caused by inadequate text structures might also influence audience perceptions of 'bias', and this might be particularly likely to occur with stories which deal with topics of significance to viewers and about which they already have a solid foundation of background knowledge.

To test this hypothesis, Berry and his colleagues set up a study to find out whether the perception of bias is favoured by incoherences arising from distorted text structure. It has already been noted that television channels (in Britain at least) differ in 'image' for political bias vis-a-vis the government (Morrison, 1986; Gunter and Svennevig, 1990). BBC1, for example, is general regarded as showing favouritism towards the Conservatives, and Channel 4 is perceived to incline towards Labour, though less strongly. This feature could be important to the impressions viewers form about specific news broadcasts because the bias 'image' of a channel was found to be correlated with the degree of bias seen in specific respects in news items broadcast on

that channel (Berry, 1990). This implies that bias in news that has actually been watched could be shaped to some degree by the more general channel image.

Berry *et al* (1993) therefore conducted an experiment in which the channel from which a news bulletin derived was manipulated as well as the text structure of certain key items in that bulletin. BBC1 and Channel 4 were chosen as channel news sources because they had already been shown by prior survey research to exhibit contrasting channel images in terms of their institutional political leanings. BBC1 was generally perceived by the public to exhibit more pro-government bias, while Channel 4 was perceived to exhibit more anti-government bias. It was hypothesized that attribution of news to BBC1 would produce greater perceived pro-Thatcher government and possibly anti-Labour bias in appropriate stories. Since such bias is held to arise through poor comprehension of incoherent text, it was predicted that it would be reduced by text restructuring in line with certain principles of story grammar and restoring narrative order.

Comprehension and bias perceptions were measured in the case of two stories which dealt with a visit by Mrs Thatcher, as British Prime Minister, to Kenya, and a second story about Yorkshire coal mines. Restructuring of the story narrative was found to produce better comprehension. Background (general) knowledge of public affairs also made a difference for one story, but not for the other. Less general bias was perceived with the reordered news texts than with the original television production version. Source attribution (ie, whether the story was shown on BBC1 or Channel 4) had no overall effect on general bias perceptions. Bias was perceived, in the Kenya story, as favouring Mrs Thatcher. This perception was diluted significantly when the news text had been re-written to improve its comprehensibility. Text revision made no significant difference to perceptions of bias in the Yorkshire miners story.

This study thus produced initial evidence that restructuring of a news text to render it more grammatical and logically ordered improved learning from both news stories, by enhancing the probability that information central to a basic understanding of the stories would be properly attended to and assimilated. This manipulation of the news text also altered perceptions of bias in one of the stories, producing more neutral perceptions of the story's political leanings.

Audience characteristics and perceptions of bias

Television audiences do not comprise a single homogenous mass of individuals. Viewers come from varying social backgrounds and hold different opinions about political and social issues. The demographic and psychological character of the audience can mediate the use viewers make of television, and their perceptions of its representations of reality. In assessing the degree of perceived bias on television, these audience variables need to be taken into consideration. Any judged 'bias' as such may reflect individual prejudices or perspectives of audience members leading them to disagree with the tenor or

argument of media messages, rather than indicating some inherent lack of neutrality of the part of media content.

Viewers' socio-economic class has emerged as a key factor in relation to the general level of audience concern about bias on television. Menneer (1988) reported that the professional classes (social grades AB), and readers of quality newspapers were easily the most likely groups to express concerns about partiality on television. The expressed political leanings of the audience can also significantly affect perceptions of political bias on television. Menneer (1988) reported that viewers who indicated an intention to vote Conservative were more likely to perceive bias towards Labour than towards the Conservatives on both BBC and ITV News. In contrast, viewers with a Labour voting intention, perceived Conservative bias more often than Labour bias in the news.

Gunter *et al*, found that opinions about impartiality in different programme types exhibited some variations according to respondents' stated degree of interest in politics and with which party they intended to vote for or were likely to support in the event of an election. This was most likely to be true with regard to perceptions of impartiality on news and current affairs programmes. Respondents who said they were very or fairly interested in politics were less likely than respondents who had little or no interest in politics to rate television news as fair and unbiased (67 per cent versus 75 per cent) and more likely to say it either favoured or discriminated against some groups, interests or events (27 per cent versus 17 per cent). A similar division of opinions occurred with regard to current affairs programmes. Politically interested respondents (30 per cent) were more likely to perceive bias in current affairs programmes than were those with little or no political interest (17 per cent).

Support for a particular political party proved to be a sensitive discriminator of opinions about impartiality in different programme types. Generally, Labour supporters were more likely to perceive factual programmes as fair and unbiased and less likely to perceive them as showing favouritism or unfair discrimination than were Conservative supporters. Liberal Democrat supporters, if anything, tended to see more favouritism and discrimination across all programme types. The latter also exhibited a marked shift in opinion in 1993 compared with 1992, adopting a more critical view of current affairs, drama documentaries and drama in terms of fairness.

In reporting conflicts in the news, producers and viewers may find it difficult to remain neutral or objective. This is particularly true when one of the sides in the conflict happens to be one's own. Although even disputes and violent confrontations between to distinct parties may be defined in terms of who is the villain and who is the victim. Media coverage of the Vietnam War and the Gulf War represent two examples of conflicts during which journalists identified with soldiers from their respective homelands (Hallin, 1986; Liebes, 1992b).

Matters of this sort can become even more complicated when conflict takes place within one society. The enemies are no longer from without; the con-

frontation is internal. In such a situation, while the public may be divided, the heroes of the story seem to be the heroes of those with access to power and media. In Northern Ireland, in South Africa, and in Israel, a struggle is portrayed between 'us' (dominant élites) and 'them' (Catholic, blacks, Arabs). Those who report such conflicts often suspend their usual sympathy for underdogs and their professional commitment to balance and produce stories that favour those in power; all the more so, as the conflict escalates and more people on 'our' side suffer (Gans, 1980; Gitlin, 1980).

In matters of industrial conflict, there are occasions when the media attempt to create an 'us' and 'them' situation by portraying one side in the dispute as having greater justification for their actions then the other. This approach may be brought into particularly sharp focus when one or both parties in this dispute are represented by powerful leaders between whom the dispute can be portrayed on a more personal level. The perceptions which people hold about media coverage of such events may depend critically on how closely involved they or their immediate communities are in those events. In a study of public reactions to media coverage of the 1984–85 coal miners strike in Britain, Waddington, Wykes, Critcher and Hebron (1990) showed that striking miners and their families held particularly critical opinions about the way they had been treated by the news media. Waddington *et al* conducted in-depth individual interviews, focus groups and a questionnaire-based survey of people living in three mining communities, some of whom were striking employees of the mining industry. These individuals were closely involved with the events being covered by the media and held strong opinions about the treatment given by broadcasters and the press to different aspects of the coverage. News coverage was generally perceived to be biased against the strikers, pickets and the miners union leader, Arthur Scargill, and generally more favourably disposed towards the police, employers and any miners who continued working. Non-mining families in those same communities exhibited opinions about the news media coverage of these various parties which were generally much less polarised, although even they felt, on balance, that the news media, including a number of mainstream television news programmes, had shown more favourable coverage of the police and employers than of the striking mineworkers.

What Waddington and his colleagues were not able to show, however, was the extent to which the perceptions that these communities held about the way this industrial dispute was covered by the major news media derived from legitimate judgements about the reports journalists had filed derived, for example from their experience of specific broadcasts, or whether for them a shift had occurred in where the fulcrum of balance and impartiality might be found, because of the closeness of their involvement with the dispute.

In neglecting to give voice to the 'other' side, journalists are trapped in what social psychologists understand to be a fundamental attribution error. According to this theory, people tend to see their own successes and others' failures as resulting from personal dispositions, while their own failures and

the successes of others are attributed to external, situational factors (Eiser, 1983; Pettigrew, 1979). Whether or not journalists are to blame for their biased presentation of the conflict, such a perspective is likely to reinforce viewers' own tendencies to blame the other side. Indeed, in reconstructing news stories, those who watch television are found to attribute diverse reasons for violence committed by each of the sides (Liebes, 1992a). Thus, reporters' representations of us (the familiar and reliable individuals who use force as a part of their job and only in response to unjustified attacks) and them (a mass that initiates irrational violence) strengthens viewers' belief that we are inherently good and that they are inherently bad.

Liebes and Riback (1994) reported a study based on conversations with 50 Jewish and 15 Arab families in Israel during and after the evening television news programme called 'Mabat'. The practices of partisan journalists who belonged to one of the sides in the conflict was found to reinforce viewers' tendencies to attribute dispositional motives to aggression of the other side (in this case Palestinian uprisers).

Analysis of the families' discourse revealed that Jewish and Arab nationalists accepted the news text at face value. Jewish extremists read it hegemonically while their Arab counterparts decoded it oppositionally. Jewish and Arab moderates, on the other hand, negotiated the text and, drawing on their personal and collective experiences, invoked various rhetorical strategies to counter the unbalanced picture it presented.

Liebes and Rivka (1994) observed that the Palestinian uprising was presented alternatively as one of two types of conflict. On some rare occasions, with much caution, the intifada was referred to as civil war, with the source always identified and the view individualised. More often, however, the intifada was framed as a protest, like violent demonstrations of powerless social groups as in cases of urban riots, anti-war protests and workers' strikes (Gans, 1980; Gitlin, 1980; Glasgow Media Group, 1976; Murdock, 1973). Such confrontation between centre and marginal groups or between two enemies may reinforce viewers' tendencies to account for their own failures in situational terms while elating others' failures to their nature and disposition.

Viewers arrived at interpretations of news texts through either dominant or oppositional readings, with either of these two groups being equally comfortable with the news at it was framed. Dominant readings by Jewish nationalists saw news as an accurate representation of a reality in which their own side was inherently good and being forced to fight back for survival. Arab nationalists placed a different interpretation on the same news texts, regarding them as siding with an élite Jewish view of the world. In either case, the text was not challenged. It was accepted as given and interpreted in different ways by these different groups of viewers.

Those Jews and Arabs occupying the middle ground integrated the news in the context of other knowledge and experiences. They rejected simplistic explanations of events. Thus, there may be a tendency to see that one's own

155

side is not always 'good' or 'right'. There is more questioning of the news, rather than taking it at face value.

Liebes and Rivka (1994) recommended that journalists strive for constructing a balanced picture, that they seek to equalize the presentation of pain and human suffering, and that they make the voices of both sides evenly heard. Bending over backward to arrive at an accurate balance may prove misleading in itself (Gitlin, 1980). In any case, it is unrealistic to expect journalists to form artificial identification with a party in a conflict other than their own side (Liebes, 1992b). It is possible, however, to require that they be consciously aware of the possibility of bias, that they attempt to remedy an unbalanced picture by confirming and contextualizing information, and that they permit minority reporters and alternative reports.

Closing Remarks

A variety of methodologies and lines of investigation have been applied to the investigation of audience evaluation of television's performance in respect of the impartiality of its news and factual content. Subjectively, viewers may adopt a variety of standpoints on whether television has been balanced and neutral in the way it presents various political and social issues. Personal opinions of impartiality exhibit varying patterns depending upon whether respondents are being invited to assess television as a whole, specific channels or the coverage given to particular individuals, parties, issues or events. Opinions about television's balance and neutrality also vary as a function of the idiosyncratic prejudices and frames of reference of members of the audience.

Quite apart from what viewers might think about the medium, however, which is more a matter for viewers than for broadcasters, it is clear that the impressions viewers form about people, issues or events appearing on television can be shaped by presentational attributes which are under the control of broadcasters. Furthermore, what audiences learn about issues and events, in the sense of knowledge as well as attitude or opinion, can be influenced by the way information is presented on television. The immediate reactions of viewers to television's treatment of subjects, people, groups, issues or events about which they feel strongly may be less powerful indicators of the real biasing potential of the medium than are measures of the lasting impressions or knowledge viewers form about such things as a direct function of the treatment they received on television. Immediate reactions to television presentations may reveal more about the prejudices of viewers than the performance of the medium as a balanced and neutral information source. Evidence that selective awareness, learning and understanding can be linked to specific narrative and format features of television programmes represent a more powerful indictment of a failure of television journalism to meet the expectations of the public as the most trusted information source.

Television,
the Future and Bias

This book has examined the issue of bias within a broader context of the delivery by television broadcasters of quality news which sets out to provide the highest standards of objective reporting. Even though the goal of objectivity may, in practice, be unattainable, an underlying assumption is proffered that there must be an intention on the part of news professionals to practice journalism which aims to be factually accurate and complete, and balanced in a sense of maintaining diversity in content selection and style of story-telling, and that each of these responsibilities is engaged from a position of political, economic, social or cultural neutrality.

Insofar as news broadcasters maintain these parameters in the production of news output, the public will receive the news they deserve and the information they need from a source which is widely trusted and regarded as the most credible news medium. Where broadcast journalists and news editors depart from the ideal of bias avoidance, television news risks losing the legitimate position it has traditionally occupied as the news source to which the public turns first for accurate and reliable accounts of key issues and events of the day.

This book has shown that there are many different perspectives on the assessment and determination of bias in the news. Bias can be conceived in a variety of ways some of which are linked directly with the nature of news production practices and the motives which lie behind them, and others of which focus on the impact of news coverage upon public knowledge and understanding of current affairs, memory for the details of specific stories, and impressions or opinions which news audiences form about the people, groups, issues and events being reported. In research on bias and related topics, a variety of different criteria have been used operationally to define and measure the nature of news provision in television broadcasts. In adopting a broad definitional frame of reference for the study of 'bias', which incorporates a range of subjective and objective indicators, and involves measures of broadcast output and measures of audience response to broadcast output, this book has chosen to include such factors as 'accuracy', 'completeness', 'truthfulness', 'balance',

and 'neutrality' as well as the traditional notion of 'impartiality' as relevant aspects of the overall assessment of the standards attained by television news.

The evidence reviewed has indicated that, biasing effects and the opportunities for such effects to occur, have been revealed in respect of television news by a variety of research perspectives which have utilised different indicators of such effects. Despite the high regard in which television is held by the public (e.g., Gunter *et al.*, 1994), measures of the news production techniques, writing style and audience memory and impression formation have all revealed various forms of actual or potential biasing effect. Content analysis and audience research techniques have been applied to demonstrate a lack of equity in the treatment of issues, events and groups featured in the news, and the consequent impact of such treatment upon public opinion and understanding. In some cases, these biasing effects follow unwittingly from professional production practices and constraints (Altheide, 1976; Schlesinger, 1978; Gunter, 1987) while in others, there has been a suggestion that such effects are ideologically motivated and deliberate (Glasgow University Media Group, 1976, 1980; Halloran *et al.*, 1970; Herman and Chomsky, 1988).

Implications of technological change

The mass media are experiencing a rapid and radical evolution driven by a mixture of political and regulatory changes, economic forces and technological developments. The numbers of television channels have increased significantly in the space of a few short years and new mechanisms for their delivery into homes have emerged. Legislative changes have attempted to create 'enabling frameworks' designed to promote increased choice for consumers in markets which were once dominated by monopolies or duopolies. This expansion of television channels has been accompanied by the arrival of new specialist or thematic channels. Among these are included a number of channels which specialise in news only, together with certain general entertainment channels which also carry their own news broadcasts. These new channels and news services have posed a serious challenge to the established broadcast news providers, creating increased competition for audiences for news and the need for news managements to bring their costs under tighter control through economies in the news gathering and production processes.

Expanded technological adoption has represented an evolutionary process in the technology-intensive television news industry. Quite simply, to continue to attract viewers, news broadcasters have often adopted new technologies either to gain a competitive edge over other news programmes or to keep up with competitors who have already acquired such technologies themselves.

Reporting strategies have been affected by economic pressures partly contributed towards by the capital outlay needed to acquire new technology, although partly consequent upon increased competition generally for audiences. Resource allocation, organizational constraints, news routines, the frequency with which newscasts have to be produced, and production cost con-

cerns have forced news editors to focus increasingly on producing enough news to fill the newscasts to which they are committed, at a cost they can accommodate within shrinking budgets. Such considerations may take precedence over matters relating to the content of the reports being produced or the real needs of audiences (see Kaniss, 1991; Shoemaker and Reese, 1991).

This problem may be especially acute in the political arena. Research on television news coverage of elections has suggested that the 'horse race' approach, which concentrates on the contenders and where they are in the polls, tends to crowd out issues-based analytical coverage because horse-race coverage, with its heavy reliance on visual images from rallies, walkabouts, and other such events, is easier (and cheaper) to do (Hallin, 1992; Patterson and McClure, 1976; Robinson and Sheehan, 1983). This problem has even been observed to surface at the local political reporting level, along with the tendency to give more coverage to incumbents (Goldenberg and Traughott, 1984; Jacobsen, 1987). Such factors can be related to a larger body of research that has concluded that political news reporting on television has become increasingly scant and reliant on a fairly narrow range of news sources (Gormley, 1978; Hess, 1990; Kaniss, 1991). For reasons of economy, local broadcasters may feed more and more off the agendas set by local newspapers, press releases and press conference, with specialist political coverage being handled as a general assignment rather than a news category requiring of specialist correspondents with a nose for where the news is happening (Berkowitz, 1987, 1992).

Politicians themselves have become increasingly 'television literate' in respect of strategically taking advantage of the medium to promulgate their own political ends. They have learned, for instance, that live events, compelling images, and human drama can attract the attention of voters. Skilful deployment of such media techniques can induce subtle but effective influences over an electorate's candidate and party preferences. In the United States, highly visual and symbolic political advertising on television emerged as a major source of voter information during the 1988 presidential election campaign (Buchanon, 1991; West, 1993). During that campaign, it also became more clearly apparent than ever before that politicians had mastered the art of soundbite journalism (Taylor, 1990). Soundbites, by their very nature, may impart only limited amounts of information, and information of a type which reveals little about where politicians stand on important issues.

Some signs are emerging, however, that television journalists are becoming more aware of the pitfalls of soundbite journalism particularly when it forms a central aspect of reporting of a major election campaign. For the 1997 general election in Britain, the BBC announced a drive to banish this style of political reporting. Following audience research which revealed that viewers were often confused by and quickly lost interest in political reports that were packed with short interview clips, the Corporation's head of news, Tony Hall, reportedly stated that: 'Soundbites are harmful to good journalism ... they are attractive to journalists because they give a rough and ready sense of balance.

But I would question whether they generate a sense of understanding about the issues' (Frean, 1997, p.9).

There is no doubt that technological advances have changed the face of television news. Content changes, however, have been much less noticeable. Television news editors have traditionally sought after stories containing strong visuals and dramatic elements. Research reviewed in this book has indicated that while these features can convey certain meanings to audiences, they can also distort the message and restrict what audience members can remember or understand about such reports. Other tried-and-tested news-gathering strategies are used to ensure that enough news is obtained daily to fill the available television airtime (Berkowitz, 1992; Smith, 1988). Although these procedures will ensure that enough news is produced to fill the newscasts, they do not necessarily make for inspired or analytical political reporting. A strong focus on political candidates' personal qualities may have some relevance to how they are assessed by the electorate, but reveal little about their stance on important political issues (Graber, 19976a, 1989). So while a television newsroom may be constantly changing in its technological wizardry, the fundamental ways in which news editors view the task of gathering and reporting news have changed little over the years. This may, in turn, explain why critics of television believe that it has failed to measure up in terms of the presentation of political news (Graber, 1989).

Quite apart from the part played by technology in the growth of new television channels, from which the main challenge to established news providers has been an economic one, there has been an important influence of new technologies on news gathering, processing and distribution with implications for the type of news product that results. Technological developments have speeded up the processes of news gathering and onward dissemination, placing the role of news editors under threat (Katz, 1992). Under these conditions, the professional editor and interviewer may get pushed aside in favour of instant exposure to a 'chaos of ever changing on-the-spot events and statements' (Blumler, 1992, p. 103). A key question for the future is how will the newer journalism of immediacy and the older journalism of professional mediation relate to each other? While viewers may welcome increased opportunities to become eyewitnesses to events as they happen, such images and sounds by themselves may convey limited meaning. There remains a significant role for the journalist to explain what these events represent, what caused them and why they occurred, and what outcome or implications do they have for those involved and for others elsewhere in the world. The skills of reporting cannot be replaced by technological advances which merely represent new ways of message delivery, but not of message construction.

Implications of political and economic change

Political changes are bound up with economic and technological changes. Even so, there may be political factors which will encroach upon the news production practice, which are quite separate from technology-related

considerations. In some countries, such as France, Italy and Poland, where journalism even in broadcasting has traditionally been closely tied to certain political factions, a process of 'journalistic depoliticization' has been observed, one consequence of which has been to confer upon journalists a modified role as analysts and interpreters of a more plural political environment (Jakubowicz, 1992; Mancini, 1992; Wolton, 1992). Yet, despite this new political sense-making role, many journalists in these evolving political cultures have been inhibited by self-denying norms of neutrality, impartiality and objectivity from taking the initiative in explaining politics to their national publics.

The economics of newsmaking has also seen changes. Prudent financial management is not a new phenomenon in the news business. Many news organizations have always had to balance their books and ensure their expenditure did not exceed their income in markets where audiences and advertisers' moods could fluctuate wildly. In recent years, however, the economic pressures upon journalists have weighed more heavily than at any previous time. Competition for audiences has intensified following a period of unprecedented expansion of media channels. This factor has led to a greater than ever focus on how to reach substantial markets for news effectively and economically. According to some observers, this trend has had dire repercussions for the news product, causing the news on television to move down market, and become more trivial and sensational or dramatic (Hallin, 1992). In sum, a commercialism has emerged in journalism which has encouraged a more entertainment-oriented approach to presentation (Mancini, 1992). The potential significance of such trends in the context of biasing effects has been indicated by research on the impact of dramatic news delivery techniques on audience memory and understanding of broadcast news content. Emotionally-arousing presentation formats might affect whether a news story is remembered at all (Gunter and Furnham, 1986; Mundorf, Drew, Zillmann and Weaver, 1990), or alternatively bias audience recall towards certain story details while impeding memory for others (Brosius, 1993).

Compounded with the entertainment orientations of certain news production practices has been the emergence of the celebrity status journalist. While this phenomenon has been present for a long time in some countries (e.g., United States), it has recently been observed to occur in other countries, with news organizations own public relations machinery playing an active role in promoting the popularity of their news channels and programmes through their celebrity newsreaders, reporters and correspondents. In consequence, it has been argued that viewers often tune in to watch a favoured newscaster more than to find out what is happening in the world (Wolton, 1992). While the naturally emerging popularity of a professionally competent and attractive news presenter cannot be seen as an inherent problem for journalistic standards, the fact that news organizations might try to manufacture such celebrity status or take advantage of it through blatant public relations techniques sheds a different complexion on the matter. The emphasis upon 'cosmetic'

aspects of news presentation, where it occurs at the expense of sound editorial judgement about content, may produce superficial news reporting in which the audience's attention is oriented towards technique rather than substance.

For some writers, the economic pressures wrought by de-regulation and the proliferation of television news outlets has resulted in the growth of 'trash television'. This term has been applied to a number of different kinds of programming, including popular daytime talk shows which combine sensation with a significant amount of serious social content. Then, there are low-brow current affairs and documentary programmes which use dramatic production techniques, or a combination of documentary accounts with reconstructions of events. Often presented under the label of 'reality television', such programmes exhibit a strong focus on violent crime and content which plays on audiences' fears (Hallin, 1992).

The emergence of this highly popular hybrid genre of 'faction' programming may, in its own way, be contributing towards further fragmentation of audiences, leading to even greater divisions between different public sectors in terms of their current affairs awareness. One suggestion is that the already better informed who also tend to be better off and better educated, will consume high quality news, while the less informed, who tend to be poorer and less well-educated will consume reality-based programming dealing with sensational and dramatic themes, but little in the way of substantial news content.

Public confidence in broadcast news

The technological developments witnessed to have taken place in television newsrooms have modernised many news gathering procedures and enabled news editors to use increasingly sophisticated production techniques to present information on screen. Advances in technology have so speeded up the news production process, however, that there may be insufficient time devoted to editorial decisions and the verification of facts (Katz, 1992; Wolton, 1992). Live reporting of events often takes precedence over considered discussion of issues.

The public have placed much confidence in television as a news medium, but the preoccupation with gathering news as quickly as possible and filling airtime as economically as possible may, according to some observers, have serious implications for the quality of the news product on television. If less time is devoted to matters of content because primary attention is paid to form, standards of objectivity and impartiality may fall. If news reports are chosen increasingly because of their capacity to fill visual space and not because they provide accurate, comprehensive and balanced accounts of events, the public's understanding of current affairs will suffer, and their opinions about significant issues will be less well-informed. In due course, there may be a knock-on effect upon public confidence in television as a reliable and trustworthy news source.

Already evidence has begun to emerge – for instance in France – that the public's confidence in journalists may be waning (see Wolton, 1992). A poll by

Mediaspouvoirs La Croix and Telerama found that with respect to political news in 1992, the French public most often had confidence in television (40 per cent) followed in equal measure by their confidence in radio (20 per cent) and daily newspapers (20 per cent), and weekly news and other magazines (10 per cent). In 1988, a comparable survey had revealed a somewhat higher confidence figures for television (47 per cent).

There is a growing bias towards reporting only that which can be shown. There is an assumption also that what is reported is important, and that those stories which do not get reported are less important or are indeed unimportant. Journalists are situated all over the world, occupied in the process of monitoring events and gathering news about them. Yet there may be many events and issues which are not chosen for coverage on the basis that they would not make good television, which means that they would provide little to show on camera.

If television news in the future is to avoid losing public confidence and a decline in the general standard of news provision, there are a number of issues with which news editors must deal. The bias towards image dependency and showing events 'live' or 'as live', needs to be weighed in the balance against the need to ensure that this does not preclude adequate and accurate explanation of those events or impede the selection of equally worthy stories with less visual appeal.

Journalists must be mindful of their main audience – the viewing public – and take appropriate steps to understand audience needs, tastes and psychology. The emergence of the powerful celebrity figure in journalism may give rise to a perception that news reporting is not simply a channel through which information about political processes is conveyed but is actually a part of the political machinery itself. Journalists may enjoy an active dialogue with politicians, but their main dialogue should be with the general public.

The event bias of television news is manifest in its political reporting in the increasing use of opinion polls. This creates a 'horse-race' scenario and adds to the drama of a political campaign. It also serves to reduce the share of time devoted to explanation of events and issues. In a more general context, there has been increasing use of public polls commissioned or arranged by news programmes themselves. These may solicit public opinion on a variety of current political, economic or social issues, some serious and many trivial in nature. The subtle biasing effects of this trend reside in the creation of a view that many problems in society can be dealt with in a political fashion, with a majority and minority body of opinion on each side of the problem. This phenomenon may create an illusion that the problem is being dealt with head-on when in fact there may be no connection between the poll and any required or eventual action needed to resolve the problem being voted upon.

The technological imperatives which have been seen to drive the news production agenda during the recent period of rapid media expansion must not be allowed, by journalists themselves, to over-ride the need for solid,

informative, accurate, factual and neutral reporting. Journalism has an important role to play in a democratic society, but can only properly fulfil that role if steps are taken to protect the fundamental professional qualities of good news reporting. This entails more than the deployment of sophisticated technological wizardry, whether used to assist with news gathering or presentation. There must be a clear recognition among journalists who work in a fast-moving medium such as television, that real events do not always move forward at the pace demanded by certain styles of television production. The reporting of events cannot be determined solely by the pace and tempo of presentation formats which are oriented more towards satisfying an entertainment than an informational need. It is not being argued that the news cannot be 'entertaining'; merely to acknowledge that an entertainment determinism in television news production may not always be compatible with effective communication of information.

In the future, the real problem of bias is as likely to take the form of a 'bias against proper understanding' as the provision of news which is impartial in its substance, if technological and economic imperatives give rise to production practices which are geared more to the cosmetics of news than the effective communication of meaning. One aspect of such biasing effects may stem from a failure by broadcast journalists to recognise that while technological developments may make it easier to perform some of the information gathering tasks of news reporting, the deployment of these technical devices per se does not represent let alone replace good news reporting. A better understanding of audiences and of the issues they choose to report on the part of journalists may go some way towards alleviating the likelihood of these 'biasing effects'. In the end, attainment of this goal will, to a significant extent, be dependent on maintaining good professional standards, and this, in turn, has implications for the way journalists are trained. On the job training alone may not be enough in the rapidly evolving media world, and may need to be supplemented or even supplanted by a more dedicated training regime which embraces academic study of relevant political, legal, cultural and management issues as well as vocational training in the basic skills of reporting.

References

Abel, E. (19840 Thirty-five years of social responsibility theory. In R. Schmuhl (Ed.), *The Responsibilities of Journalism*, pp. 86-92. South Bend, IN: University of Notre Dame Press.

Abel, J. D. and Wirth, M.D. (1977) Newspaper vs TV credibility for local news. *Journalism Quarterly*, 54, 371-375.

Adams, W.C. (Ed.) (1982) *Television Coverage of International Affairs*. Norwood, NJ: Ablex.

Adams, W.C. (Ed.) (1983) *Television Coverage of the 1980 Presidential Campaign*. Norwood, NJ: Ablex.

Ajzen, I. (1977) Intuitive theories of events and the effects of baserate information on prediction. *Journal of Personality and Social Psychology*, 35, 303-314.

Alba, R.D. and Moore, G. (1983) Elite social circles. In R. Burt and M.J. Minor (Eds.) *Applied Network Analysis* pp. 245-261. Beverly Hills, CA: Sage.

Alexander, J. (1981) The mass news media in systematic., historical and comparative perspective. In E. Katz and T. Szecsko (Eds.), *Mass Media and Social Change*. London: Sage, pp. 17-51.

Altheide, D.L. (1974) *Creating Reality*. Beverly Hills, CA: Sage.

Altheide, D.L. (1982) Three-in-one news: network coverage of Iran. *Journalism Quarterly*, 59, 482-486.

Altheide, D.L. (1985) *Media Power*. Beverly Hills, CA: Sage.

Altheide, D. and Snow, R.P. (1979) *Media Logic*. Beverly Hills, CA: Sage.

Anderson, D. and Sharrock, W. (1979) Biasing the news: technical issues in media studies. *British Journal of Sociology*, 13(3), 367-385.

Arvidson, P. (1977) Trovardigheten hos massmedierna/ Mass media credibility. *Psykologiskt forsvar*, 81, Stokcholm: Beredskapsnamnden fur psykologiskt forsvar.

Asp, K. (1981) Mass media as the molders of opinion and suppliers of information. In C. Wilhoit and C. Whitney (Eds.) *Mass Communication Review Yearbook*, Vol.2., pp. 332-354. Beverly Hills, CA: Sage.

Atwater, T. (1986) Consonance in local television news. *Journal of Broadcasting and Electronic Media*, 30, 467-472.

Atwater, T. (1987) network evening news coverage of the TWA hostage crisis. *Journalism Quarterly*, 64, 520-525.

Atwater, T. (1989) News format in network evening news coverage of the TWA hijacking. *Journal of Broadcasting and Electronic Media*, 33, 293-304.

Baggaley, J.P. (1980) *The Psychology of the TV Image*. Aldershot, UK: Saxon House.

Baggaley, J.P. and Duck, S.W. (1974) Experiments in ETV: Effects of adding background. *Educational Broadcasting International*, 7.

Baggaley, J.P. and Duck, S.W. (1976) *The Dynamics of Television*. Franborough, UK: Saxon House.

Bar-Hillel, M. and Fischhoff, B. (1981) When do base rates affect predictions? *Journal of Personality and Social Psychology*, 41, 671-680.

Bavelas, J.B., Black, A., Bryson, L. and Mullett, J. (1988) Political equivocation: A situational explanation. *Journal of Language and Social Psychology*, 7, 137-145.

Bavelas, J.B., Black, A., Chovil, N. and Mullett, J. (1990) *Equivocal Communication*. Newbury Park, CA: Sage.

BBC/ITC (1992) *The 1992 General Election: A Survey of Public Opinion*. London: British Broadcasting Corporation and Independent Television Commission

Becker, L.B. (1982) The mass media and citizen assessment of issue importance. In C. Whitney and E. Wartella (Eds.) *Mass Communication Review Yearbook*, Vol.3, pp. 521-536. Beverly Hills, CA: Sage.

Behr, R. L. and Iyengar, S. (1985) Television news, real world cues, and changes in the public agenda. *Public Opinion Quarterly*, 49, 38-57.

Bell, A. (1991) *The Language of News Media*. Oxford: Blackwell.

Berkowitz, D. (1987) TV news sources and news channels: A study in agenda building. *Journalism Quarterly*, 64, 508-513.

Berkowitz, D. (1992) Non-routine news and newswork: Exploring a what-a-story. *Journal of Communication*, 42, 82-94.

Berry, C. (1983a) A dual effect of pictorial enrichment in learning from television news: Gunter's data revisited. *Journal of Educational Television*, 9, 171-174.

Berry, C. (1983b) Learning from television news: A critique of the research. *Journal of Broadcasting*, 27, 359-370.

Berry, C, (1988) Memory studies and broadcast messages. In M.M. Gruneberg, P.E. Morris and R.N. Sykes (Eds.), *Practical Aspects of Memory: Current Research and Issues*. Vol.1. *Memory in Everyday Life*. Chichester: Wiley.

Berry, C. (1990) Channel images and mental models: perceived bias on British television. *Media, Culture and Society*, 12, 231-245.

Berry, C. and Brosius, H-B (1991) Multiple effects of visual format on TV news learning. *Applied Cognitive Psychology*, 5, 519-528.

Berry, C. and Clifford, B. R. (1986) *Learning from television news: Effects of presentation and knowledge on comprehension and memory*. London: Independent Broadcasting Authority and North East London Polytechnic.

Berry, C. Scheffler, A. and Goldstein, C. (1993) Effects of text structure on the impact of heard news. *Applied Cognitive Psychology*, 7, 381-395.

Berry, F.C. (1967) A study of accuracy in local news stories of three dailies. *Journalism Quarterly*, 44, 482-490.

Blankenberg, W. (1970) News accuracy: Some findings on the meaning of the term. *Journalism Quarterly*, 47, 375-386.

Blood, R.W. (1989) Public agendas and media agendas: Some news that may matter. *Media Information Australia*, 52, 7-15.

Blumler, J.G. (Ed.) (1983) *Communicating to Voters: TV in the First European Parliamentary Elections*. London: Sage.

Blumler, J. G. (1992) News media in flux: An analytical afterword. *Journal of Communication*, 42(3), 100-107.

Blumler, J.G., Franklin, B., Mercer, D. and Tutt, B. (1990) Monitoring the public experiment in televising the proceedings of the House of Commons. In *Review of the Experiment in Televising the Proceedings of the House*, pp. 8-67 (265-1). London: HMSO.

Bogart, L. (1979) Editorial ideals, editorial illusions. *Journal of Communication*, 29(2), 11-21.

Bogart, L. (1980) Television news as entertainment. In P.H. Tannenbaum (Ed.), *The Entertainment Functions of Television*, pp. 209-249. Hillsdale, NJ: Lawrence Erlbaum Associates.

Bogart, L. (1984) The public's use and perception of newspapers. *Public Opinion Quarterly*, 48, 709-719.

Bransford, J.D. and Johnson, M.K. (1972) Contextual prerequisites for understanding: Some investigations of comprehension and recall. *Journal of Verbal Learning and Verbal behaviour*, 11, 717-726.

Brosius, H-B. (1989a) Die Bebilderung von Fernsehnachrichten: Unter welchen Bedingungen ist sie von Vorteil? *Rundfunk und Fernsehen*, 37, 458-472.

Brosius, H-B. (1989b) Influence of presentation features and news content on learning from television news. *Journal of Broadcasting and Electronic Media*, 33(1), 1-14.

Brosius, H-B. (1990a) Bewertung gut, Behalten schlecht: Die Wirkung von Musik in Informationsfilmen: medien-psychologie. *Zeitschrift fur Individual- und Massen-kommunikation*, 2, 44-55.

Brosius, H-B. (1990b) Verstehnarkeit von Fernsehnachrichten. In M. Kuncik and U. Weber (Eds.), *Fernsehen: Aspekte eines Mediums* (pp. 37-51). Cologne: Bohlau.

Brosius, H-B. (1993) The effects of emotional pictures in television news. *Communication Research*, 20(1), 105-124.

Brosius, H-B. and Bathelt, A. (1994) The utility of exemplars in persuasive communication. *Communication Research*, 21, 48-78.

Brosius, H-B. and Berry, C. (1990) Ein Drei-Faktoren Modell der Wirkung von Fernsehnachrichten. *Media Perspecktiven*, 9(90), 573-583.

Brown, J.D., Bybee, C.R., Wearden, S.T. and Straughan, D.M. (1987) Invisible power: newspaper news sources and the limits of diversity. *Journalism Quarterly*, 64, 45-54.

Buchanon, B. (1991) *Electing a President: The Markle Commission Report on Campaign '88*. Austin, TX: University of Texas.

Buckalew, J.K. (1969) A Q-analysis of television news editors' decisions. *Journalism Quarterly*, 46, 135-137.

Buckalew, J.K. (1970) News elements and selection by television news editors. *Journal of Broadcasting*, 14, 47-54.

Buckalew, J.K. (1974) The local radio news editor as a gatekeeper. *Journal of Broadcasting*, 18, 211-221.

Bull, P. (1994) On identifying questions, replies, and non-replies in political interviews. *Journal of Language and Social Psychology*, 13(2), 115-131.

Bull, P.E. and Mayer, K. (1993) How not to reply to questions in political interviews. *Political Psychology*, 14, 651-666.

Bunker, D. (1988) *Trustworthiness and bias in BBC and ITV news*. London|: BBC Broadcasting Research, Special Projects Report, October.

Burgoon, J.K., Burgoon, M. and Atkin, C.L. (1982) *The World of the News*. New York: Newspaper Advertising Bureau, Inc.

Capella, J.N. and Jamieson, K.H. (1994) Broadcast adwatch effects: A field experiment. *Communication Research*, 21(3), 342-365.

Carroll, R.L. (1985) Content values in TV news programmes in small and large markets. *Journalism Quarterly*, 62, 877-882, 938.

Carroll, R.L. (1989) Market size and TV news values. *Journalism Quarterly*, 66, 49-56.

Carter, R.E. (1958) Newspaper 'gatekeepers' and the sources of news. *Public Opinion Quarterly*, 22(2), 133-144.

Carter, R.F. (1978) A very peculiar horse race. In G.F. Bishop, R.G. Meadow, and M. Jackson-Beeck, (Eds.) *The Presidential Debates*, pp. 3-17, New York: Praeger.

Carter, R.F. and Greenberg, B.S. (1965) Newspapers or television: Which do you believe? *Journalism Quarterly*, 42, 28-34.

Chaffee, S.H. and Wilson, D.G. (1977) Media rich, media poor: Two studies of diversity in agenda-holding. *Journalism Quarterly*, 54, 466-476.

Charnley, M.V. (1936) Preliminary notes on a study of newspaper accuracy. *Journalism Quarterly*, 13(2), 394-400.

Chew, F. (1992) Information needs during viewing of serious and routine news. *Journal of Broadcasting and Electronic Media*, 36(4), 453-466

Churchman, C.W. (1971) *The Design of Inquiring Systems: Basic Concepts of Systems and Organization*. New York: Basic Books.

Cirino, R. (1971) *Don't Blame the People: How the News Media Use Bias, Distortion and Censorship to Manipulate Public Opinion*. New York: Random House.

Clarke, P. and Fredin, E. (1978) Newspapers, television and political reasoning. *Public Opinion Quarterly*, 42(2), 143-160.

Clancy, M. and Robinson, M.J. (1988) The media in campaign '84': General election coverage. *Public Opinion Quarterly*, Dec/Jan.: 49-54, 59.

Clayman, S.E. (1989) The production of punctuality: Social interaction, temporal organization and social structure. *American Journal of Sociology*, 95, 659-691.

Cohen, A.R. (1957) Need for cognition and order of communication as determinants of opinion change. In C.I. Hovland (Ed.), *The Order of Presentation in Persuasion*, pp. 79-97. New Haven: Yale University Press.

Cohen, A.R., Stotland, E. and Wolfe, D.M. (1955) An experimental investigation of need for cognition. *Journal of Abnormal and Social Psychology*, 51, 291-294.

Coldevin, G. (1978a) Experiments in TV presentation strategies I: Effectiveness of full screen vs. corner screen location establishment background visuals. *Educational Broadcasting International*, 11, 17-18.

Coldevin, G. (1978b) Experiments in TV presentation strategies II: Effectiveness of full screen vs. corner screen 'symbol establishment' background visuals. *Educational Broadcasting International*, 11, 158-159.

Coldevin, G. (1979) The effects of placement, delivery format and missed cues on TV presenter ratings. In J. Baggaley and J. Sharpe (Eds.), pp. 73-90. *Proceedings of the Second International Conference on Experimental Research in Televised Instruction*. St. Johns: Memorial University of Newfoundland.

Collins, M. (1984) The perception of bias in television news. In *BBC Broadcasting Research Findings*, No. 10. London: BBC Data Publications, pp. 100-115.

Comstock, G. (1988) Today's audience, tomorrow's media. In O. Oskamp (Ed.) *Television as a Social Issue*. pp. 324-345. Newbury Park, CA: Sage.

Connolly, C.P. (1962) *An experimental investigation of eye-contact on television*. Unpublished master's thesis, Ohio University.

Cooper, M. and Soley, L. (1990) All the right sources: A two-year study documents the bias in network reporting. *Mother Jones*, (September), pp. 20-27, 45.

Crigler, A.N., Just, M. and Neuman, W.R. (1994) Interpreting visual versus audio messages in television news. *Journal of Communication*, 44(4), 132-149.

Cuilenburg, J.J. van, de Ridder, J. and Kleinnijenhuis, J. (1986) A theory of evaluative discourse. *European Journal of Communication*, 1(1), 65-96.

Cumberbatch, G., McGregor, R., Brown, B. and Morrisson, D. (1985) *Television news and the miner's strike.* Aston University and the broadcasting Research Unit, Research Report.

Cundy, D.T. (1994) Televised news, trait inferences and support for political figures. *Journal of Broadcasting and Electronic Media*, 38(1), 49-63.

Curran, J., Douglas, A. and Whannel, G. (1980) The political economy of human interest stories. In A. Smith (Ed.) *Newspapers and Democracy*. pp. 288-316. Cambridge, MA: MIT Press.

Danielson, W.A. and Adams, J.B. (1961) Completeness of press coverage of the 1960 campaign. *Journalism Quarterly*, 38, 441-452.

Davies, M.M., Berry, C. and Clifford, B. (1985) Unkindest cuts? Some effects of picture editing on recall of television news information. *Journal of Educational Television*, 11, 85-98.

Davis, D. and Robinson, J. (1985) News story attributes and comprehension. In J.P. Robinson and M.R. Levy (Eds.), *The Main Source: Learning from Television News*. Beverly Hills, CA: Sage.

Davis, D. and Robinson, J. (1989) Newsflow and democratic society in an age of electronic media. In G. Comstock (Ed.), *Public Communication and Behaviour*, Vol.2. Orlando, Fla: Academic Press.

Davis, H. and Walton, P. (1983) *Language, Image, Media*. Oxford: Basil Blackwell.

Dijk, T. van (1988) *News as Discourse*. Hillsdale, NJ: LEA.

Dijk, T. van (1991) *Racism and the Press*. London: Routledge

Dionisopoulos, G.N. and Crable, R.E. (1988) Definitional hegemony as a public relations strategy: The rhetoric of the nuclear power industry after Three Mile island. *Central States Speech Journal*, 39, 134-145.

Dominick, J.R. (1977) Geographic bias in national television news. *Journal of Communication*, 27, 94-99.

Dominick, J.R., Wurtzel, A. and Lometti, G. (1975) Television journalism vs show business: A content analysis of eyewitness news. *Journalism Quarterly*, 52, 213-218.

Donohue, T.R., Olien, C.N. and Tichenor, P.J. (1985) Reporting conflict by pluralism, newspaper type and ownership. *Journalism Quarterly*, 62, 489-499, 507.

Donsbach, W. (1991) *Medienwirkung trotz Selektion: Einflusfaktoren auf die Zuwendung von Zeitungsinhalten*. Cologne: Bohlau.

Dooling, D.J. and Lachman, R. (1971) Effect of comprehension in retention of prose. *Journal of Experimental Psychology*, 88, 216-222.

Dooling, D.J. and Mullet, R.L. (1973) Locus of thematic effects in retention of prose. *Journal of Experimental Psychology*, 97, 404-406.

Drew, D.G. and Cadwell, R. 91985) Some effects of video editing in television news. *Journalism Quarterly*, 62, 828-831.

Drew, D.G. and Grimes, T. 91987) Audio-visual redundancy and TV news recall. *Communication Research*, 14, 452-461.

Edelman, M.J. (1977) *Political Language: Words that Succeed and Politics that Fail*. New York: Academic Press.

Edelman, M.J. (1993) Contestable categories and public opinion. *Political Communication*, 10, 231-242.

Edelstein, A.S. and Tefft, D.P. (1974) Media credibility and respondent credulity with respect to Watergate. *Communication Research*, 1, 426-439.

Edwardson, M., Grooms, D., and Pringle, P. (1976) Visualisation and TV news information gain. *Journal of Broadcasting*, 20, 373-380.

Edwardson, M., Grooms, D. and Proudlove, S. (1981) Television news information gain from interesting video vs talking heads. *Journal of Broadcasting*, 25, 15-24.

Edwardson, M., Kent, K., Engstrom, E. and Hofmann, R. (1992) Audio recall immediately following video change in television news. *Journal of Broadcasting and Electronic Media*, 36(4), 395-410

Efron, E. (1971) *The News Twisters*. Los Angeles: Nash Publishing.

Eiser, J.R. (1983) Attribution theory and social cognition. In J. Jaspers, F.D. Fincham, and M. Hewstone (Eds.), *Attribution Theory and Research: Conceptual Development and Social Dimensions* (pp. 91-116). London: Academic Press.

Entman, R.M. (1989) *Democracy Without Citizens: Media and the Decay of American Politics*. New York: Oxford University Press.

Entman, R.M. (1991) Framing US coverage of international news: Contrasts in narratives of the KAL and Iran Air incidents. *Journal of Communication*, 41(4), 6-28.

Entman, R.M. (1993) Framing: Toward clarification of a fractured paradigm. *Journal of Communication*, 43(4), 51-58.

Entman, R.M. and Rojecki, A. (1993) Freezing out the public: Elite and media framing of the US anti-nuclear movement. *Political Communication*, 10, 151-167.

Epstein, E.J. (1974) *News From Nowhere*. New York: Vintage Books.

Epstein, E.J. (1975) *Between Fact and Fiction: The problem of Journalism*. New York: Vintage Books.

Erbring, L., Goldenberg, E.N. and Miller, A.H. (1980) Front page news and real world cues: A new look at agenda-setting by the media. *American Journal of Political Science*, 24, 14-49.

Evans, R. (1987) TV presenters accused on left-wing bias. *The Times*, December 30, p.2.

Faber, R.J., Reese, S.D. and Steeves, H.L. (1985) Spending time with the news media: The relationship between reliance and use. *Journal of Broadcasting and Electronic Media*, 29, 445-450.

Findahl, O. (1971) *The effects of visual illustrations upon perception and retention of news programmes*. Stockholm, Sweden: Swedish Broadcasting Corporation, Audience and Programme Research Department.

Findahl, O. and Hoijer, B. (1972) *Man as a receiver of information: Repetitions and reformulations in a news programme*. Stockholm, Sweden: Swedish Broadcasting Corporation, Audience and Programme Research Department.

Findahl, O. and Hoijer, B. (1975) *Man as a receiver of information: On knowledge, social privilege and the news*. Stockholm, Sweden: Swedish Broadcasting Corporation, Audience and Programme Research Department.

Findahl, O. and Hoijer, B. (1976) *Fragments of reality: An experiment with news and TV visuals*. Stockholm, Sweden: Swedish Broadcasting Corporation, Audience and Programme Research Department.

Findahl, O. and Hoijer, B. (1985) *Some characteristics of news memory and comprehension*. Stockholm, Sweden: Swedish Broadcasting Corporation, Research Paper.

Fishman, M. (1980) *Manufacturing the News*. Austin, TX: University of Texas Press.

Fiske, J. (1987) *Television Culture* London: Methuen.

Fiske, S.T. and Taylor, S.E. (1984) *Social Cognition*. New York: Random House.

Fowler, R. (1991) *Language in the News*. London: Routledge.

Fowler, J.S. and Showalte, S.W. (1974) Evening network news selection: Confirmation of news judgement. *Journalism Quarterly*, 51, 212-215.

Frank, R.S. (1973) *Message Dimensions of Television News*. Lexington, MA: Lexington Books.

Frean, A. (1997) BBC seeks to ban soundbites from political coverage. *The Times*, February 4, p.9.

Funkhouser, G.R. (1973) Trends in media coverage of the issues of the 60s. *Journalism Quarterly*, 50, 533-538.

Gallup Organization (1986) *The People and the Press: A Times/Mirror Investigation of Public Attitudes toward the News Media*. Los Angeles: Times Mirror.

Galtung, J. and Ruge, M. (1965) The structure of foreign news. *Journal of Peace Research*, 1, 64-90.

Gamson, W.A. (1989) News as framing. *American Behavioural Scientist*, 33, 157-161.

Gamson, W.A. and Modigliani, A,. (1989) Media discourse and public opinion on nuclear power. *American Journal of Sociology*, 95, 1-37.

Gans, H.J. (1979) *Decoding What's News*. New York: Free Press.

Gantz, W. (1981) The influence of researcher methods on television and newspaper news credibility evaluations. *Journal of Broadcasting*, 25(2), 155-169.

Garramone, G.M. (1984) Voter responses to negative political ads. *Journalism Quarterly*, 61, 250-259.

Garrison, B. (1992) *Advance Reporting: Skills for the Professional*. Hillsdale, NJ: Lawrence Erlbaum associates.

Gaunt, P. (1990) *Choosing the News*. Westport, CT: Greenwood Press.

Gaziano, C. (1983) The knowledge gap: An analytic review of media effects. *Communication Review*, 19(4), 447-486.

Geiger, S. and Reeves, B. (1989) *The effects of scene changes and semantic relatedness on attention to television*. Paper presented at the conference of the International Communication Association, San Francisco.

Geis, M.L. (1987) *The Language of Politics*. Berlin: Springer Verlag.

Gerbner, G. and Marvanyi, G. (1977) The many worlds of the world's press. *Journal of Communication*, 27(1), 52-66.

Gerbner, G., Signorielli, N. and Morgan, M. (1982) Charting the mainstream: Television's contributions to political orientation. *Journal of Communication*, 32(2), 100-127.

Gieber, W. (1955) Do newspapers overplay 'negative' news? *Journalism Quarterly*, 32, 311-318.

Giffard, A. (1989) *UNESCO and the Media*. New York: Lexington.

Ginosaur, Z. and Trope, Y. (1980) The effects of base rates and individuating information on judgments about another person. *Journal of Experimental Social Psychology*, 16, 228-242.

Gitlin, T. (1980) *The Whole World is Watching*. Berkeley, CA: University of California Press.

Glasgow Media Group (1976) *Bad News*. London: Routledge and Kegan paul.

Glasgow Media Group (1980) *More Bad news*. London: Routledge and Kegan Paul.

Glasgow Media Group (1985) *War and Peace News*. London: Routledge and Kegan Paul.

Goldenberg, E. (1976) *Making the Papers: The Access of Resource Poor Groups to the Metropolitan Press*. Lexington, MA: Lexingon Books.

Goldenberg, E. and Traugott, M. (1984) *Campaigning for Congress*. Washington, DC: Congressional Quarterly Press.

Golding, P. and Elliott, P. (1979) *Making the News*. London: Longman.

Goodhardt, G.J., Ehrenberg, A.S.C. and Collinson (1975) *The Television Audience: Patterns of Viewing*, Farnborough, UK: Saxon House.

Gordon, G.N. (1969) *The Language of Communication*. New York: Hastings House.

Goshorn, K. and Gandy, O.H. Jr. (1995) Race-risk and responsibility: Editorial constraint in the framing of inequality. *Journal of Communication*, 45(2), 133-151.

Graber, D. (1971) The press as opinion resource during the 1986 Presidential campaign. *Public Opinion Quarterly*, 35(2), 168-182.

Graber, D. (1976a) Press and TV as opinion resources in Presidential campaigns. *Public Opinion Quarterly*, 40(3), 285-303.

Graber, D.A. (1976b) *Verbal Behaviour in Politics*. Urbana, IL: University of Illinois Press.

Graber, D.A. (1979) Is crime news coverage excessive? *Journal of Communication*, 29(3), 81-92.

Graber, D. (1987) Kind pictures and harsh words: How television presents the candidates. In K. Schlozman (Ed.) *Elections in America*. Winchester, MA: Allen & Unwin.

Graber, D. (1989) Flashlight coverage: State news on national broadcasts. *American Politics Quarterly*, 17, 277-290.

Graber, D. (1990) Seeing is remembering: How visuals contribute to learning from television news. *Journal of Communication*, 4(3), 134-155.

Greatbatch, D.L. (1985) *The social organisation of news interview interaction*. Unpublished PhD dissertation, University of Warwick, UK.

Greatbatch, D.L. (1986) Aspects of topical organisation in news interviews: The use of agenda shifting procedures by interviewees. *Media, Culture and Society*, 8, 441-455.

Greatbatch, D. (1988) A turn-taking system for British news interviews. *Language and Society*, 17, 401-430.

Green, M. (1969) *Television News: Anatomy and Process*. Belmont, CA: Wadsworth Publishing Company, Inc.

Greenberg, B.S. (1964) Person-to-person communication in the diffusion of news events. *Journalism Quarterly*, 41, 489-494.

Greenberg, B.S. and Roloff, M.E. (1974) Mass media credibility: Research results and critical issues. *News Research Bulletin No. 6*. Washington, DC: American Newspaper Publishers Association, 4 November.

Grimes, T. (1991) Mild auditory-visual dissonance in television news may exceed viewer attentional capacity. *Human Communication Research*, 18, 268-298.

Gunter, B. (1979) Recall of television news items: Effects of presentation mode, picture content and serial position. *Journal of Educational Television*, 5, 57-61.

Gunter, B. (1980a) Remembering television news: Effects of picture content. *Journal of General Psychology*, 102, 127-133.

Gunter, B. (1980b) Remembering televised news: Effects of visual format on information gain. *Journal of Educational Television*, 6, 8-11.

Gunter, B. (1985) News sources and news awareness: A British survey. *Journal of Broadcasting*, 29(4), 397-406.

Gunter, B. (1987) *Poor Reception: Misunderstanding and Forgetting Broadcast News*. Hillsdale, NJ: Lawrence Erlbaum Associates.

Gunter, B. (1991) Responding to news and public affairs. In J. Bryant and D. Zillmann (Eds.) *Responding to the Screen: Reception and Reaction Processes*, pp. 229-260. Hillsdale, NJ: Lawrence Erlbaum Associates.

Gunter, B., Berry, C. and Clifford, B. (1981) Release from proactive interference with television news items: Further evidence. *Journal of Experimental Psychology: Human Learning and Memory*, 7, 480-487.

Gunter, B., Clifford, B. and Berry, C. (1980) Release from proactive interference with television news items: Evidence for encoding dimensions within televised news. *Journal of Experimental Psychology: Human Learning and Memory*, 6, 216-223.

Gunter, B. and Furnham, A. (1986) Sex and personality differences in recall of violent and non-violent news from three presentation modalities. *Personality and Individual Differences*, 7, 829-837.

Gunter, B., Furnham, A. and Gietson, G. (1984) Memory for the news as a function of the channel of communication. *Human Learning*, 3, 265-271.

Gunter, B. and McLaughlin, C. (1992) *Television: The Public's View.* London: John Libbey.

Gunter, B., Sancho-Aldridge, J. and Winstone, P. (1994) *Television: The Public's View – 1993.* London: John Libbey.

Gunter, B. and Svennevig, M. (1988) *Attitudes to Broadcasting: Over the Years.* London: John Libbey.

Gunter, B. and Svennevig, M. (1990) *Attitudes to Broadcasting.* London: Independent Broadcasting Authority.

Gunter, B., Svennevig, M. and Wober, M (1986) *Television and the 1983 General Election.* Aldershot, UK: Gower.

Gunter, B. and Winstone, P. (1993) *Television: The Public's View – 1992.* London: John Libbey.

Hallin, D. C. (1986) *The Uncensored War: The Media and Vietnam.* Berkeley: University of California Press.

Hallin, D.C. (1990) Sound bite news. In G. Orren (Ed.) *Blurring the Lines.* New York: The Free Press.

Hallin, D.C. (1992a) Sound bite news: Television coverage of elections, 1968-1988. *Journal of Communication*, 42, 5-24.

Hallin, D.C. (1992b) The passing of the 'high modernism' of American journalism. *Journal of Communication*, 42(3), 14-25.

Halloran, J.D., Elliott, P. and Murdock, G. (1970) *Communications and Demonstrations.* Harmondsworth: Penguin.

Hamill, R., Wilson, T.D., and Nisbett, R.E. (1980) insensitivity to sample bias: generalizing from atypical cases. *Journal of Personality and Social Psychology*, 39, 578-589.

Hargreaves, I. (1989) Impartiality and truth: Balance, objectivity, accuracy and judgment. In *Impartiality: Representing Reality.* London: British Broadcasting Corporation, pp. 16-20.

Harlow, H.F., Harlow, M.K. and Meyer, D.R. (1950) Learning motivated by a manipulation drive. *Journal of Experimental Psychology*, 40, 228-234.

Harris, S. (1991) Evasive action: How politicians respond to questions in political interviews. In P. Scannel (Ed.), *Broadcast talk*, pp. 76-99. London: Sage.

Hartley, J. (1982) *Understanding News.* London: Methuen.

Hartman, P. and Husband, C. (1974) *Racism and Mass Media.* London: Davis Poynter.

Harvey, R.F. and Stone, V.A. (1969) Television and newspaper front-page coverage of a major news story. *Journal of Communication*, 19(2), 181-188.

Haskins, J.B. (1981) The trouble with bad news. *Newspaper Research Journal*, 2(2), 3-16.

Haskins, J.B. and Miller, M.M. (1984) The effects of bad news and good news on a newspaper's image. *Journalism Quarterly*, 61, 3-13, 65.

Hemanus, P. (1976) Objectivity in news transmission. *Journal of Communication*, 26(4), 102-107.

Heritage, J.C. (1984) *Garfunkel and Ethnomethodology.* Cambridge: Polity Press.

Heritage, J.C. (1985a) Analysing news interviews: Aspects of the production of talk for an over-hearing audience. In T. van Dijk (Ed.), *Handbook of Discourse Analysis: Vol.3.: Discourse and Dialogue*, pp. 95-117. New York: Academic Press.

Heritage, J.C. (1975b) Recent developments in conversation analysis. *Sociolinguistics*, 5, 1-19.

Heritage, J.C. Clayman, S.E. and Zimmerman, D. (1988) Discourse and message analysis: The micro-structure of mass media messages. In R. Hawkins, S. Pingree and J. Weiman (Eds.), *Advancing Communication Science: Merging Mass and Interpersonal Processes*, pp. 77-109. Newbury park, CA: Sage.

Heritage, J.C. and Greatbatch, D.L. (1991) On the institutional character of institutional talk: The case of news interviews. In D. Boden and D. Zimmerman (Eds.) *Talk and Social Structure*, pp. 93-137. Cambridge: Polity Press.

Herman, E.S. (1985) Diversity of news: 'Marginalizing' the opposition. *Journal of Communication*, 35(3), 135-146.

Herman, E.S. and Chomsky, N. (1988) *Manufacturing Content*. New York: Pantheon Books.

Hess, S. (1990) *Washington as seen on local TV*. Paper presented at the annual meeting of the American Political Science Association, San Francisco, CA, August.

Hester, H. (1976) *Foreign news on US television*. Paper presented at the annual conference of the International Association of mass Communication Research, Leicester, England.

Hetherington, A. (1985) *News, Newspapers and Television*. London: Macmillan.

Hicks, R.G. (1981) How much news is enough? *Newspaper Research Journal*, 2(2), 58-67.

Hill, D.B.(1981) Letter opinion on ERA: A test of the newspaper bias hypothesis. *Public Opinion Quarterly*, 45(3), 384-392.

Hill, R.J. and Bonjean, C.M. (1964) News diffusion: A test of the regularity hypothesis. *Journalism Quarterly*, 41, 336-342.

Hoffstetter, C.R. (1976) *Bias in the News: Network Television Coverage of the 1972 Election Campaign*. Columbus, OH: Ohio State University Press.

Hoffstetter, C.R. and Buss, T.F. (1978) Bias in television news coverage of political events: A methodological analysis. *Journal of Broadcasting*, 22(4), 517-530.

Holsti, O. (1969) *Content Analysis for the Social Sciences and Humanities*. Reading, MA: Addison-Wesley.

Horne, E.E. (1983) Question generation and formulation: An indication of information need. *Journal of the American Society for Information Science*, 34, 5-15.

Hornig, S. (1990) Science stories: Risk, power and perceived emphasis. *Journalism Quarterly*, 67, 767-776.

Hudson, T.J. (1992) Consonance in depiction of violent material in television news. *Journal of Broadcasting and Electronic Media*, 36(4), 411-425.

Hutchins, R. (1947) *A Free and Responsible Press: Commission on the Freedom of the Press*. Chicago: University of Chicago Press.

Ibbctson, P. (1989) Bias, balance and being fair. In *Impartiality: Representing Reality*. London: British Broadcasting Corporation.

ITC (1991) *Television Programme Code*. London, UK: Independent Television Commission.

Iyengar, S. (1990) Framing responsibility for political issues: The case of poverty. *Political Behaviour*, 12, 19-40.

Iyengar, S. (1994) *Is Anyone Responsible: How Television Frames Political Issues*, Chicago: University of Chicago Press.

Iyengar, S. and Kinder, D.R. (1987) *News that Matters: Television and American Opinion*. Chicago: University of Chicago Press.

Iyengar, S. and Simon, A. (1993) News coverage of the Gulf crisis and public opinion: A study of agenda-setting, priming and framing. *Communication Research*, 20, 365-383.

Izard, R.S., Culbertson, H.M. and Lambert, D.A. (1990) *Fundamentals of News Reporting*. Dubuque, IA: Kendall/Hunt.

Jacobsen, G.C. (1987) *The Politics of Congressional Elections*. (2nd. ed.) Boston: Little, Brown.

Jacubowicz, K. (1992) From party propaganda to corporate speech? Polish journalism in search of a new identity. *Journal of Communication*, 42(3), 64-73.

Janowitz, M. (1975) Professional models in journalism: The gatekeeper and the advocate. *Journalism Quarterly*, 52, 618-626.

Jay, P. and Birt, J. (1975a) Can television news break the understanding barrier? *The Times*, 28 February.

Jay, P. and Birt, J. (1975b) Why television is in danger of becoming an anti-social force. *The Times*, 3 September.

Jenkins, S. (1986) Bias and the Beeb: Does the charge stick? *Sunday Times*, October 5, p.26.

Johnstone, J.W.C., Slavski, E.J. and W.W. Bowman. (1976) *The News People*. Urbana,IL: University of Illinois Press.

Jucker, J. (1986) *News Interviews: A Pragmalinguistic Analysis*. Amsterdam: Gieben.

Julian, F.D. (1977) *Nonverbal determinants of a television newscaster's credibility: An experimental study*. Unpublished doctoral dissertation, University of Wisconsin, Madison.

Kahneman, D., Slovic, P. and Tversky, A. (Eds.) *Judgement under Uncertainty: Heuristics and Biases*. New York: Cambridge University Press.

Kaid, L.L., Chanslor, M. and Hovind, M. (1992) The influence of programme and commercial type on political advertising effectiveness. *Journal of Broadcasting and Electronic Media*, 36(3), 303-320.

Kaniss, P. (1991) *Making Local News*. Chicago: Chicago University Press.

Kanno, A. (1972) *Evaluative Encoding of the New York Times and London Times during Selected African Crises*. Ann Arbor, MI: Microfilms.

Katz, E. (1992) The end of journalism: Notes on watching the war. *Journal of Communication*, 42(3), 5-13.

Katz, E., Adoni, H. and Parness, P. (1977) Remembering the news – what the picture adds to recall. *Journalism Quarterly*, 54, 231-239.

Kepplinger, H.M. (1983) Visual biases in television campaign coverage. In E. Wartella, C. Whitney and S. Windahl (Eds.), *Mass Communication Review Yearbook*, Vol. 4, pp. 391-405. Beverly Hills, CA: Sage.

Kepplinger, H.M. and Roth, H. (1979) Creating a crisis: German mass media and the oil supply in 1973-4. *Public Opinion Quarterly*, 43, 285-296.

Klein, A. (1978) How telecast's organisation affects viewer retention. *Journalism Quarterly*, 55, 356-359, 411.

Kocher, R. (1986) Bloodhounds or missionaries: Role definitions of German and British journalists. *European Journal of Communication*, 1(1), 43-64.

Kozminsky, E. (1977) Altering comprehension: The effect of biasing titles on text comprehension. *Memory and Comprehension*, 5, 482-490.

Kumar. C. (1975) Holding the middle ground. *Sociology*, 9(3), 67-88.

Lachman, R.J., Lachman, L. and Butterfield, E.C. (1979) *Cognitive Psychology and Information Processing: An Introduction*. Hillsdale, NJ: Lawrence Erlbaum Associates.

Lang, K. and Lang, G.E. (1953) The unique perspective of television and its effect. *American Sociological Review*, 18(1), 103-112.

Larsen, S.F. (1981) *Knowledge updating: Three papers on news memory, background knowledge and text processing*. (Psychological Reports, 6(4)). Aarhus: University of Aarhus, Institute of Psychology.

Lasorsa, D. and Reese, S. (1990) News source use in the crash of 1987: A study of four national media. *Journalism Quarterly*, 67, 60-71.

Lasswell, H.D. and Leites, N. (1949) I. Cambridge: The MIT Press.

Lasswell, H.D., Lerner, D. and de S. Pool, I. (1952) *The Comparative Study of Symbols*. Stanford, CA: Stanford University Press.

Lazarsfeld, P. Berelson, B. and Gaudet, H. (1944) *The People's Choice*. New York: Columbia University Press.

Lee, R. 91975) Credibility of newspaper and TV news. *Journalism Quarterly*, 55, 282-287.

Lehman, C. (1984) *Meeting readers' multiple needs*. Research Report, New York: Newspaper Advertising Bureau, Inc.

Lemert, J.B. (1974) Content duplication by the networks in competing evening newscasts. *Journalism Quarterly*, 51, 238-244.

Levy, M.R. (1978) The audience experience with television news. *Journalism Monographs*, 55.

Lewis, J. (1994) The absence of narrative: Boredom and the residual power of television news. *Journal of Narrative and Life History*, 4(1-2), 25-40.

Lichter, S.R. and Rothman, S. (1986) *The Media Elite: America's New Powerbrokers*. Bethesda, MD: Adler and Adler.

Liebes, T. (1992a) Decoding television news: The political discourse of Israeli hawks and doves. *Theory and Society*, 21, 357-381.

Liebes, T. (1992b) Our war/their war: Comparing the intifada and the Gulf War on U.S. and israeli television. *Critical Studies in Mass Communication*, 9, 44-55.

Liebes, T. and Roback, R. (1994) In defense of negotiated readings: How moderates on each side of the conflict interpret the Intifada news. *Journal of Communication*, 4492), 108-124.

Lind, R.A. (1995) How can TV news be improved? Viewer perceptions of quality and responsibility. *Journal of Broadcasting and Electronic Media*, 39(3), 360-375.

Linne, A. and Veirup, K. (1974) *Radio Producers and their Audiences: A Confrontation*. Danish radio Training Department, No.24.

Lynch, M.D. (1968) The measurement of human interest. *Journalism Quarterly*, 45, 226-236.

Lynch, M.D. and Effendi, A. (1964) Editorial treatment of India in the New York Times. *Journalism Quarterly*, 41, 430-432.

McArthur, L.Z. (1981) What grabs you? The role of attention in impression formation and causal attribution. In E.T. Higgins, C. Herman, and M.P. Zanna (Eds.), *Social Cognition: The Ontario Symposium* (Vol.1, pp. 201-246). Hillsdale, NJ: Lawrence Erlbaum Associates.

McCain, T. A., Chilberg, J. and Wakshlag, J. (1977) The effect of camera angle on source credibility and attention. *Journal of Broadcasting*, 21, 35-46.

McClure, R. and Patterson, T. (1973) *Television news and voter behaviour in the 1972 presidential election*. Unpublished paper, American Political Science Association.

McCombs, M.E. and Shaw, D.L. (1972) The agenda-setting function of the press. *Public Opinion Quarterly*, 36(2), 176-187.

McDonald, D.G. and Reese, S.D. (1987) Television news and audience selectivity. *Journalism Quarterly*, 64, 763-768.

Mcgregor, R., Ledger, C. and Svennevig, M. (1987) *Public Reactions to Broadcasting Coverage of the 1987 General Election*. London: BBC Broadcasting Research Department.

McNair, B. (1988) *Images of the Enemy*. London: Routledge.

McQuail, D. (1977) *Analysis of Newspaper Content*. Royal Commission on the Press, Research Studies 4, London: HMSO.

McQuail, D. (1992) *Media Performance: Mass Communication and the Public Interest*. London: Sage.

McQuail, D. (1993) *Mass Communication Theory: An Introduction*. Beverly Hills, CA: Sage.

Mancini, P. (1992) Old and new contradictions in Italian journalism. *Journal of Communication*, 2(3), 42-47.

Mandell, L.M. and Shaw, D.L. (1973) Judging people in the news – unconsciously – effect of camera angle and bodily activity. *Journal of Broadcasting*, 17, 352-362.

Manis, M., Dovalina, I., Avis, N.E. and Cardoze, S. (1980) base rates can affect individual predictions. *Journal of Personality and Social Psychology*, 38, 231-248.

Mazzoleni, G. (1987) Media logic and party logic in campaign coverage: The Italian General Election of 1983. *European Journal of Communication*, 291), 81-103.

Meadow, R.G. (1973) Cross-media comparison of coverage of the 1972 presidential campaign. *Journalism Quarterly*, 50, 482-488.

Menneer, P. (1989) Representations and public perceptions ... and reality. In *Impartiality: Representing Reality*. BBC Seminar Proceedings, pp. 34-38. London: British Broadcasting Corporation.

Metallinos, N. (1980) Asymmetry of the visual field: Perception, retention and preference of still images. In J. Baggaley (Ed.), *Proceedings of the Third International Conference on Experimental Research in Televised Instruction*. St. Johns: Memorial University of Newfoundland.

Meyer, P. (1988) A workable measure for auditing accuracy in newspapers. *Newspaper Research Journal*, 19(1), 39-52.

Milburn, M.A. and McGrail, A.B. (1992) The dramatic presentation of news and its effects on cognitive complexity. *Political Psychology*, 13(4), 613-632.

Miller, D.C. (1945) A research note on mass communication. *American Sociological Review*, 10, 691-694.

Mills, C.W. (1956) *The Power Elite*. New York: Oxford University Press.

Monge, P. (1987) Network level of analysis. In C. Berger and S. Chaffee (Eds.), *Handbook of Communication Science*. pp. 239-270. Beverly Hills, CA: Sage.

Monge, P. and Contractor, N. (1988) Communication networks: Measurement techniques. In C. Tardy (Ed.), *For the Study of Human Communication: Methods and Instruments for Observing*, pp. 107-138. Norwood, NJ: Ablex.

Montgomery, K.C. (1954) The role of the exploratory drive in learning. *Journal of Comparative and Physiological Psychology*, 47, 60-64.

Morin, V. (1976) Televised current events sequences or a rhetoric of ambiguity. In *News and Current Events on TV*, Rome: Edizioni, RAI.

Morris, C. (1989) Impartiality and truth: The problem of moral neutrality. In *Impartiality: Representing Reality*. London: British Broadcasting Corporation, pp. 21-25.

Morrisson, D. (1986) *Invisible Citizens: British Public Opinion and the Future of Broadcasting*. London: John Libbey.

Mundorf, N., Drew, D., Zillmann, D. and Weaver, J. (1990) Effects of disturbing news on recall of subsequently presented news. *Communication Research*, 17, 601-615.

Mundorf, N. and Zillmann, D. (1991) Effects of story sequencing on affective reactions to broadcast news. *Journal of Broadcasting and Electronic Media*, 35(2), 197-211.

Murch, A.W. (1971) Public concern for environmental pollution. *Public Opinion Quarterly*, 35, 100-106.

National Cancer Institute (1984) *Cancer Prevention and Awareness Survey*. Washington, D.C.: US Government Printing Office.

Newson, D. and Wollert, J.A. (1985) *Media Writing: News for the Mass Media*. Belmont, CA: Wadsworth.

Nimmo, D.D. and Combs, J.E. (1985) *Nightly Horrors: Crisis Coverage by Television Network News*. Knoxville, TN: University of Tennessee Press.

Nisbert, R.E. and Ross, L. (1980) *Human Inference: Strategies and Shortcomings of Social Judgement*. Englewood Cliffs, NJ: Prentice-Hall.

Nisbert, R.E. and Ross, L. (1980) *Human Inference: Strategies and Shortcomings of Social Judgment*. Englwood Cliffs, NJ: Prentice-Hall.

Noelle-Neuman, E. (1973) Return to the concept of powerful mass media. *Studies in Broadcasting*, 9, 66-112.

Noelle-Neuman, E. (1974) *The Spiral of Silence*. Chicago: University of Chicago Press.

Noelle-Neuman, E. and Mathes, R. (1987) The 'event as event' and the 'event as news': The significance of 'consonance' for media effects research. *European Journal of Communication*, 2, 391-414.

Nordenstreng, K. (1974) *Informational Mass Communication*. Helsinki: Tammi.

Nordenstreng, K. (1984) *The Mass Media Declaration of UNESCO*. Norwood, NJ: Ablex.

Ogan, C.L. and Lafky, S.A. (1983) 1981's most important events as seen by reporters, editors, wire services and media consumers. *Newspaper Research Journal*, 5(1), 3-12.

Osgood, C.E., Tannenbaum, P.H. and Suci, G. (1957) *The Measurement of Meaning*. Urbana, IL: University of Illinois Press.

Ostgaard, E. (1965) Factors affecting the flow of news. *Journal of Peace Research*, 1, 39-55.

Page, B.I., Shapiro, Y. and Dempsey, G.R. (1987) What moves public opinion? *American Political Science Review*, 81(1), 23-43.

Paivio, A. (1971) *Imagery and Verbal Processes*. New York: Holt.

Paletz, D. and Elson, M. (1976) Television coverage of presidential conventions. *Political Science Quarterly*, 9, 109-131.

Paletz, D. and Entman, R. (1981) *Media, Power, Politics*. New York: Free Press.

Pan, Z. and Kosicki, G.M. (1993) Framing analysis: An approach to news discourse. *Political Communication*, 10, 55-76.

Park, E. and Kosicki, G.M. (1995) Presidential support during the Iran-Contra affair: People's reasoning process and media influence. *Communication Research*, 22(2), 207-236.

Patterson, T. (1980) *The Mass Media Election*. New York: Praeger.

Patterson, T.E. and McClure, R.D. (1976) *The Unseeing Eye*. New York: G.P. Putnam.

Peeters, G. (1991) Evaluative inference in social cognition: The roles of direct versus indirect evaluation and positive-negative asymmetry. *European Journal of Social Psychology*, 21, 131-146.

Peterson, T. (1956) The social responsibility theory of the press. In F.S. Siebert, T. Peterson and S. Schramm (Eds.) *Four Theories of the Press*, pp. 73-103. Urbana,IL: University of Illinois Press.

Pettigrew, T.F. (1979) The ultimate attribution error: extending Allport's cognitive analysis of prejudice. *Personality and Social Psychology Bulletin*, 5, 461-476.

Pfau, M. and Louden, A. (1994) Effectiveness of adwatch formats in deflecting political attack ads. *Communication Research*, 21(3), 325-341.

Porter, M.J. (1983) Applying semiotics to the study of selected prime time television programs. *Journal of Broadcasting*, 2791), 69-75.

Potter, J. (1975) *Critics and viewers*. Independent Broadcasting, May, p. 17.

Preston, W., Herman, E.S. and Schiller, H.I. (1989) *Hope and Folly: The US and UNESCO 1945-1985*. Minneapolis: University of Minnesota Press.

Quirk,R., Greenbaum, S., Leech, G. and Svartik, J. (1985) *A Comprehensive Grammar of the English Language*. London: Longman.

Reagan, J. and Zenaty, J. (1979) Local news credibility: Newspapers vs TV revisited. *Journalism Quarterly*, 56, 168-172.

Reese, S.D. (1984) Vidusal-verbal redundancy effects on television news learning. *Journal of Broadcasting*, 28(1), 79-87.

Reese, S.D., Grant, A. and Danielian, L.H. (1994) The structure of news sources on television: A network analysis of 'CBS News', 'Nightline', 'MacNeil/Lehrer' and 'This Week with David Brinkley'. *Journal of Communication*, 44(2), 84-107.

Reisberg, D., Heuer, F., Mclean, J. and O'Shaughnessy, M. (1988) The quantity, not the quality, of affect predicts memory vividness. *Bulletin of the Psychonomic Society*, 26, 100-103.

Renckstorff, K (1977) Nachrichtensendungen im Fernesehen eine empirische Studie zur Wirking unterschiedlicher Darstellung in Fersehnachrichten. *Media Perspektiven*, 1/77, 27-42.

Reynolds, A.G. and Flagg, P.W. (1977) *Cognitive Psychology*. Cambridge, MA: Winthrop.

Rikardsson, G. (1978) *The Middle East Conflict in the Swedish Press*. Stockholm: Esselte Studium.

Robinson, J.P. and Davis, D.K. (1990) Television news and the informed public: An information processing approach. *Journal of Communication*, 40, 106-119.

Robinson, J.P., Davis, D., Sahin, H., and O'Toole, T. (1980) *Comprehension of television news: How alert is the audience?* Paper presented to the Association for Education in Journalism, Boston, August.

Robinson, J.P. and Levy, M.R. (1986) *The Main Source*. Newbury Park, CA: Sage.

Robinson, J.P. and Sahin, H. (1984) *Audience Comprehension of Television News: Results from Some Exploratory Research*. London: British Broadcasting Corporation, Broadcasting Research Department.

Robinson, J.P., Sahin, H. and Davis, D. (1982) Television journalists and their audiences. In J.S. Ettema and D.C. Whitney (Eds.) *Individuals in Mass Media Organisations: Creativity and Constraint*. Beverly Hills, CA: Sage

Robinson, M.J. and Kohut, A. (1988) Believability and the press. *Public Opinion Quarterly*, 52(2), 174-189.

Roger, D.B. and Schumacher, A. (1983) Effects of individual differences on dyadic conversational strategies. *Journal of Personality and Social Psychology*, 45, 700-705.

Rogers, E.M. and Dearing, J.W. (1987) Agenda setting research. In C. Berger and S.H. Chaffee (Eds.) *Handbook of Communication Science*, pp. 555-594. Newbury Park, CA: Sage.

Rogers, W.T. and Jones, S.W. (1975) Effects of dominance tendencies on floor holding and interruption behaviour in dyadic interaction. *Communication Research*, 1, 113-122.

Roper Organisation (1979) *Public Perceptions of Television and Other Mass Media: A Twenty Year Review: 1959-1978*. New York: Television Information Office.

Roper Organisation (1987) *America's Watching: Public Attitudes Toward Television*. New York: Television Information Office.

Rosengren, K.E. (1977) International news: Four types of tables. *Journal of Communication*, 27, 67-75.

Rosengren, K.E. (1980) Bias in the news: Methods and concepts. In C.G. Wilhoit and H. de Bock (Eds.) *Mass Communication Review Yearbook*, vol.1. pp. 249-263. Beverly Hills, CA: Sage.

Rositi, F. (1976) The television news programme: Fragmentation and recomposition of our image of society. In News and Current Events on TV. Rome: Edizioni RAI.

Rothbart, M., Fulero, S., Jensen, C., Howard, J. and Birrell, P (1978) From individual to group impressions: Availability heuristics in stereotype formation. *Journal of Experimental Social Psychology*, 14, 237-255.

Royal Commission on the Press (1977) Report. Comnd 6810. London: HMSO.

Rubin, A. (1983) Television uses and gratifications: The interactions of viewing patterns and motivations. *Journal of Broadcasting*, 27, 37-51.

Russo, F.D. (1971) A study of bias in TV coverage of the Vietnam War 1969 and 1970. *Public Opinion Quarterly*, 35, 539-543.

Russomanno, J.A. and Everett, S.E. (1995) Candidate sound bites: Too much concern over length? *Journal of Broadcasting and Electronic Media*, 39(3), 408-415.

Sanbonmatsu, D.M. and Fazio, R.H. (1991) Construct accessibility: determinants, consequences, and implications for the media. In J. Bryant and D. Zillmann (Eds.), *Responding to the Screen: Reception and Reaction Processes*, pp. 45-62. Hillsdale, NJ: Lawrence Erlbaum Associates.

Sande, O. (1971) The perception of foreign news. *Journal of Peace Research*, 8, 3-4.

Scanlon, T.J. (1969) A new approach to the study of newspaper accuracy. *Journalism Quarterly*, 49, 587-590.

Scannell, P. and Cardiff, D. (1991) *A Social History of British Broadcasting*, Volume I. Oxford: Basil Blackwell.

Schlegoff, E.A. (1989) From interview to confrontation: Observations on the Bush/Rather encounter. *Research on Language and Social Interaction*, 22, 215-240.

Schlesinger, P. (1978) *Putting Reality Together*. BBC News London: Constable.

Schlesinger, P., Murdock, G. and Elliot, P. (1983) *Televising Terrorism*. London: Comedia.

Schleuder, J., McCombs, M. and Wanta, W. (1991) Inside the agenda-setting process: How political advertising and TV news prime viewers to think about issues and candidates. In F. Biocca (Ed.) *Television and Political Advertising: Volume 1: Psychological Process*. Hilsdale, NJ: Lawrence Erlbaum Associates, pp. 263-309.

Schudson, M. (1978) *Discovering News*. New York: Basic Books.

Semetko, H.A. (1989) Television news and the 'third force' in British politics: A case study of election communication. *European Journal of Communication*, 4(4), 453-479.

Semetko, H.A., Blumler, J.G., Gurevitch, M., and Weaver, D.H. (1991) *The Formation of Campaign Agendas: A Comparative Analysis of Party and Media Roles in Recent American and British Elections*. London: Lawrence Erlbaum Associates.

Semetko, H.A., Scammell, M. and Nossiter, T. (1994) The media's coverage of the campaign. In A Heath, R. Jowell and J. Curtice (Eds.) *Labour's Last Chance?* Aldershot, UK: Dartmouth

Sherman, S.J. and Corty, E. (1984) Cognitive heuristics. In R.S. Wyer and T.K. Srull (Eds.), *Handbook of Social Cognition* (Vol.1., pp. 189-286). Hillsdale, NJ: Lawrence Erlbaum Associates.

Shoemaker, P.J. (1983) Bias and source attribution. *Newspaper Research Journal*, 5(1), 25-32.

Shoemaker, P.J. (1984) Media treatment of deviant political groups. *Journalism Quarterly*, 61, 66-75.

Shoemaker, P.J. (1991) *Communication Concepts 3: Gatekeeping*. Newbury Park, CA: Sage.

Shoemaker, P.J. and Mayfield E.K. (1987) Building a theory of news content: A synthesis of current approaches. *Journalism Monographs*, 103.

Shoemaker, P.J. and Reese, S.D. (1991) *Mediating the Message: Theories of Influences on Mass Media Content*. New York: Longman.

Slattery, K. and Tiedge, J.T. (1992) The effect of labeling staged video on the credibility of TV news stories. *Journal of Broadcasting and Electronic Media*, 36(3), 279-286.

Smith, A. (1976) *The Shadow in the Cave*. London: Quartet.

Smith, C. (1988) News critics, newsworkers and local television news. *Journalism Quarterly*, 65, 341-346.

Son, J., Reese, S.D. and Davie, W.R. (1987) Effects of visual-verbal redundancy and recaps on TV news learning. *Journal of Broadcasting and Electronic Media*, 31, 207-216.

Sparkes, V.M. and Winter, J.P. (1980) Public interest in foreign news. *Gazette*, 20, 149-170.

Srull, T.K. and Wyer, R.S. (1979) The role of category accessibility in the interpretation of information about persons: Some determinants and implications. *Journal of Personality and Social Psychology*, 37, 1660-1672.

Srull, T.K. and Wyer, R.S. (1986) The role of chronic and temporary goals in social information processing. In R.E. Sorrentino and E.T. Higgins (Eds.), *The Handbook of Motivation and Cognition: Foundations of Social Behaviour*, pp. 503-549. New York: Guilford Press.

Stanley, H. and Niemi, R. (1990) *Vital Statistics on American Politics*. (2nd. Ed.). Washington,DC: Congressional Quarterly.

Stauffer, J., Frost, R. and Rybolt, W. (1980) Recall and comprehension of radio news in Kenya. *Journalism Quarterly*, 57, 612-617.

Stauffer, J., Frost, R. and Rybolt, W. (1983) The attention factor in recalling network television news. *Journal of Communication*, 33, 29-37.

Steele, J. (1990) Sound bite seeks expert. *Washington Journalism Review*, September, pp. 28-29.

Stempel. G.H. III (1981) Readability of six kinds of content in newspapers. *Newspaper Research Journal*, 3(1), 32-37.

Stephens, M. (1986) *Broadcast News*. New York: Holt, Rinehart and Winstone

Stern, A.A. (1971) Presentation to the Radio-Television News Directors Association, Boston. Unpublished paper, University of California at Berkeley, Graduate School of Journalism.

Stevenson, R.L. and Greene, M.T. (1980) A reconsideration of bias in the news. *Journalism Quarterly*, 57, 115-121.

Stevenson, R.L. and Shaw, D.L. (1973) Untwisting The News Twisters: A replication of Efron's study. *Journalism Quarterly*, 50, 211-219.

Stone, G.C. and Grusin, E. (1984) Network TV as the bad news bearer. *Journalism Quarterly*, 61, 517-523, 592.

Stone, G., Hartung, B. and Jensen, D. (1986) Local TV news and the good-bad dyad. *Journalism Quarterly*, 63, 37-45.

Tankard, J.W., Jr. (1971) Eye contact research and television announcing. *Journal of Broadcasting*, 15, 83-90.

Tannenbaum, P.H. (1954) Effect of serial position on recall of radio news stories. *Journalism Quarterly*, 31, 319-323.

Tannenbaum, P.H. and Lynch, M.D. (1960) Sensationalism: The concept and its measurement. *Journalism Quarterly*, 37, 381-392.

Taylor, P. (1990) *See How They Run: Electing the President in the Age of Mediaocracy*. New York: Alfred A. Knopf.

Taylor, S.E. (1981) The interface of cognitive and social psychology. In J. Harvey (Ed.) *Cognition, Social Behaviour, and the Environment*. Hillsdale, NJ: Lawrence Erlbaum Associates.

Taylor, W.L. (1953) Cloze procedure: A new tool for measuring readability. *Journalism Quarterly*, 30, 415-433.

Taylor, S.E. and Thompson, S.C. (1982) Stalking the elusive 'vividness' effect. *Psychological Review*, 89, 155-181.

Thorndyke, P.W. (1979) Knowledge acquisition from newspaper stories. *Discourse Processes*, 2, 95-112.

Thorson, E., Christ, W.G. and Caywood, C. (1991) Effects of issue-image strategies, attack and support appeals, music, and visual content in political commercials. *Journal of Broadcasting and Electronic Media*, 35(4), 465-486.

Tiemens, R.K. (1970) Some relations of camera angle to communicator credibility. *Journal of Broadcasting*, 14, 483-490.

Tiemens, R.K., Sillars, M.O., Alexander, D.C. and Werling, D. (1988) Tv coverage of Jesse Jackson's speech to the 1984 Democratic Convention. *Journal of Broadcasting*, 32(1), 1-22.

Tillinghast, W.A. (1983) Source control and evaluation of newspaper inaccuracies. *Newspaper Research Journal*, 5(1), 13-24.

Tolman, E.C. (1932) *Purposive Behaviour in Animals and Men*. New York: Century.

Tuchman, G. (1978) *Making the News: A Study in the Construction of Reality*. New York: Free Press.

Tunstall, J. (1983) *The Media in Britain*. New York: Columbia University Press.

Tunstall, J. (1992) Europe as world news leader. *Journal of Communication*, 42(3), 84-99.

Tversky, A. and Kahneman, D. (1973) Availability: A heuristic for judging frequency and probability. *Cognitive Psychology*, 5, 207-232.

Waddington, D., Wykes, M., Critcher, C. and Hebron, S. (1991) *Split at the Seams?: Community, Continuity and Change after the 1984-85 Coal Dispute*. Milton Keynes, UK: Open University Press.

Wallack, L., Dorfman, L., Jernigan, D. and Themba, M. (1993) *Media Advocacy and Public Health*, Newbury Park, CA: Sage.

Walters, L.M., Wilkins, L. and Walters, T (Eds.) (1989) *Bad Tidings: Communications and Catastrophe*. Hillsdale, NJ: Lawrence Erlbaum Associates.

Wanta, W., Stephenson, M.A., Turk, J.V. and McCombs, M.E. (1989) How president's state of union talk influenced news media agendas. *Journalism Quarterly*, 66, 537-541.

Weaver, D.H. (1979) Estimating the value of newspaper content for readers: A comparison of two methods. *Newspaper Research Journal Prototype*, 7-13.

Weaver, D.H., McCombs, M., Graber, D. and Eyal, C. (1981) *Media Agenda Setting in a Presidential Election: Issues, Images and Interest*. New York: Praeger.

Weinberger, M.G., Allen, C.T., and Dillon, W.R. (1984) The impact of negative network news. *Journalism Quarterly*, 61, 287-294.

Wenner, L.A. (1982) Gratifications sought and obtained in programme dependency: A study of network evening news programmes and 60 Minutes. *Communication Research*, 9, 539-560.

West, D. (1993) *Air Wars* Washington, DC: Congressional Quarterly Press.

Westerhahl, J. (1970) Objectivity is measurable. *EBU Review*, 121 B, 13-17.

Westerhahl, J. (1972) *Objektiv Nyhetsformedling/Objective News*, Stockholm, Sweden: Scandinavian University Books.

Westerhahl, J. (1983) Objective news reporting. *Communication Research*, 10, 403-424.

Westerhahl, J. and Andersson, F. (1991) Chernobyl and the nuclear power issue in Sweden. *International Journal of Public Opinion Research*, 3, 115-131.

Westley, B.H. and Higsbie, C.E. (1963) The news magazines and the 1960 conventions. *Journalism Quarterly*, 40, 523-531, 647.

Westley, B.H. and MacLean, M. (1957) A conceptual model of mass communication research. *Journalism Quarterly*, 34, 31-38.

Westley, B.H. and Mobius, J.B. (1960) *The effects of 'eye-contact' in televised instruction*. University of Wisconsin, Madison, unpublished paper.

Whitney, D.C., Fritzler, M., Jones, S., Mazzarella, S. and Rakow, L. (1989) Geographic and source biases in network TV news 1982-1984. *Journal of Broadcasting*, 33(2), 159-174.

Wicks, R.H. (1992) Improvement in recall of media information: An exploratory study. *Journal of Broadcasting and Electronic Media*, 36(3), 287-302.

Wicks, R.H. and Korn, M. (1995) Factors influencing decisions by local television news directors to develop new reporting strategies during the 1992 political campaign. *Communication Research*, 22(2), 237-255.

Williams, A. (1975) Unbiased study of TV news bias. *Journal of Communication*, 25(4), 393-408.

Wilson, T.D. (1981) On user studies and information needs. *Journal of Documentation*, 37, 3-15.

Winterhoff-Spurk, P. (1983) Fiktionen in der Fernsehnachrichten-forschung: Von der Text-Bild-Schere, der Uberlegenheit des Fernsehens und vom ungestorten Zuschauer. *Media Perspektiven*, October, 722-727.

Wober, M. (1992) *Television and the 1992 General Election*. London: Independent Television Commission, Research paper.

Wolton, D. (1992) Journalists: The Tarpeian rock is close to the capitol. *Journal of Communication*, 42(3), 26-41.

Womack, B. (1981) Attention maps of 10 major newspapers. *Journalism Quarterly*, 58, 260-265.

Wulfmeyer, K.T. (1983a) The interests and preferences of audience for local television news. *Journalism Quarterly*, 60, 323-328.

Wulfmeyer, K.T. (1983b) Use of anonymous sources in journalism. *Newspaper Research Journal*. 4(2), 43-50.

Wyer, R.S. and Srull, T.K. (1981) Category accessibility: Some theoretical and empirical issues concerning the processing of social stimulus information. In E. T. Higgins, C.P. Herman, and M.P. Zanna (Eds.), *Social Cognition: The Ontario Symposium*, Vol.2. pp. 161-197. Hillsdale, NJ: Lawrence Erlbaum Associates.

Youman, R.J. (1972) What does America think now? *TV Guide*, September 30.

Zettl, H. (1973) *Sight, Sound, Motion: Applied Media Aesthetic*s. Belmont, CA: Wadsworth.

Zillmann, D., Gibson, R., Ordman, V.L. and Aust, C.F. (1994) Effects of upbeat stories on broadcast news. *Journal of Broadcasting and Electronic Media*, 38(1), 65-78.

Zillmann, D., Perkins, J.W. and Sundar, S.S. (1992) Impression formation effects of printed news varying in descriptive precision and exemplifications. *Medienpsychologies: Zeitschrfit fur Individual und Massenkommunikation*, 4(3), 168-185, 239-240.